Build Your Own Home Darkroom

**Lista Duren &
Will McDonald**

Amherst Media Amherst, New York

Published by
Amherst Media, Inc.
P.O. Box 586
Buffalo, NY 14226

Printed and bound in the United States of America
Library of Congress Catalog Card Number: 90-80187

ISBN 0-936262-04-4

Interior and cover design: Susan Marsh

Illustrations: Will McDonald

Photographs: Alan Oransky

Composition: DEKR Corporation

Sixth Printing 1997

Both plumbing and electrical work can be dangerous if done incorrectly. Instructions in this book are intended as a guide so that you can discuss the job with an expert or do the work with expert supervision. All new installations should be in accordance with local codes and at the very minimum checked by a licensed professional to be sure they meet local codes. Although the information in this book is as nearly complete as possible at the time of publication, manufactured items and techniques for installing them may change. The Publishers cannot assume liability for any changes, errors, or omissions leading to problems you may encounter.

Acknowledgments

This book came into being with the help of many generous people and we would like to acknowledge their contributions. The authors take ultimate responsibility for shortcomings, but appreciation should be directed to those who provided answers and assistance. Our thanks are extended particularly to:

Dennis Curtin whose whirlwind energy got this book off the ground and whose constant flow of ideas helped sustain it.

Barbara London for continuous support and enthusiasm, and for comments from the viewpoint of a novice carpenter.

Marvin Mendelssohn for blending a sense of humor with his design input and very patient woodworking instruction.

William Yarlett of Meynell Valve Co. for supplying the temperature control unit and contributing to the design of the water supply panel.

Don King of GTE Products Corp. for taking the time to answer questions about the properties of fluorescent lights.

Joe DeMaio, Fred Bodin, Elizabeth Hamlin, Don Dietz, Terry McKoy, Ken Buck, Alan Oransky, Catherine Renken, Bill Covington, and all the other photographers who offered their darkrooms for perusal and shared their ideas so freely.

Phil Edgerton for his typewriter and his general neighborly encouragement.

Fred Walling who answered questions when we were far away from our woodworking consultant and who built the most beautiful light box we've seen yet.

David Robinson for his multi-faceted editing and scrupulous attention to detail.

Susan Marsh for bringing aesthetic sense to the book.

Nancy Benjamin for calmly guiding this book into print.

This book is dedicated to our grandmothers, Emma and Maran, who have helped us to see the pleasure of working with our hands, and to the inventive spirit of Chester who once built an enlarger out of tin cans.

Contents

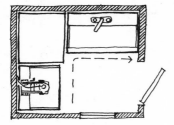
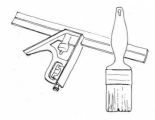

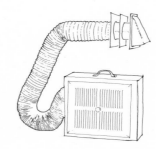
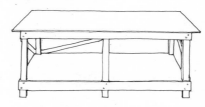

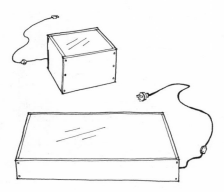
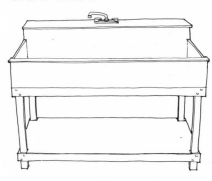

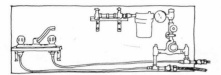
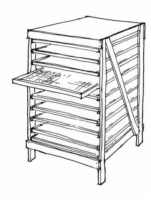

Introduction

Most home darkrooms are home made and most are assembled on a low budget. The designs are original and the various parts are purchased, scavenged second-hand, built to fit, combined in ingenious ways, and often put to a use other than their intended one. The photographers who built their own home darkrooms looked at other darkrooms, swapped ideas with friends, and took designs from books and articles. Some of them called in a carpenter, but many took hammer in hand themselves to build the counter, sinks, drying racks, and other equipment that would best fit their needs.

This book of designs for your darkroom grows out of the tradition of those photographers who pass on darkroom ideas, each one adapting and refining for their own situation.

For the most part, the designs in this book are not new. You will see these ideas and solutions in darkroom after darkroom with the form varying a little according to space, size and quantity of prints, and the personal styles of the people who built them.

For each project we have collected designs as you might collect versions of a folk tale. We have combined the best features of each and generalized the designs to fit the greatest number of situations. What we offer you here is a collection of time-tested ideas with detailed step-by-step instructions for building each project at home, as well as some basic carpentry instruction.

This book will be useful in every phase of building your darkroom— designing the room and deciding what equipment you need, light-proofing, ventilating, building a work table, enlarger wall mount, adjustable baseboard, light box, sink, water supply panel, and print drying rack.

We hope that this book will be a resource for your darkroom design as well as an easy-to-follow step-by-step guide to building the items you need.

Using this book

Don't be intimidated by the number of projects in this book. Very few darkrooms will contain every single item and Chapter 1, "Darkroom design," will help you decide which ones to build. Here you will also find pointers on choosing the best darkroom space in your house and information about designing an efficient and comfortable darkroom within that space.

We know that hammers and drills may not be as familiar to you as cameras and enlargers (we are photographers ourselves, although we have done some carpentry), so we've described all the tools and basic skills you will need in Chapter 2, "Woodworking." This chapter was developed with the help of a professional woodworker, Marvin Mendelssohn.

The designs in Chapters 3–11 were also worked out with Marvin's help. Our considerations were ease of construction, sturdiness, darkroom space limitations, and budget. Not all of these projects are beautiful, but they are functional. For the apartment-dweller or the photographer who might progress from one darkroom to another, these designs are moveable. Most of the projects can be built without bolting into walls or permanently sealing off windows, and the larger ones disassemble for moving.

We built each item ourselves, at home using simple tools, before writing the step-by-step instructions. We have tried to cover every detail of construction. If you don't fully understand the instructions on the first reading, they should become clear when you have the materials in your hands.

Time, cost, and difficulty ratings at the beginning of each project give you some idea what to expect. Since we probably can't revise this book as fast as lumber prices go up, we've indicated the relative cost of materials with the terms *low, medium,* and *high.* The current price ranges are:

Low: under $40
Medium: $40-$75
High: over $75

In addition to the step-by-step instructions for each project, we've included alternatives—ways that you can adapt the design to your needs, and tips—helpful hints passed on by other darkroom builders.

What to build for your darkroom

Many of the articles needed in your darkroom can be built with standard materials from a builders supply or hardware store and a usual selection of home tools. If you're willing to invest your time, you can build equipment yourself at less cost than buying it from a manufacturer, and you can build to fit the measurements and specific needs of your darkroom.

Following are some of the most commonly used pieces of darkroom equipment that you can build. Not every darkroom will need all of these items, so here is some information to help you decide which ones you want to build.

Lightproofing is a necessity unless you plan to print in an interior bathroom or closet that's already totally dark. Permanent lightproofing is easiest, but if you want the option of using your windows to admit light, we've provided a couple of plans for easily removeable lightproof panels.

Ventilation removes chemical fumes and keeps your darkroom from getting stuffy. Unless the room you've chosen has an air intake and exhaust system capable of 6 to 8 air changes per hour, you will need to provide one.

Install a bathroom exhaust fan in your darkroom or, if you don't want to make a permanent installation, build a portable exhaust fan. This fan can also be used for doing smelly projects outside your darkroom, such as painting the items you're building.

For fresh air intake, build a lightproof vent in your wall or door, or install a window air conditioning

unit that will also provide temperature control. (See Chapter 4.)

A small light box (left) (about 12 × 12 inches) can be used in a black-and-white or color darkroom for evaluating negative density before printing. It sure beats holding your negatives up to the light and squinting at them. We think every darkroom should have one.

A large light box (right) (about 24 × 35 inches) with a light source similar in color to daylight is used for evaluating, sorting, and editing color transparencies. It is very bright and is usually used in the studio rather than in the darkroom. If you work a lot with color transparencies (or if you do any kind of layout or graphic design work) you will find a large light box worthwhile.

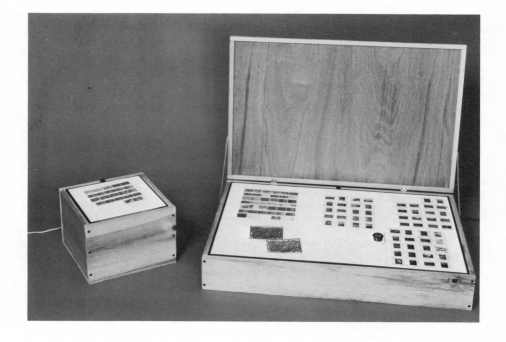

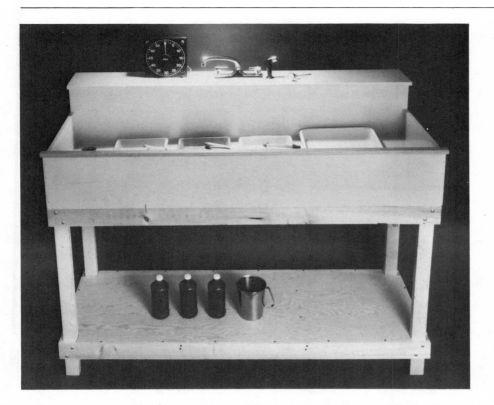

A darkroom sink is a great convenience but not a necessity. Many a professional photographer has worked for years without one by keeping developed prints in a "holding tray" of water and carrying them in batches to a nearby sink for washing. Among the advantages to having a sink: you don't have to worry about splashes or spills. All of your operations are in the same place, making setting up and cleaning up a lot easier and faster because you don't have to walk to and from your water supply with trays of chemicals.

The ideal darkroom sink is at counter height. It is large and shallow so that you can handle the trays and prints easily. You can buy one ready made or build your own. Darkroom sinks are made of stainless steel or plastic. They are generally

expensive, will usually have to be ordered, and may not come in the exact size you need for your darkroom. Occasionally, a suitably shaped sink (such as an industrial sink or a shallow restaurant sink) will turn up, second hand, at a builders salvage yard.

Because of the deep shape, a laundry sink or bathtub is not a comfortable substitute for a darkroom sink. If you have one in your darkroom already, you might find it useful as an auxiliary sink in which to mix chemicals or wash trays, or you might build your darkroom sink over it and take advantage of the existing drain.

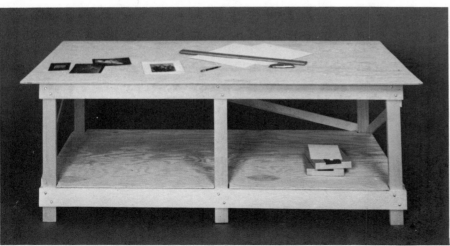

A work table is useful in just about every phase of darkroom work—reviewing transparencies and prints, enlarging, mounting and matting, and so on. Perhaps you already have desks, tables, or built-in counters to serve some of these functions. The table shown is designed to fill in wherever you need another sturdy work surface. You can alter the dimensions to fit your situation, and build any kind of storage you want under the tabletop. See Chapter 5 for instructions.

What to build for your darkroom

What to build for your darkroom (cont.)

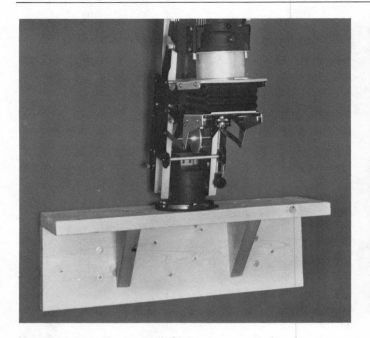

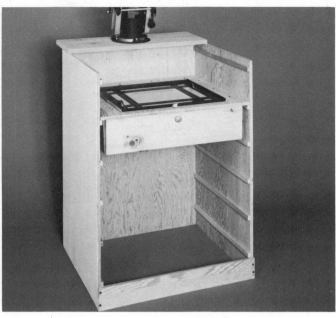

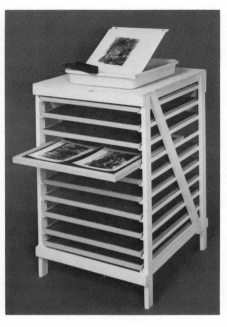

An enlarger wall mount (left) is a sturdy shelf attached to the wall to hold your enlarger. In most situations, leaving your enlarger mounted onto its own baseboard or mounting it onto a sturdy counter is perfectly adequate. We only recommend wall-mounting your enlarger if you need to:

1 Leave your entire counter free for work space.

2 Make larger prints by projecting onto a lower counter or the floor. (If you plan to build the adjustable enlarger baseboard [Chapter 6], you won't need to wall-mount your enlarger.)

A disadvantage to wall-mounting your enlarger is the problem of making sure the film plane is parallel to your printing surface. This is crucial for the overall sharpness of your prints, and may not be easy to do.

Ready-made wall mounts are available from some enlarger manufacturers.

An adjustable enlarger baseboard (right) has a narrow shelf for mounting your enlarger and a moveable shelf for your printing easel. This gives you two advantages:

1 It increases the maximum distance between the enlarger head and the printing surface so you can make oversize prints.

2 It allows you to print any size with the enlarger head low on the shaft. This minimizes vibrations, giving you sharper prints.

The disadvantages to the adjustable baseboard? Some working heights are not very comfortable, and at low levels the vertical sides of the baseboard cabinet might get in your way. Unless you know that you want to make prints bigger than the capacity of your enlarger, we suggest building the adjustable baseboard later if you decide you want it.

A print drying rack is a rack with fiberglass screens for drying printing papers. It's recommended for archival processing of fiber-based papers. If you are working only with resin-coated papers or color print materials, you can dry the prints by hanging them on a line.

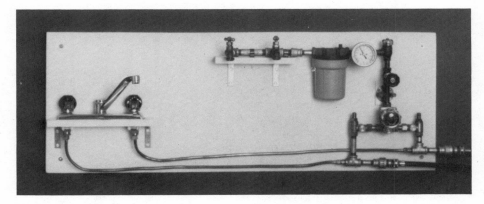

A water supply panel is a plywood panel with your water lines, filters, temperature-regulating unit, and faucets on it. (If you don't have a temperature-regulating unit, all of your plumbing will probably fit easily on your sink and you won't need this panel.) It sits above your sink and connects to the house water supply with washing machine hoses. If you own your house and plan to stay there, you will probably choose built-in plumbing. If you expect to move your darkroom some time, it is best to put all your plumbing on a panel. Then all you have to do is unscrew the hoses, take the plumbing with you and attach it to the water supply at your new location.

TIPS: Other things you might want

Print-viewing light This light is good for evaluating prints when you remove them from the fixer. It should be the same intensity as the light under which the final print will be viewed. We suggest a lamp with a spring-balanced arm, such as a Luxo lamp. To examine print details or proof sheets, you can get one with a built-in magnifying glass.

Rubber floor mat A floor mat makes hours of stand-up darkroom work considerably more comfortable. Get a thick mat with a nonslip surface. Suggestions: Leedall's rubber mat for darkrooms or a commercial floor mat such as the Ace Core-Lite. Carpeting is not desirable because it absorbs chemical spills; the dried powder from these spills may be corrosive to prints, equipment, or anything else it settles on.

Storage space Lots of it! Plan to put up extra shelves if necessary. You can also bring in an old chest of drawers or a second-hand cabinet for under-the-counter storage.

Tackboard A tackboard is handy for tacking up developing instructions, notes to yourself, printing records, and so on. Put some homosote or other tackboard material on one of your walls, on the back of the door, or over a window as part of the lightproofing.

Stereo Music makes darkroom work more pleasant. A radio or stereo can have a great effect on your mood during a long printing session.

Phone or intercom With your stereo blaring, water running, and the door closed, it's hard for anyone to reach you. This kind of isolation may be exactly what you want in the darkroom. However, if you need to maintain contact with the outside world, install an intercom and/or extension phone. Extension cords are available for some kinds of phone jacks, so you can just take a nearby phone into your darkroom.

Work-in-progress warning If other people will be in your house when you're printing, put a sign on the door reminding people to knock or install a light outside your door on the same switch as your safelight (when the light is on, do not enter).

Child proofing Most photographic chemicals are poisonous and make the darkroom a dangerous place for small children. If you have children, put a lock on your darkroom door or make sure the lower areas of your darkroom are child-safe. You'll also feel better knowing that your light-sensitive materials and costly equipment are safe from inquisitive youngsters.

What to build for your darkroom (cont.)

Choosing a suitable space

All kinds of spaces can be used as darkrooms. Attic or basement rooms or any spare room are obvious possibilities. A darkroom doesn't have to be large: a walk-in closet or pantry, sometimes even a hallway, can be suitable. It's also common to convert a kitchen or bathroom each time you want to print. Here's a list of what to look for in a potential darkroom space and some ideas for rooms that might be used as darkrooms.

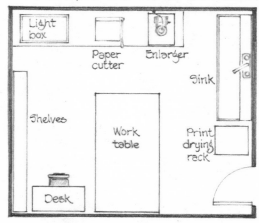

SPARE ROOM, ATTIC or BASEMENT

What to look for in a darkroom location

Proximity of running water Water is necessary for mixing chemicals, for washing prints, and for cleaning up. Choose a room that has running water (a sink, bathtub, or washing machine outlet). If that's not possible, choose a space that's close to a water supply so you don't have to carry water too far.

Ease of lightproofing Fewer windows and doors mean less time spent blocking out light; if you can, choose a space that's already somewhat dark. If you'll be printing only at night, adequate lightproofing will be much easier for you.

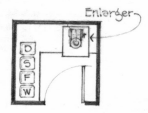

PANTRY or CLOSET

Electricity You will need electricity for room lights, safelights, and your enlarger. In addition, you may have a developing timer, clock, radio, light box, ventilating fan, air conditioner, heater, print dryer, and—for color printing—a motor base for the processing tube. Air conditioners and heaters pull a lot of current, so check to be sure you have a circuit that will support them. For the other items, you just need enough outlets. Make sure you have at least one outlet on each side of the darkroom so you do not have wires running across the room.

Ventilation A constant supply of fresh air and an adequate exhaust system are important, especially in a very small room where fumes can build up quickly. Check your potential darkroom space for an existing exhaust fan and fresh air supply. Plan to build whatever you need to complete the system.

Temperature and humidity control
Both are important, not just for your own comfort, but for the effectiveness of your chemicals. An attic or basement space with too little heat or air conditioning can make darkroom work miserable. Too much humidity is bad for your equipment, prints, and negatives. Too dry a room will cause problems with static electricity and dust.

Size of room Just about any size room can be a darkroom. Use an extremely small darkroom, such as a closet, only for the activities that require darkness, reserving space in some other room for the rest of the process. A large darkroom may be your studio or workroom as well. If so, lightproof only part of the room or install easy-to-remove lightproofing on your windows.

Storage Provide yourself with as much storage space and counter space as possible. If the space you choose has built-in cabinets, counters, or shelves, so much the better. Be sure the counter is large enough and sturdy enough to hold your enlarger.

Other uses of the space If a space you are considering for a darkroom is also used regularly for some other activity (a kitchen, laundry room, or bathroom, for example), consider what the shared use of that space will mean. Will there be enough room for you to work comfortably? How much equipment will you have to move out of the way after printing? How much time will it take to set up and break down your darkroom for each printing session? Can you schedule your printing sessions so they don't conflict with other uses of the room?

Some possible locations

An attic is generally remote from the rest of the house. This can be an advantage for separating your darkroom from other household activities, but it's bad if you have no plumbing and have to carry water and chemicals up and down the stairs. Many attics are not heated or air conditioned and have little or no insulation, so you may have to provide for temperature control. Electrical outlets may be scarce, while ventilating and lightproofing will probably be easy. In a large, unfinished attic, the best way to deal with dust, temperature, and humidity is to build a room or other lightproof enclosure within the attic.

A basement usually is not heated, so humidity and temperature control are likely to be your biggest problems. Dust will also be a problem if your basement is unfinished. As long as both plumbing and electricity enter your house through the basement, it will be relatively inexpensive to have your faucets and electrical outlets installed. Be sure to check into the drainage, though. If the house drain pipe is higher than the drain pipe leaving your sink, you will have to install a pump on the drain from your sink to get the water out.

Basements commonly have so few windows that lightproofing will probably be easy, and it's usually no great loss to lightproof a basement window permanently.

KITCHEN

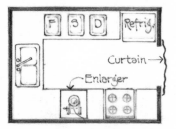

A spare room will probably be heated or air conditioned along with the rest of your house, and it may be near water. Your biggest problems are likely to be lightproofing and ventilation. A room larger than you need for a darkroom might also serve as a studio, containing your desk, negative files, photographic library, and so on. In this case, you will probably want the light from the windows when working in your studio. There are two lightproofing solutions: you can install removeable lightproofing on the windows, or you can darken the windows with heavy curtains or dark shades and then partition off the darkroom section with a wall or lightproof curtain.

A walk-in pantry is especially suitable for a darkroom because it probably has a sturdy counter for your enlarger and plenty of storage space. Lightproofing a single door and window is easy. A pantry will probably be a dry darkroom; you can use a nearby kitchen sink to mix chemicals and wash prints. Check your pantry for electrical outlets and plan for ventilation.

A small closet or walk-in closet can serve as a minimal darkroom. Plan to use it only for the processes that require darkness—exposing and developing black-and-white prints, exposing color prints and putting them into the light-tight drum, and loading film into the developing tank. All other activities can be set up somewhere else where there's more space. For example, you can wash prints and mix chemicals in your bathroom, develop film at your kitchen table, and keep your negatives, light box, print drying rack, and other apparatus somewhere near your closet darkroom.

The best thing about this setup is that the only opening you have to lightproof is the closet door. The most difficult part is likely to be ventilating the closet.

A bathroom can be a great darkroom. It's usually easy to lightproof and is often ventilated. It has running water and you can install your darkroom sink over the tub or sink to use the existing drain. With a shower diverter or faucet adaptor (available at many hardware or builders supply stores), you can run hoses from your faucets or shower head to your darkroom sink faucets. The space over the toilet can be an ideal place to build an enlarger shelf; other storage space you can build as needed. If you're planning to use the *only* household bathroom as your darkroom, both the shared use and the high humidity are likely to be problems.

A kitchen will probably be free for several hours of darkroom work only after the dinner dishes are washed. If you can print at night, you'll find some advantages to this situation: water is right there and after dark lightproofing is much easier. A disadvantage is that setting up your equipment for each session and putting it away again takes time. You'll need to cover the counters you're working on and clean up very carefully so that you don't end up eating traces of your photographic chemicals.

A laundry or utility room can be ideal for darkroom work because it already has a water supply. Just unscrew the washing machine hoses and attach the hoses that run to your sink faucets when you want to print. Ventilation also may be simple. Dryers are vented and you can install a simple "T" connection at the vent to connect your ventilating fan. If the room is still used for laundry or some other purpose, dust may be a problem, and you will have to consider scheduling.

BATHROOM

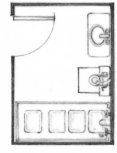

Enlarger mounted over toilet

Sink over tub

Designing your darkroom

In every darkroom there is a work pattern—a path you follow as you process a print. An efficient work pattern allows you to process prints quickly with a minimum amount of walking. The following information can help you lay out a darkroom that is efficient and functional.

Dry and wet areas

The first step in laying out your darkroom is to designate a *dry area* and a *wet area*. The dry activities (loading film onto developing reels and exposing paper) and the wet activities (mixing chemicals and processing exposed film and paper) must be kept separate—film or paper can be ruined if contaminated by drops of chemicals.

In the dry area of your darkroom you will need:

Counter space for loading film, cutting photographic paper, and other tasks involving dry materials.

An enlarger that may be placed on the counter, mounted on a sturdy desk or table, or mounted on the wall. You will need space around it for equipment such as timer, focusing aids and filters, and space for handling light-sensitive materials.

Storage for paper, filters, and other dry side supplies.

In the wet area, plan to have:

Counter or sink for your processing trays. Allow extra space or a shelf above for your developing timer, beakers, tongs, and other equipment.

Storage for trays, beakers, mixed and unmixed chemicals, and other wet side supplies.

Print drying rack to hold processed prints. If your darkroom tends to be too humid, drying prints in another (less humid) room will help reduce your darkroom humidity and will speed drying.

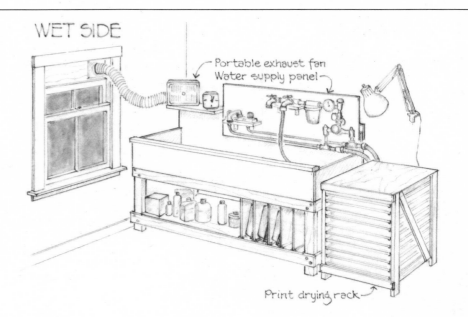

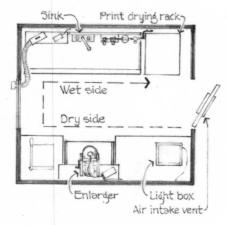

This is a typical darkroom design with a center aisle separating the wet side from the dry side. The work pattern is shown by the dotted line.

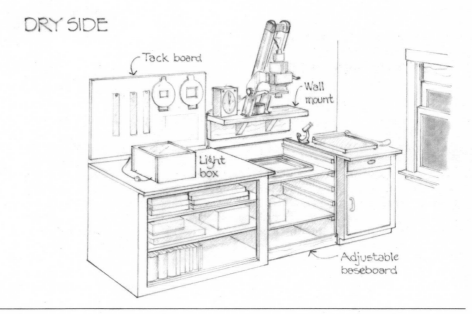

Other design criteria

Water supply Place your sink so that your sink drain is not more than 4½ feet from the drain pipe you're tapping into. (A drain pipe that is too long can create a situation where sewer gas can flow back through the drain into your darkroom. See Drains, p. 124.)

Air circulation Place your exhaust fan as close as possible to your processing counter or sink. If possible, put your air intake vent across the room from the exhaust. With this setup, the air coming in circulates from the dry side to the wet side and then out. This prevents moisture and fumes from the sink area from reaching the dry side of the darkroom.

Left- or right-handed? Many right-handed people prefer to work in a clockwise direction. Place the wet area to the right of the dry area so that as you evaluate negatives, operate the enlarger, and process the print, you will be moving from left to right. Left-handed people should reverse the pattern and place the wet area to the left of the enlarger, so that you move from right to left as you print.

You may find this helpful, but don't base your darkroom design on this rule unless it fits with the other criteria we've mentioned. We know plenty of people who work in the "wrong" direction with no difficulties.

Safelight location Your safelight should be at least 4 feet away from both the enlarger and the processing trays to avoid fogging your prints. Put the switch where you can reach it from either side of the darkroom, or, in a large darkroom, install two switches.

Counter height Many people find the standard counter height of 36 inches uncomfortable. Try working at different-height work surfaces to find out what's comfortable for you. A counter about 2 inches below the elbow usually feels best.

A small darkroom

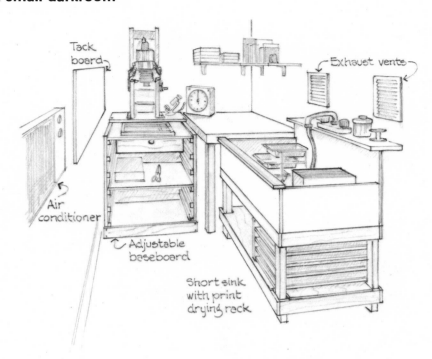

A smaller darkroom without room for a center aisle may be laid out in an L-design. The work pattern is shown by the dotted line. The print drying rack and light box (which have been left out because the room is so small) might be kept in an adjoining room.

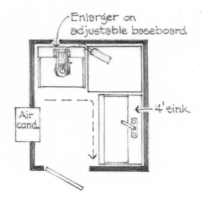

Designing a color darkroom

The darkroom design on the previous page can be used for color, as well as black and white, printing and processing. However, if you process color prints in a drum using a roller base or a tabletop processer, your darkroom design can be greatly simplified.

A drum processing darkroom

Drum processing is commonly used for making color prints from negatives or transparencies. The process is simple: expose the print in your enlarger and load it into a processing drum. Then process the print in room light by pouring the chemicals into and out of the drum.

Since the processing steps take place in daylight, your darkroom setup can be minimal. In the darkroom itself you will need:

Counter space for cutting photographic paper and loading exposed prints into the processing drum.

An enlarger with space around it for timer, focusing aids, filters, and a voltage regulator and color analyzer if you have them.

A safelight (optional). Check the information with your printing paper to see what kind is allowed. Because drum processing requires very little time in the dark, many photographers choose not to use a safelight at all.

Storage for paper, negatives, processing drums, and other darkroom supplies.

In the processing area, which may be in the darkroom or in a nearby room, you will need:

Counter, table, or sink for processing the prints. Allow space for the processing drum, chemistry, beakers, and timer. This area must be well-ventilated.

Sink space for one print washing tray.

Storage for beakers, mixed and unmixed chemicals, washing tray, and other processing supplies.

A print dryer for processed prints. This might be a line on which you hang the prints, a plastic rack that holds the prints vertically, or a small electric forced-air dryer.

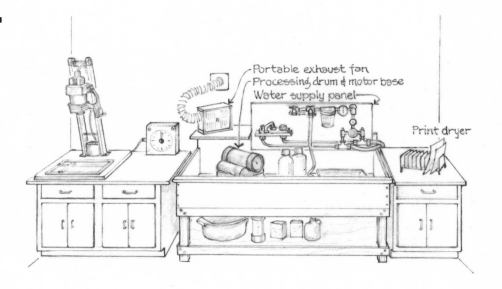

Portable exhaust fan
Processing drum & motor base
Water supply panel
Print dryer

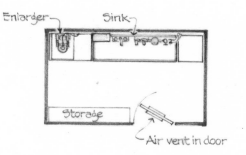

Enlarger
Sink
Storage
Air vent in door

The color processor darkroom

A tabletop processor provides a compact efficient processing area, so it is ideal for a very small darkroom, or for a kitchen darkroom that must be set up and taken down each time you print. Even if you have a spacious, permanent darkroom, you might choose a processor for the convenience and accuracy it offers. A tabletop processor provides a thermostatically controlled water jacket for the processing drum and chemicals, a timer, and a motorized base for the drum. These units assure consistent results by precisely controlling temperature and agitation. They take up very little counter space. The smallest ones measure about 26" wide, 12" deep, and 10" high.

It is most convenient to set up your processor near a sink because it is easier to fill and empty the water bath and drain the chemicals. However, most tabletop processors are designed so that they can be used in a dry darkroom if you don't mind carrying a few gallons of water. In either case, the processor does not have to be in the darkroom itself because the print is loaded into a light-tight drum after exposure. This

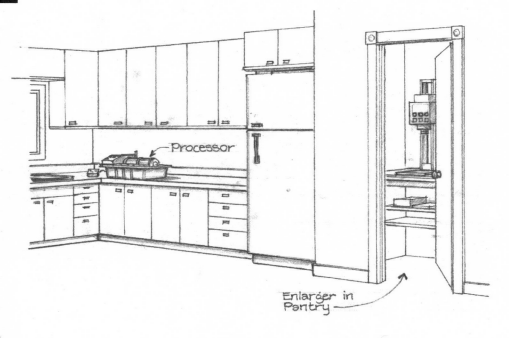

means that you can print in a tiny closet darkroom and set up the processor on a kitchen counter or near a utility sink.

Darkroom space requirements are the same as those for the drum processing darkroom:

Counter space (minimal).

Enlarger.

Safelight (optional).

Storage for darkroom supplies.

The processing area requirements are:

Counter for the tabletop processor with a little extra work space.

Sink in processing area or nearby for filling and emptying the water bath. You do not need to plan sink space for a wash tray since washing is done most efficiently in the processor.

Storage for chemicals, processor, beakers, and other supplies.

Print drying area.

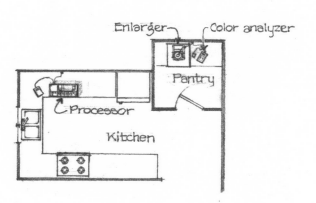

Planning cutouts

Figuring out how to lay out your darkroom is easiest if you have scale drawings of your equipment that you can move around on a floor plan. The cutouts on this page represent a *plan* (overhead view) of several common pieces of darkroom equipment. The cutouts on the facing page represent an *elevation* (front view) of these same items. Photocopy these pages. Then cut out the pieces you expect to use and arrange them on the grids on the following pages.

Plan cutouts

In most cases we've shown each item in only one size, but you may want to make some things larger or smaller to match your equipment. See the first page of each chapter for more information about sizes.

Enlarging easel Use the cutout for the size print you commonly make.

Sink Choose the size sink that fits best in your darkroom.

Adjustable enlarger baseboard If you plan to build one, use this cutout instead of an enlarger easel cutout. (Maximum print size for this baseboard is 16 × 20 inches.)

Small light box

Large light box

Print drying rack Capacity forty 8 × 10 or twenty 11 × 14 prints.

Other items Measure and draw other pieces of darkroom equipment that will require counter or floor space in your darkroom. Each square on this grid equals 1 square foot. Some items you might have:

- Work table
- Paper cutter
- Contact printer
- Drymount press
- Humidifier or dehumidifier
- Stereo speakers
- Heater

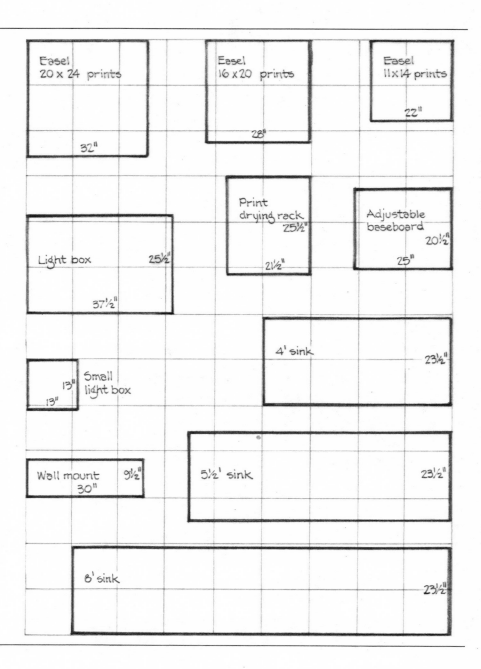

Elevation cutouts

If you changed the size of any items on the opposite page, be sure to change them on this page also.

DRY SIDE

Enlarger Measure the height of your enlarger with the head up as high as it will go and correct the height of this cutout.

Wall mount

Adjustable enlarger baseboard

Small light box

Large light box

Other Measure and draw in other items that will take up wall space or shelf space in the dry area of your darkroom.

WET SIDE

Sink

Exhaust fan The size may vary slightly according to the fan you buy and whether you mount it in your wall or build it into the portable unit described in Chapter 4.

Water supply panel The one shown here is 4 feet long and is adequate for a sink up to 6 feet long. For a longer sink, turn to page 131 to determine the size of your panel.

Print drying rack

Other Measure and draw in other items that will take up wall space or shelf space in the wet area of your darkroom.

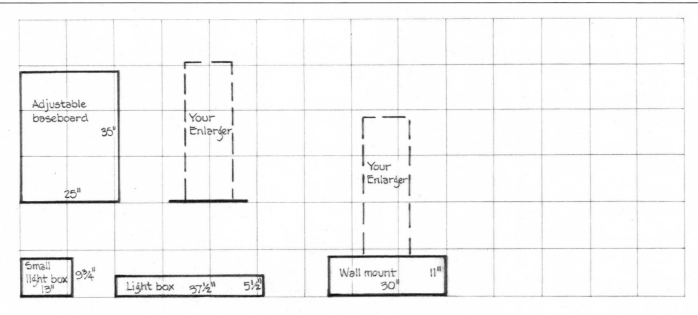

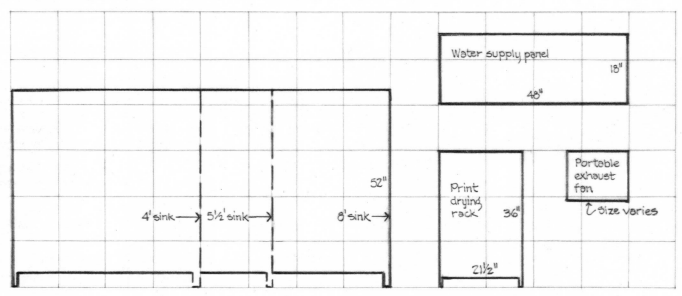

Planning cutouts

Drawing the plan

A plan is an overhead view of your darkroom used to arrange your equipment and to plan the work pattern. Use tracing paper over this grid to draw your darkroom plan. Then arrange the cutouts from the previous page on your drawing.

How to draw a plan

1 Measure the outline of your darkroom and draw it on this grid. Each square on the grid equals 1 square foot.

2 Draw in doors and windows. Show which way the doors open.

3 Draw in existing counters, shelves, and cabinets. Indicate overhead cabinets or shelves with a dotted line.

4 Arrange the cutouts from the previous page on your darkroom plan.

Design checklist

Aisle width Have you allowed a 30- to 36-inch aisle for a one-person darkroom? This is enough aisle space for movement but no additional steps are needed to move from one side to the other.

Proximity to plumbing If you have plumbing in your darkroom, is your sink located close to it?

Doors and drawers Have you allowed enough room for doors and drawers to open fully? If your print drying rack is in your darkroom, can you take the trays all the way out?

Entryway Is your doorway large enough to bring in your largest piece of equipment?

Size Have you allowed enough space to process the largest prints you expect to make?

Wet and dry sides Are they clearly separated?

Counter space Leave yourself as much free counter space as you can. Be sure to leave some work space on both sides of your enlarger.

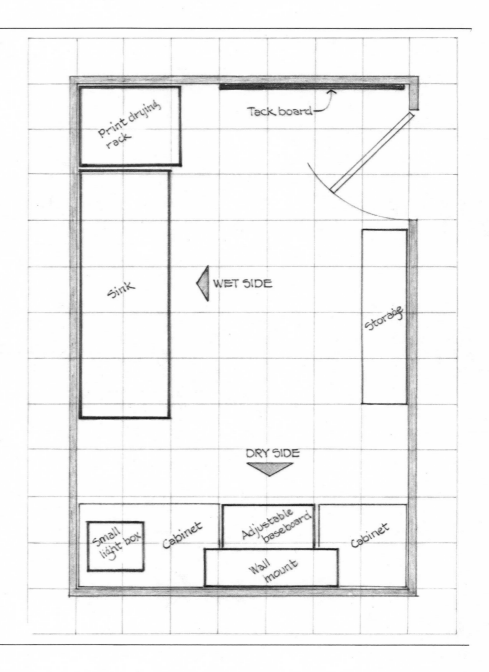

Drawing the plan

Drawing elevations

An elevation is a straight-on view of one wall, and is used to find out if everything in your plan will fit vertically. Most darkrooms have two main walls that need to be studied—the wet side and the dry side. Depending on your layout, you may need to draw other walls as well. Use tracing paper over this grid to draw your elevations.

How to draw elevations

1 Measure the length and height of the wall and draw it on the grid (each square on the grid equals 1 square foot).

2 Measure the size and location of doors and windows and draw them to scale on the grid.

3 Draw in existing counters, shelves, plumbing outlets, and so on.

4 Arrange the elevation cutouts from page 13 on your elevation drawings the same way you have them arranged in the floor plan. If you change anything in the elevation, remember to change it in the plan also.

Wet side checklist

Safelights should be at least 4 feet from the processing trays.

Exhaust fan(s) should be over the processing area to evacuate chemical fumes quickly.

Storage can be under the sink, under a wet side counter, or on an overhead shelf. Be sure that overhead shelves are low enough that you can reach them.

Dry side checklist

Counter height should be a comfortable working height for you.

Storage may be under the counters or on overhead shelves.

Enlarger should be positioned at such a height that it isn't hitting the ceiling.

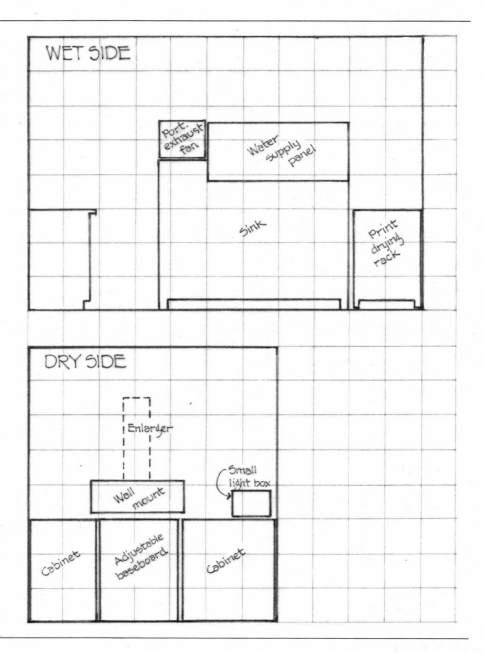

Drawing elevations

Buying and caring for tools

Buying tools, especially good-quality ones, can run into a lot of money, so it's important to buy tools that you find comfortable and that will continue to be useful to you. Below is some information about shopping for tools and caring for them. On the following pages individual tools are described in detail.

Buying tools

When you are thinking about buying a particular tool, see if you can borrow it from a friend first. See how it feels to you, if you enjoy using it, and whether it provides a worthwhile advantage over other tools you may have been using for the same job. Keep the following points in mind when you shop for tools:

■ Check on tool quality. Consider the materials, workmanship, and weight of the tool, as well as how it feels in your hand. When buying power tools, inquire about whether the tool can be repaired.

■ Shop around for a good price.

■ You can often find good tools, particularly hand tools, second hand at garage sales or flea markets. Check them for damage (such as broken teeth or damaged screwdriver tips). Used power tools are not as good a bet because faults may not show up until you put the tool to work.

■ Look for good-quality materials and methods of manufacturing (described below).

Hand tool quality Tools that are well made are usually costly. However, they are stronger; the cutting edges stay sharp longer; and they generally give you better service. Good hand tools, usually made from carbon steel or low-alloy steel, may be manufactured by casting or forging.

Casting—pouring molten metal into a mold—produces metal that breaks easily. It is suitable for tools that do not receive a lot of stress (such as the body of a plane) but not for tools such as hammer heads or wrenches that undergo rough treatment. You can usually identify a cast tool by the seam left from the mold.

Tools made by forging and machining processes are stronger than cast

tools. Many of them will have the words "drop-forged" stamped into the metal.

Power tool quality Power tools should have cutting blades made from high-speed steel (steel that contains a high percentage of alloys) that can withstand heat from friction. If the housing is metal, the tool should have a 3-pronged plug for grounding. However, many new power tools are "double insulated," which means they have plastic housings to protect you from electrical shocks. On these tools, 2-pronged plugs are adequate.

TIPS: Caring for your tools

Good tools will last for years if they are used and maintained properly. To keep your tools in good shape:

Store them carefully Rulers, saws, and squares can get bent and sharp blades can get nicked or dulled if they are piled on top of each other in a tool box. Hang up as many of your tools as possible. Store them in the plastic cases they come in, and make a place for each tool. Hang up paintbrushes or store them, handle down, in a can so that the bristles don't get bent.

Keep them clean Brush off sawdust accumulation with a clean paint brush. It is especially important to clean out the air vents in your power tools so that they don't get clogged.

Prevent rust Wipe down metal tools with light household oil after using them. Do not oil hammers, files, or wrenches because that would make them too slippery to work properly.

Keep them sharp Only sharp tools can do the jobs they were made to do. They are also safer because they are easier to control and more predictable.

Use them properly You can ruin a screwdriver by opening paint cans with it, and you can damage the head of a good hammer by hitting rock or cement with it. Tools were made for specific purposes—don't ruin a good tool by using it for the wrong job.

Sharpening your tools

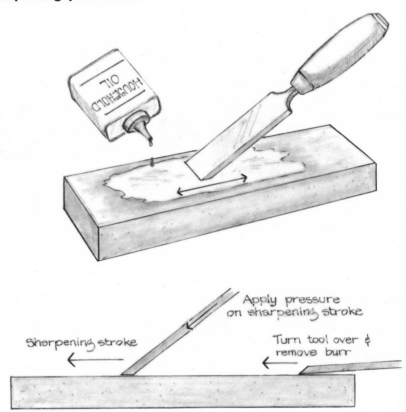

Planes and chisels Hold the blade with the bevel (the slanted edge) flat on a whetstone that is lightly coated with household oil. Carefully keeping it at the same angle, rub the blade back and forth on the coarse side of the stone until you see a thin curl of metal along the cutting edge. Then turn the blade over so it is flat against the stone and rub it until the burrs on the edge disappear. Repeat several times. To hone the cutting edge, turn the stone over and, with the bevel at a slightly steeper angle, stroke it a few more times on the fine-grained side of the stone.

Saws Have your cross-cut saw, back saw, or circular saw blades professionally sharpened. Replace hack saw or saber saw blades instead of sharpening them.

Tools

All of the tools called for in these darkroom projects are described on the following pages. The ones that are starred (*) are required in all or most of the projects; we suggest having them in your basic tool kit. Check the tool lists for each project you are going to do and acquire additional tools as you need them. Some tools are seldom needed—these you may want to borrow from a friend.

Saws

A hand saw is fine for cutting lumber, but whenever you are making many cuts or are cutting plywood, a power tool will be much faster and more accurate. You can also change a power saw blade to get a finer, smoother cut when you need one. For the projects in this book, a saber saw will be most useful. Borrow or buy a circular saw later if you find you need it for heavy work.

Saber saw* Used for cutting plywood, lumber, metal, plastics, or ceramics. It will cut curves, make bevelled cuts, or cut holes in the center of a panel. A variable-speed motor allows you to run the saw at the most effective speed for the material you're cutting and is worth the extra money. Buy a saw with a blower to keep the cutting line free of sawdust.

Many different kinds of saber saw blades are available. Start with a *wood blade* with 12 or 14 teeth per inch, and a taper-ground blade. This is a *plywood blade* with teeth that are not *set* (bent to alternate sides) to minimize splintering. Blades are

small and inexpensive, so replace rather than sharpen them. They also break easily, so it's a good idea to keep some extras on hand.

Hand saw Your hand saw should be a good-quality cross-cut saw about 24 or 26 inches long with 8 or 10 teeth per inch.

Circular saw Used to cut plywood or lumber, the circular saw is quite heavy and is best used with a straightedge (called a *fence*) when making long cuts. Because a circular saw is very noisy, powerful, and dangerous (it can injure you severely if it bucks or kicks out of control), we suggest using it only when you have a particularly difficult job. When buying one look for these features:

■ An automatic clutch to help eliminate kickback when the blade jams.

■ An automatic brake that stops the blade instantly when you turn the saw off.

■ A large base—it makes the saw more stable.

■ A 7- or 7¼-inch blade.

Many different kinds of blades are available for circular saws. To begin with, get a *cross-cut blade* for fairly smooth cuts, and a *plywood blade*, which has smaller, closely spaced teeth to minimize splintering. Have your blades professionally sharpened when they get dull.

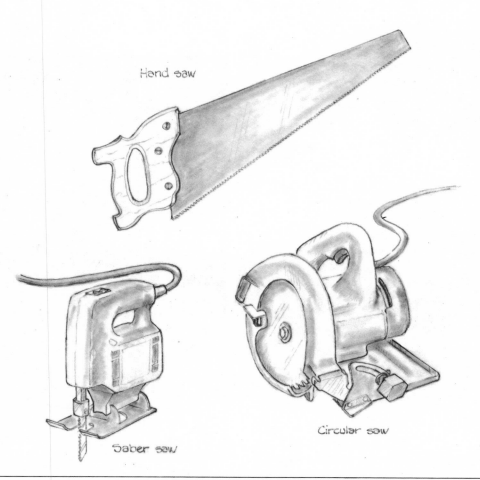

Hand saw

Saber saw

Circular saw

Drills

You'll need a drill, primarily to drill pilot holes for screws and bolts. A hand drill can do this, but the projects in this book have a lot of screws and an electric drill will be a lot faster. Also, the electric drill is more versatile and doesn't cost too much more than a good-quality hand drill.

Hand drill Can be used to drill holes in wood, metal, and other materials. Buy a good-quality, all-metal, "egg-beater"-style drill.

Electric drill* It does everything a hand drill can do. With various attachments it can also be used for many other jobs. We recommend buying a variable-speed drill so that you can use it to put in screws. (A reversible one will also take them out.) Get a drill with a ¼-inch or ⅜-inch chuck. A ⅜-inch chuck will accept bits with a larger shank and we think this added flexibility is worth the few extra dollars.

Drill bits*

Buy a set of bits (sizes ¹⁄₁₆ to ¼ inch) with your drill, and buy larger bits as you need them. Be sure the shank of your drill bits is the same size or smaller than the chuck size of your drill.

A pilot bit, also called a *screwsink* or a *counterbore bit*, drills the top of the hole larger than the bottom to accommodate the head and shank of the screw; it makes drilling for screws a lot faster. A pilot bit may be tapered or it may have an adjustable collar at the top. (See drawing.) If

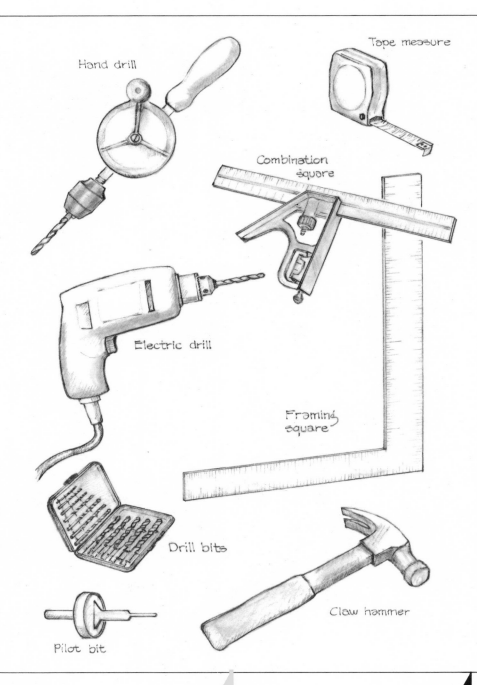

Hand drill

Tape measure

Combination square

Electric drill

Framing square

Drill bits

Pilot bit

Claw hammer

you have a variable-speed drill, buy a Phillips-head screwdriver bit.

Tape measure*

You will need a tape measure that is at least 8 feet long with a locking device to keep it from winding up while you're using it. Buy one that will take refills if the tape gets broken or damaged. A *belt hook* is also handy.

Combination square*

Used for marking and checking 90° and 45° cuts on lumber. A ruler, a small level, and a scribing tool are also part of the square.

Framing square

Used in these projects to check plywood for squareness and to draw or check right-angle lines.

Claw hammer*

Try several different hammer weights and styles to find one that feels comfortable when you hold it near the end of the handle. A rubber-sheathed fiberglass or steel handle will stay fixed to the head more securely than a wood handle. Cheap hammers have cast iron heads that can shatter easily and possibly injure you, so buy a good-quality one with a drop-forged head and a curved claw for pulling nails.

For the second hammer in your tool box, choose an inexpensive, lightweight *tack hammer*, which will be better suited to small jobs using tacks and brads.

Tools (cont.)

Wrenches

Every time you put in a bolt, you will need a wrench the right size for the nut. You have a choice of buying an adjustable wrench or a set of wrenches. Here's what's available.

Open-end wrenches These are simple one-piece wrenches, each designed to fit two sizes of nuts. You can buy a set or acquire them as you need them.

Crescent wrench* This adjustable wrench can be used on nearly any size or shape nut or bolt. It saves you the trouble of keeping several wrenches or wondering whether you have a wrench the right size for the job. The adjustable jaw can be broken if it is used incorrectly, so always be sure to put the pressure on the solid piece, not on the adjustable part. Buy a good-quality one about 10 inches long.

Socket wrench A more sophisticated but costly alternative is the socket wrench set. This is a wrench handle with a ratchet on the end that accepts sockets to fit different-size nuts. The ratchet makes it possible to tighten bolts with a quick back-and-forth action without taking the wrench off the bolt. It saves a lot of time on jobs with many bolts and nuts. You will have a choice of $\frac{1}{4}$-inch, $\frac{3}{8}$-inch, or $\frac{1}{2}$-inch drive shaft. The larger shaft gives you more turning leverage, and $\frac{3}{8}$ inch is adequate for home projects.

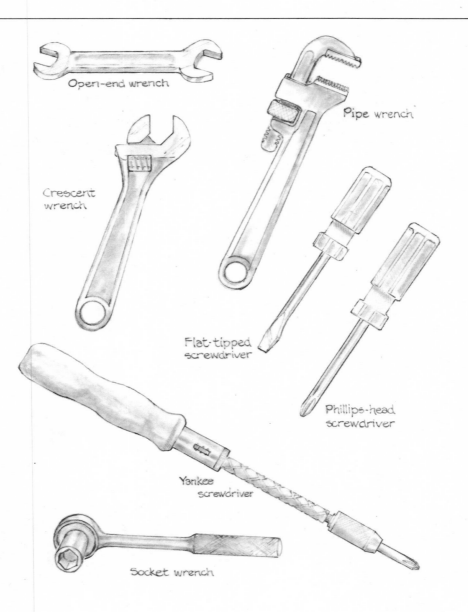

Open-end wrench

Pipe wrench

Crescent wrench

Flat-tipped screwdriver

Phillips-head screwdriver

Yankee screwdriver

Socket wrench

You can buy the sockets individually but they are more economical in sets. They come in metric or American sizes and you can get extra-long sockets and extension arms to reach recessed nuts. A screwdriver tip attachment is also available.

Pipe wrench This is a large, heavy-duty adjustable wrench with rough, serrated jaws made for gripping pipe. For extensive plumbing work, you will need two pipe wrenches (one to hold the pipe and one to turn the fitting) or a pipe wrench and *vise-grip pliers* (a more versatile tool to have than a second pipe wrench). We suggest buying a 10-inch pipe wrench first and getting a 14-inch one later if you find it will be useful.

Screwdrivers*

Start by getting a medium-sized, flat-tipped and a #2 Phillips-head screwdriver. Then add others to your collection as you need them. Always buy insulated handles.

A time-saving alternative for putting in large numbers of screws is a *spiral ratchet screwdriver*, commonly known as a *Yankee screwdriver*. The spring return handle with a ratchet mechanism makes it possible to drive screws into predrilled holes by pushing once or twice on the handle.

Another alternative is a variable-speed drill with a screwdriver attachment.

Pliers

Slip-joint pliers* For the first set of pliers in your tool box, buy inexpensive 8-inch slip-joint pliers. The jaws have two positions for holding different-size objects and a wire cutter near the bottom of the jaw.

Needlenose pliers These special pliers are not required for the projects in this book, but they are useful for reaching into small places, holding very small nuts and bolts, or working with electrical wiring. Buy a 6- or 7-inch model that has a wire cutter and insulated handles.

Vise-grip pliers Vise grips are actually a cross between a wrench and pliers. They have rough, serrated jaws that can be adjusted and a spring-loaded clamp that will lock the pliers onto the work. In your darkroom they are useful for plumbing work (more about this earlier under "Pipe wrench") and for grabbing and holding all kinds of objects.

Surform tool

This simple tool has open teeth on the bottom (like a cheese grater) and is used like a rasp to shave down a board that has been cut too wide or too long. It leaves a rougher surface than a plane or file. It is inexpensive and comes in different sizes and styles. A small one is most useful for these projects.

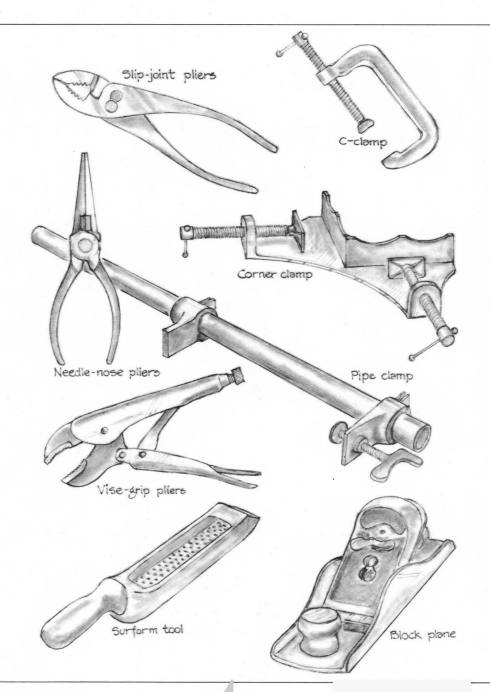

Slip-joint pliers

C-clamp

Corner clamp

Needle-nose pliers

Pipe clamp

Vise-grip pliers

Surform tool

Block plane

Clamps

C-clamps* These are simple, inexpensive clamps used for holding a piece of wood steady while you drill, plane, or saw, or for holding a joint that is being glued. Get at least two 4-inch clamps.

Corner clamp This special clamp holds a corner while you nail it together. It is not necessary for joining a corner, but it makes the job go much more quickly and ensures accuracy. An inexpensive one is adequate and well worth the price if you have several corners to join (as in building the wood screens for the print drying rack).

Pipe clamps These are long clamps used for holding pieces of furniture together while gluing. You'll find it helpful to have a couple of pipe clamps for building your darkroom sink or adjustable enlarger baseboard. If you don't have any, try to borrow a couple—you probably won't use them enough to justify buying them.

Plane

In these projects, a plane is used to smooth rough or uneven surfaces or to take a sharp corner off of a piece of wood. The body of the plane holds a wide blade at a low angle for shaving off thin layers of wood. Control knobs allow you to adjust the blade or to remove it for sharpening. A *block plane* is quite versatile and the most sensible choice for the only plane in your tool kit. It is fairly small and easy to handle.

Tools and supplies

Tools

Chalk line Used for marking straight lines. The case contains chalk dust and a 50-foot or 100-foot spool of string. A chalk line isn't essential, but a 50-foot one is handy, especially when you don't have a straightedge long enough for the job.

Staple gun Choose a regular or heavy-duty model that will take staples $\frac{3}{8}$ inch or $\frac{1}{2}$ inch long. Be sure that staples are commonly available for the brand you buy.

Hack saw A hack saw is made for cutting metal, though you can also buy blades for cutting other materials. It's required only a couple of times in this book, so you may prefer to borrow rather than buy one.

Miter box This is a wood or metal box with guides for making angled cuts. It is useful when you need to cut a mitered corner and whenever you're making numerous cuts on small pieces of wood. For projects in this book, an inexpensive wood miter box is fine. Use a back saw to do the cutting.

Back saw A back saw is a hand saw that has a spine on the top of the blade to keep it rigid. It is used with a miter box. Buy one about 14 inches long with at least 13 teeth to the inch.

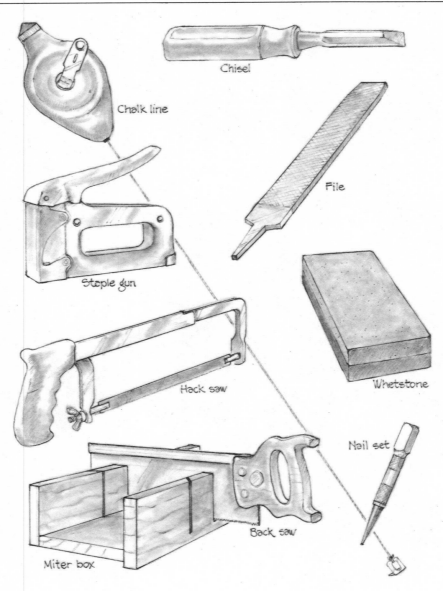

Chalk line

Staple gun

Hack saw

Miter box

Chisel

File

Whetstone

Nail set

Back saw

Chisel You'll need a chisel only for recessing the drain in your sink and for cutting out the areas for the switch or the hinges in your light box. Get a good-quality $\frac{1}{2}$-inch wood chisel.

File Made for working with metals, the flat file shown opposite is often used to smooth rough edges of wood as well. It's only called for twice in this book—first to smooth the edge of the acrylic for the light box and then to remove the burr when cutting copper pipe for darkroom plumbing. (For these jobs, a single-cut, smooth file is best.) However, it's inexpensive. You're likely to use it often if you add it to your tool collection.

Whetstone This is a rectangular stone for sharpening tools. It has a coarse side for rough sharpening and a finer side for honing down the sharpened edge. You need a small one, about 7 inches long, and a small can of household oil (such as 3-in-1 oil) to use with it.

Nail set This is an inexpensive tool used for setting finish nails below the surface of the wood or for hammering nails in flush without marring the wood with the hammer. Buy the smallest one you can find—preferably $\frac{1}{32}$ inch. To use it, place the small end on the nail head and tap the square end lightly with a hammer.

Caulking gun A caulking gun holds a tube of caulk and squeezes out the contents with a plunger. Get the cheapest one available.

Putty knife This is a dull, flat-bladed knife for applying and smoothing wood filler and caulk. You need a fairly small one, about 1¼ inches wide.

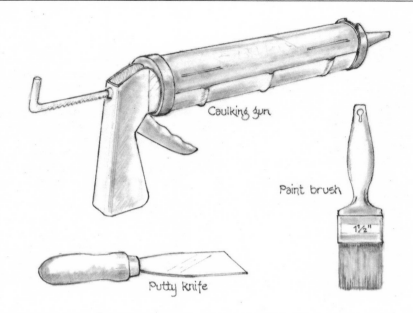

Caulking gun

Paint brush

1½"

Putty knife

Paintbrush For dusting, buy an inexpensive 1½-inch brush. Keep it around to clean dust off your tools, respirator, and the projects you're working on. For painting or applying polyurethane, good-quality brushes will give you a better-looking finish, but they must be cleaned and cared for. If you don't want to deal with smelly solvents, get a cheap brush or a sponge brush and throw it away after using it.

Supplies

Finishes Two coats of paint or varnish make a wood surface easy to clean and keep the wood from swelling or warping by keeping moisture out. Paint or varnish all wood counter surfaces and everything on the wet side of your darkroom. Use clear polyurethane if you want to see the wood and alkyd paint when you want a color or you want to cover ugly plywood. (We recommend alkyd paint because it is more durable than latex and it dries faster than oil-base paint. You will need mineral spirits to clean the brushes.) The only part of your darkroom that needs a special finish is the inside of the sink (see Chapter 8).

Glue Whenever you are making a permanent joint, it is wise to glue it as well as nailing or screwing it. The nails or screws will act as clamps until the glue dries and begins to hold the joint together. A good glue joint is as strong as—or stronger than—the wood itself. Common yellow wood glue, an aliphatic resin, is found in any workshop; Tite Bond (trade name) is a standard because it is made for cabinetry and is very strong. Find it in hardware or building supply stores.

Sandpaper A few strokes of sandpaper on the rough edges of your work to remove splinters will save you from suffering later with tweezers and sterilized needles, and sanding will greatly improve the looks of your projects.

Buying sandpaper at the hardware store may be confusing at first, but here's how it works.

The most common types are *flint* and *garnet*. Buy garnet. It costs more but it lasts longer and works better. The table below explains two systems that indicate the relative coarseness of sandpapers.

	Coarse			Medium			Fine		Very fine		
System 1:	20	40	60	80	100	120	140	160	180	200	220
System 2:	3	2	1	0	1/0	2/0	3/0	4/0	5/0	6/0	

It's a good idea to buy several grades—50, 80, 120, 140—and to get extra sheets of the medium grades.

Using your tools

All tools have been devised to make specific tasks possible or at least easier, and your work will go more smoothly if you know how to use them. On the following pages are some pointers for setting up a workspace and using several important tools. Before you use a tool for the first time, read the instructions that come with it. If you have any doubts, ask a friend to show you the best way to use it.

To learn more about working with tools, we suggest the following books: *The Use of Hand Woodworking Tools* by McDonnell (Albany, NY: Delmar Publishers, 1978), *How to Work With Tools and Wood*, by N. H. Mager (New York: Pocket Books), and *The Carpenter's Manifesto* by Jeffrey Ehrlich and Marc Mannheimer (New York: Holt, Rinehart, & Winston, 1977).

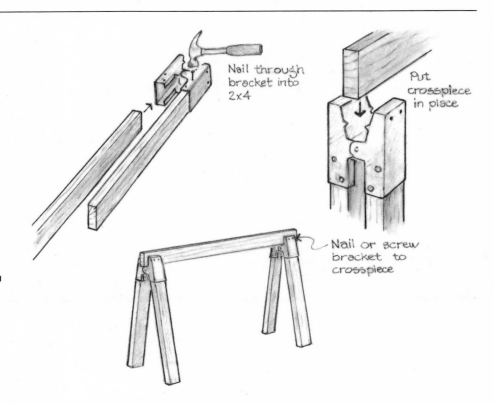

Nail through bracket into 2x4

Put crosspiece in place

Nail or screw bracket to crosspiece

Your workspace

The ideal workspace has enough room to maneuver around a 4 × 8-foot sheet of plywood and a floor that can be easily cleaned. It should be a place where the sounds of your power tools won't disturb anyone and where you won't be distracted. If you have small children in the house, it's best to be able to lock the door for their safety. It's helpful to have a sturdy workbench and a place to hang your tools. If you don't build things regularly, you may not have a room that meets all these requirements, so choose the best space you have—a garage or basement if you have one, a spare room, or even a temporary setup outdoors or in your kitchen in the evenings.

Here's what you will need to set up your workspace:

A table or workbench where you can clamp small pieces while you work on them. (This table will get beat up so don't use a good one.) Extra plywood can be set on sawhorses as a temporary table.

A vise or two C-clamps to clamp small pieces to the workbench for planing, sanding, drilling, joining corners, and so on. A small clamp-on vise is made for this purpose. It's easier to use (and it costs more) than the C-clamps.

Heavy-duty extension cord with a 3-pronged plug for grounding your power tools. It should be long enough to reach any part of your workspace.

Some place to put your tools so you can find them easily—a pegboard, shelf, countertop, or cabinet.

Sawhorses or other supports, at least two, preferably three the same height. The quickest way to make them is to buy sawhorse brackets and cut 2 × 4's for the four legs and the crosspiece. They're easy to assemble. For each sawhorse, you will need two brackets and five 30-inch 2 × 4's.

Instead of using sawhorses, you can work close to the floor on sturdy crates such as milk crates. For some operations, such as cutting lumber, two or three chairs will be all the support you need.

Safety gear

Goggles Get flexible plastic ones with an elastic band. They fit over most eyeglasses and protect your eyes from flying chips and particles. Wear them whenever you use power tools and with most hand tools as well.

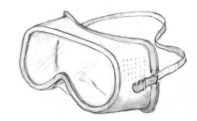

Dust mask When you sand or saw, a mask will keep you from breathing the sawdust. Buy two or three inexpensive, disposable paper masks.

Noise muffler Wear ear plugs or a noise muffler when you use a circular saw. You may also want to use one with a saber saw or power drill.

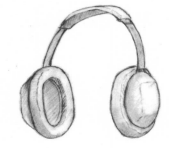

Gloves Buy a good pair of work gloves and wear them to avoid nicks and scratches when you're using hand tools. *Don't* wear gloves when using power tools—they can get caught in the tool.

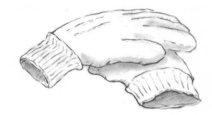

TIPS: Workshop safety

Respect your tools! They are made to work for you, but they can also injure you. Here are some safety precautions:

GENERAL TOOL SAFETY

Clamp the work down. Use a vise or clamps whenever possible so that materials won't slip. You'll then have both hands free for tools.

Keep your tools sharp. A dull blade is more likely than a sharp one to slip and cut you.

Keep an orderly work area. If you clean up as you go, you won't be likely to trip or knock things over while working.

Dress safely. Wear tight-fitting clothing, with no loose ties or floppy sleeves to get in the way or get caught in your tools. Remove all jewelry, even rings, and tie back long hair for the same reason.

POWER TOOL SAFETY

Read all instructions. Read carefully the guidelines that come with a tool for its use, care, and maintenance. Don't use a tool with which you feel uncomfortable.

Check for proper grounding. Buy double-insulated tools or make sure your tool is grounded with a 3-prong plug. (If you don't have 3-hole outlets, use an *adaptor*—see p. 42.) Avoid using power tools, even grounded ones, in damp areas.

Wear goggles or a face shield. Protect your eyes against flying wood chips or bits of metal.

Guide the tool with both hands. This gives you more control and keeps your hands from getting in the way.

Avoid awkward positions. If you are off balance or uncomfortable, you are more likely to lose control of the tool. As often as necessary, turn off the tool and change positions or move the work so it's more accessible. Never stand in line with the blade of a circular saw.

Don't force your tool. If a power saw or drill seems stuck, turn it off and check to see if you are hitting a knot or other obstruction, or if your blades or bits are dull. By putting pressure on the tool, you can snap a blade, overheat the motor, or lose control of the tool.

Unplug the tool. If you stop to make adjustments or change blades or bits, unplug the tool. It could get turned on accidentally while you're handling it. Always unplug it when you're finished using it, too.

Measuring and using squares

It's easy to make a measuring mistake, especially when you're measuring fractions of inches. The first rule of thumb is to double-check *all* your measurements. Here are several other tips that will make your measuring faster, easier, and more accurate.

Inside and outside measurements

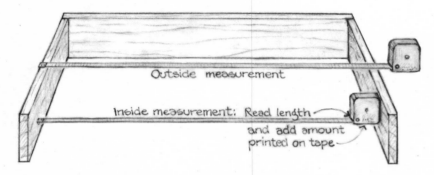

Outside measurement

Inside measurement: Read length and add amount printed on tape

The metal piece on the end of your tape measure has a little bit of play in it so that both inside and outside measurements will be accurate. Most tape measures also have the width of the case printed on the side to help you figure inside measurements exactly (see above).

Allow for the saw kerf

Whenever you're planning to cut several pieces out of one piece of wood, remember that the width of the saw cut will be $\frac{1}{16}$ to $\frac{1}{8}$ inch (depending on your blade). You cannot get four 24-inch lengths out of a board that is exactly 8 feet long because the saw will eat up at least $\frac{1}{4}$ inch. Also because of the saw kerf, you can only measure accurately by measuring from the edge, making your cut, and *then* measuring for the next cut.

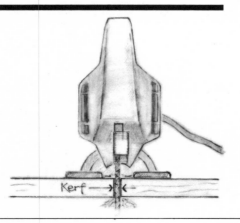

Kerf

Use templates when you can

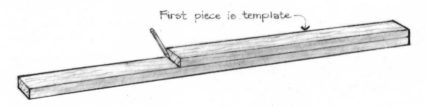

First piece is template

Any time you are cutting several boards or pieces of plywood to the same length, use the first one as a *template* to measure for the other cuts. That is, put it on top of the next piece you want to cut, line up the edges and draw your cutting line from the first piece instead of remeasuring. (Use the same piece every time as your template.) This minimizes your chances of making a measuring error and it means that if the first piece is slightly long or short, all the other ones will be, too. As long as they're all the *same* length, the absolute measurement isn't so important.

Measure from the work

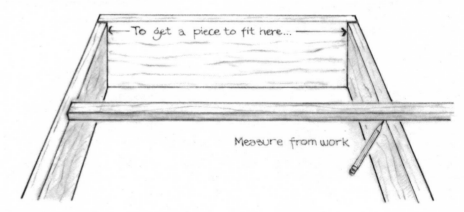

To get a piece to fit here...

Measure from work

Whenever possible, measure a board by holding it in place on the project and marking it where you need to cut it. This will often give you a more exact fit. It's also faster, and you're less likely to make a mistake.

Using squares

A square will tell you instantly if the angle you're looking at is actually a right angle. It's also the quickest way to draw a line perpendicular to the edge of a piece of wood. Use a *combination square* on lumber; on plywood use a larger *framing square,* which is more accurate for drawing long lines.

Using a framing square

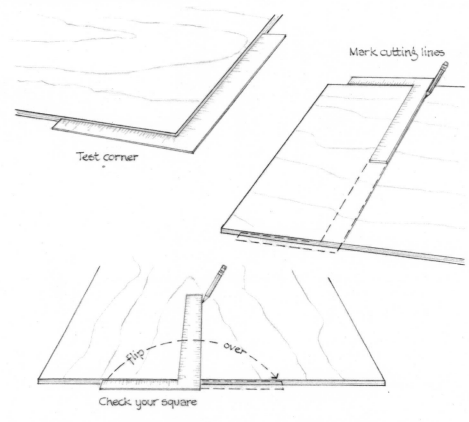

Using a combination square

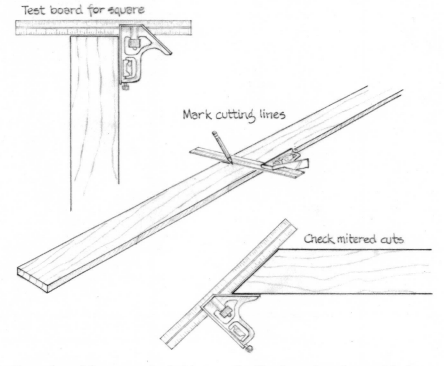

1 Test a board for square by holding the combination square at the end of the board as shown.

2 Mark cutting lines by lining the square up with the side of the board. You can set the square for 90° or 45° cuts.

3 Check a mitered cut with the slanted part of the square.

1 Test the corner of a sheet of plywood against the inside of the framing square.

2 Mark cutting lines on the plywood by pointing the long arm across the plywood and placing the inside of the short arm against the edge of the plywood.

3 Check your square. A framing square that isn't exactly 90° can throw your whole project out of square. To see if your square is actually a right angle, place it on a sheet of plywood with the inside of the short arm against a *straight edge* of the plywood as shown. Draw a line across the plywood. Now flip the square over so that the long arm is in the same place and the short arm points in the other direction. If the inside of the long arm follows the line, it is square.

Nails, screws, and bolts

There are many fasteners for many needs. Nails and screws are most common and are often used with glue to provide a more secure joint. Bolts are handy for bigger jobs and are easy to remove when you want to disassemble the project. Here are descriptions of the kinds of fasteners called for in this book.

Nails

Nails are the quickest and easiest fasteners to use. They do not give the strength of screws or bolts but are adequate in many situations, particularly when used with glue. Standard sizes of nails are 4d, 6d, 8d, and so on. The *d* stands for penny (it's the symbol for penny in the old British monetary system). So when you want a size 4d nail, you ask for a 4-penny nail. In old hardware stores, nails are sold by the pound like candy, but many places now sell them prepackaged.

Common nails Common nails have broad heads that keep the nails from pulling through the board. They are used when it doesn't matter that the heads show. We didn't use common nails for any of the projects in this book, but if you decide to build new walls or partitions in your darkroom, you will probably use them.

Finish nails If you do not want the head of the nail to show, use a finish nail. Finish nails have small heads that are driven into the wood with a nail set (see p. 24); when covered with wood filler, they become almost invisible. The lengths are the same as common nails (that is, a 4d finish nail is the same length as a 4d common nail), but finish nails are thinner and are not as strong.

Wire brads Brads are small finish nails made from wire. They are sold in boxes and are identified by length (in inches) and diameter. Common sizes are $\frac{1}{2} \times 19$, $\frac{3}{4} \times 18$, and 1×17. The second number is the gauge of wire used in making the brad: a higher number indicates a thinner wire. Be sure to get wire *brads*, which have small heads like finish nails. They may be right next to the wire *nails*, which have large flat heads.

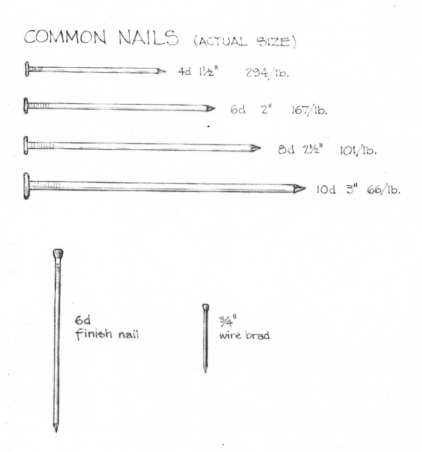

COMMON NAILS (ACTUAL SIZE)

4d 1½" 294/lb.

6d 2" 167/lb.

8d 2½" 101/lb.

10d 3" 66/lb.

6d
finish nail

¾"
wire brad

Screws

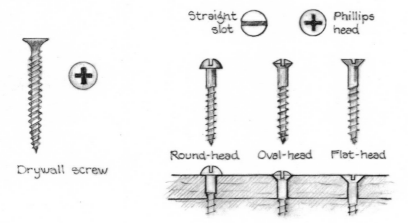

Straight slot

Phillips head

Drywall screw

Round-head Oval-head Flat-head

Bolts

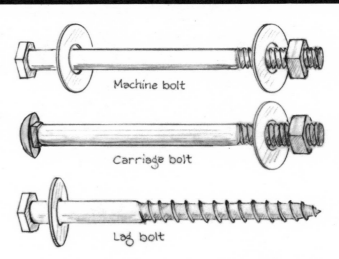

Machine bolt

Carriage bolt

Lag bolt

Screws are stronger than nails because their threads grip the wood. They are also easy to remove if you want to take something apart. Several kinds of screws are described below. For the projects in this book, we've specified *drywall screws* because they hold as well in plywood as in lumber, and they are easy to work with.

If you can't find drywall screws, common wood screws will do and are described here. A #8 flat-head screw is comparable in size to a drywall screw.

Drywall screws Drywall screws, as their name indicates, were devised for putting up gypsum wallboard or drywall but they are becoming popular for a variety of uses and are sometimes called multipurpose screws. They have flat heads with Phillips-head slots and they will countersink themselves in soft wood, saving you the trouble of drilling the

extra countersink hole. They are also cheaper than other screws. They are identified by length only.

Standard screws When buying screws, you will have to specify:

■ Slot type. Screws come with straight slots or Phillips-head slots. The Phillips head is easier to work with because the screwdriver is less likely to slip out of the slot.

■ Head type. The shape of screw heads can be round, oval, or flat. The round-head screw sits on the surface of the wood; the oval-head screw is partially countersunk; and the flat-head screw is countersunk so that the top is flush with the surface of the wood.

■ Gauge. This will be a number from 2 to 24 indicating the diameter of the screw. A smaller number is a thinner screw.

■ Length.

Bolts are used when extra strength is needed and whenever you want to be able to disassemble and reassemble the project. Because bolts are tightened with a wrench rather than a screwdriver, you can use greater leverage for a tighter joint.

Machine bolts and carriage bolts
These bolts look similar. Both are put all the way through the wood and tightened with a nut on the other side. The difference is the kind of head each has. The machine bolt has a hexagonal head that should be countersunk so it won't snag anything. The carriage bolt has a smooth, round head that looks more finished and need not be countersunk. A square shoulder under the head is pulled into the wood and

keeps the bolt from turning when the nut is tightened.

Lag bolts Also called *lag screws*, these are basically large wood screws with hexagonal or square heads so that you can put them in with a wrench.

Buying bolts Bolts come in many sizes. They are identified by their length and diameter, such as $3\frac{1}{2}$ inch × $\frac{1}{4}$ inch.

When buying bolts, remember to buy washers—two for each machine bolt, one for each carriage bolt or lag bolt. The washer helps to spread out the pressure against the wood and provides a metal-to-metal connection so the joint won't loosen. Every machine or carriage bolt also needs a nut to fit on the threaded end.

Nails, screws, and bolts

Drilling pilot holes for screws and bolts

A pilot hole is a hole drilled ahead of time for a screw or bolt. The drilling procedure to use will depend on the kind of bolt or screw you are using and how the pieces you are joining fit together.

Screws

Drilling a *pilot hole* for a screw enables you to put the screw in easily and without splitting the wood. A slightly larger *shank hole* through the initial piece of wood will give you the tightest possible joint because the screw threads will catch only in the second piece of wood and the head of the screw will pull the joint together. A still-larger *countersink hole* allows you to set the head of the screw in flush with the surface of the wood. (You need not drill countersink holes for drywall screws; they will countersink themselves in soft wood or plywood.)

These are the steps to follow when drilling for screws. (Steps 1 and 2 are sometimes reversed—see the project instructions.)

A pilot bit will drill the pilot hole, shank hole, and countersink hole all in one step. Be sure the bit is the right size for the screws you are using.

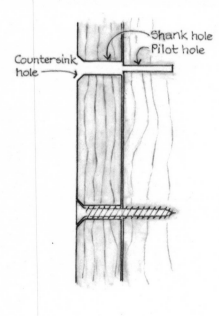

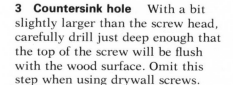

1 Pilot hole Clamp the two pieces of wood together with two C-clamps and drill a pilot hole, using a bit the same size as the screw shank not counting the threads. (For standard drywall screws or #8 screws, this will be a $\frac{3}{32}$-inch bit.)

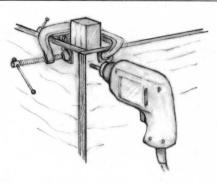

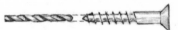

2 Shank hole Remove the clamps and enlarge the hole through the first piece of wood using a bit the same size as the screw shank including the threads. (For drywall screws this will be a $\frac{5}{32}$-inch bit. For #8 screws it will be a $\frac{3}{16}$-inch bit.)

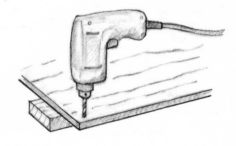

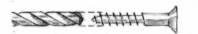

3 Countersink hole With a bit slightly larger than the screw head, carefully drill just deep enough that the top of the screw will be flush with the wood surface. Omit this step when using drywall screws.

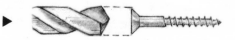

Bolts

Drilling for a bolt is different from drilling for a screw because a bolt goes all the way through both pieces of wood. It's common (but not essential) to countersink bolts so that the bolt head won't get in the way or snag things. Here's how to drill for the kinds of bolts called for in these projects.

Lag bolt A lag bolt is special because it is actually a very large screw that has a square or hexagonal bolt head. These are the steps to drill for a lag bolt:

1 Countersink hole Drill a countersink hole slightly larger than the washer, about $\frac{1}{4}$ inch into the wood.

2 Shank hole Drill all the way through the initial piece of wood, using a bit the same size as the shank of the bolt (for a $\frac{1}{4}$-inch lag bolt, use a $\frac{1}{4}$-inch bit). The bolt should slip easily through this hole.

3 Pilot hole Hold the two pieces of wood together and mark the holes on the second piece. Then drill the second piece using a bit slightly smaller than the threaded part of the bolt (for a $\frac{1}{4}$-inch bolt, use a $\frac{3}{16}$-inch bit). Screw the lag bolt in with a washer under the head as shown.

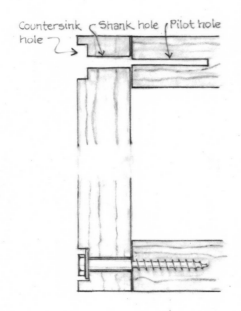

Machine bolt The hexagonal head of a machine bolt should be countersunk. Drill in two steps:

1 Countersink hole Drill a hole slightly larger than the washer about $\frac{1}{4}$ inch into the wood.

2 Pilot hole Clamp both pieces of wood together and drill a pilot hole all the way through them using a bit the same diameter as the bolt (for a $\frac{1}{4}$-inch bolt, use a $\frac{1}{4}$-inch bit).

Put in the bolt with two washers and a nut as shown.

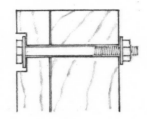

Carriage bolt The smooth, rounded head of a carriage bolt doesn't need countersinking, so drilling for a carriage bolt is a one-step process.

1 Pilot hole Clamp both pieces of wood together and drill a pilot hole through them using a bit the same diameter as the bolt (for a $\frac{1}{4}$-inch bolt, use a $\frac{1}{4}$-inch bit). Tap the head of the bolt with a hammer to set the square shoulder into the wood, then tighten the bolt with a washer and a nut as shown.

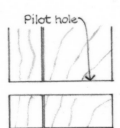

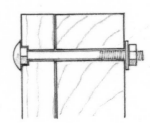

Clamping and sawing

Whenever clamps are needed in these projects, we've called for C-clamps because they are inexpensive and useful in a variety of situations. *Pipe clamps* and *corner clamps* are also useful for gluing particular kinds of joints. Here's how to use all three:

C-clamp A C-clamp is best at clamping one piece of wood flat against another piece, for example, clamping a cleat to a piece of plywood while you drill and put in screws. With two C-clamps and a small block of wood, you can also hold two pieces of lumber (or plywood) together at a right angle while you drill holes for screws.

Place a block inside the corner and clamp both pieces of wood to it. Carefully place the clamps so that they won't get in the way of your work.

Pipe clamp A pipe clamp is good for holding large pieces together because it will span several feet. It's especially useful when you're building with plywood—for the sink and the adjustable enlarger baseboard projects.

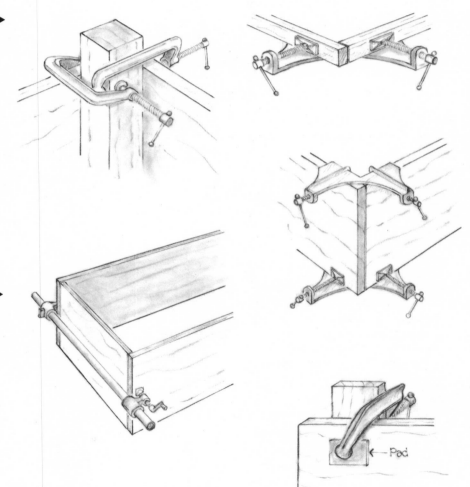

Corner clamp A corner clamp holds two pieces of lumber in place while you glue and nail the corner joint. It's made to hold small cross-sections—1 × 2 lumber is the largest that you can easily join with one corner clamp. It can be used for butt joints or mitered joints. Mount your corner clamp onto a board or piece of plywood that you can clamp to the table.

Use two corner clamps—one at the top and one at the bottom—to hold large pieces of lumber.

Pad the clamps Any of these clamps can apply enough pressure to indent the surface of the soft woods you will be using, so whenever you are clamping onto a good surface, place a thin piece of wood (larger than the surface area of the clamp) as a pad under the jaw of the clamp.

Portable power saws are designed to cut on the upstroke because this pulls the wood and the saw together. This means that the upper surface of the wood will be rougher and more splintered than the lower one. Therefore, when cutting plywood, place the *good side down.*

For accuracy on long cuts, use a *fence* (straightedge) to guide the saw. Go slowly and don't force the saw; you could damage the motor or the blade. When making long cuts, stop as often as necessary to change your position or move the piece you're cutting to be more accessible.

Power saws are dangerous if you lose control. Grip the saw firmly and stand to the side of the saw, never behind it, since it could kick back. Stop the blade each time you want to move or check the saw. Make sure you are balanced—don't lean on the saw for support.

Always wear safety gear.

Making a saw template

A power saw should be guided by a fence because doing so is easier, safer, and gives a straighter cut than free-handing. This fence is not set right on the cutting line because the side of the saw base that runs against the fence is a couple of inches from the blade. A simple wood template, which you can make in a few minutes, will show you exactly where to place the fence. A saber saw is shown here but the process is the same for circular saws.

Clamp a piece of 1 × 2 or 1 × 4 lumber onto a piece of plywood as shown. This is the fence. Now look at your saw. If the base is wider on one side of the blade than on the other, the wider side should be placed against the fence (for *all* cutting). Hold the saw against the fence and cut into the plywood about ¼ inch.

Find or cut a small block of 1 × 2 or 1 × 4 lumber (3 or 4 inches long) and place it on edge with one end against the fence as shown. Mark both edges of the saw cut on the block and draw an arrow pointing to the end which goes against the fence. Each time you measure for a cut, this template will show you exactly how far to place the fence from the cutting line.

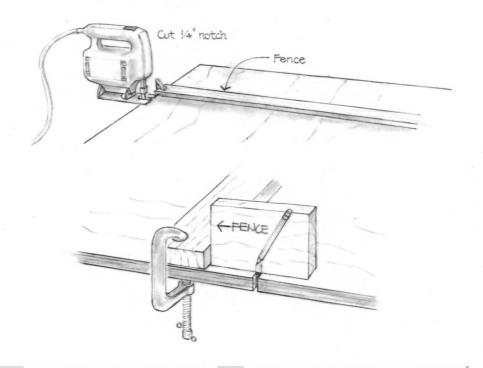

Cut ¼" notch

Fence

←FENCE

Saber saws

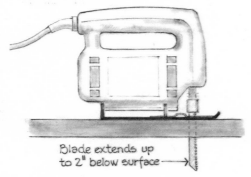

Blade extends up to 2" below surface →

When you're using a saber saw, remember that the blade is exposed and that it may extend a couple of inches below the piece you are cutting. Check underneath the cutting line for obstructions before you begin the cut.

Circular saws

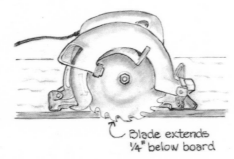

Blade extends ¼" below board

Before cutting with a circular saw, set the blade so that it extends about ¼ inch below the bottom surface of the wood. To do this, place the saw on the wood so that the blade extends over the edge. Then follow the instructions with your saw for adjusting the blade.

Clamping and sawing

Planing

By shaving off thin layers of wood, a plane enables you to remove unevenness or unwanted curvature from the surface of a piece of wood.

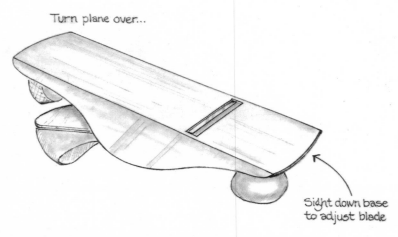

Turn plane over...

Sight down base to adjust blade

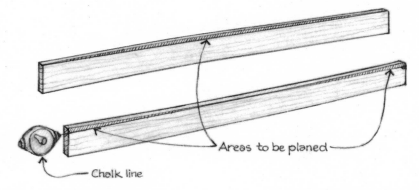

Areas to be planed

Chalk line

Marking a board for planing ▲
To determine which areas need to be planed, stretch a chalk line along one side of the board even with the low-est points of the edge to be planed. When you have it positioned, snap it once to leave a line on the board.

Setting the blade Turn the plane over and sight down the base as you turn the knob that extends the blade. The blade is set when it extends barely beyond the base (about $\frac{1}{64}$ inch) and the cutting edge is parallel to the base. Try it on a scrap of wood. It should produce fine shavings without much effort. When your plane is set for a very thin cut your work will be easier and more accurate. Retract the blade when you finish working so it won't get nicked or dulled. Always store a plane lying on its side.

Using the plane Use only light pressure to guide the plane. Check to see which areas of the board are highest and plane the high points first, lengthening your stroke on each pass until you've removed the hump. Stop frequently and check your progress.

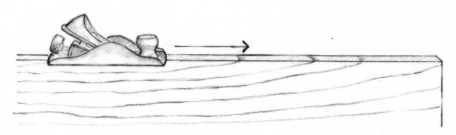

Which direction to plane Follow ▲ the direction of the grain as it rises to the surface of the wood. If you go against the grain, the blade will be drawn into the wood and will jam or tear out chips of wood.

Checking the angle Check the top ▶ edge of the board with your combination square to make sure you are not tilting the plane to one side or the other.

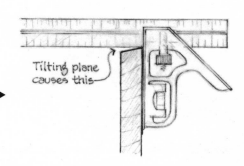

Tilting plane causes this

Making a long straightedge

A long straightedge is used as a guide for a circular saw or saber saw when you are cutting a sheet of plywood. It is quick to make and will help ensure accurate and safe cutting and therefore, ease of construction. You will need an 8-foot straightedge when you cut a full sheet of plywood. It's also good to have a 4-foot one for cutting smaller pieces.

Materials and tools

1 × 4 lumber (An 8-foot length, the straightest one you can find)

Chalk line

Plane

4-inch C-clamps (2)

Combination square

1 CHOOSE A STRAIGHT BOARD

1 Choose a straight piece of 1 × 4 lumber. Look for a piece with no obvious twists or warps and one edge free of knots and other unevenness. A quick way to tell if an edge is likely to be straight is to hold first one edge and then the other edge against the edge of another board. If the edges meet down the entire length, the board is a good bet. Follow the next 2 steps to smooth out any irregularities.

2 CLAMP AND MARK BOARD

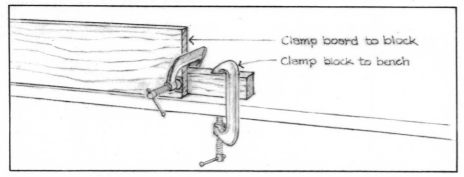

Clamp board to block
Clamp block to bench

2 Place your board on the workbench with the best edge up. Clamp it to the bench and snap a chalk line to mark the areas that need to be planed. (See "Marking a board for planing," above.)

3 PLANE UNTIL STRAIGHT

3 Starting at the highest points and planing with the grain of the wood, plane the edge down until you just reach the chalk line. Check periodically with a combination square to be sure that you haven't tilted the plane and made one side lower than the other. Check occasionally with the chalk line to see how you're doing. Label the side you have planed *good edge* or mark it so that you can find it easily.

Planing

Buying and cutting plywood

Plywood is made up of several thin layers of wood laminated together with the grain going in alternate directions. There are many different kinds. When you buy plywood, you will have to specify the thickness, the grade you want, and whether you need an interior or exterior type. Unless you ask for something else, you will get a full sheet with a standard softwood surface veneer.

Size and thickness Plywood is manufactured in several thicknesses. Three different sizes, ¼ inch, ½ inch, and ¾ inch are called for in this book. The standard sheet size is 4 × 8 feet, but many lumberyards and home supply stores stock half-sheets, quarter-sheets, and sometimes even eighth-sheets.

Kind of wood Plywood made from softwood (which is usually fir) is adequate for darkroom projects, espe-cially if you plan to paint it. When you want an especially nice-looking natural wood surface, ask for ply-wood with a hardwood veneer. Birch and oak are commonly available; you might also find cherry, maple, wal-nut, or other woods. These are usu-ally more expensive than ordinary plywood.

Grade Plywood is graded according to the quality of the face veneer. The most common grades are A, B, C, and D. Of these, A is the best quality—all knotholes and splits in the surface are neatly patched and the surface is smooth. Grade D is the worst—the surface is somewhat rough and may have large knotholes and splits. In most finished projects, only one side of the plywood will show, anyway. That's why "good-one-side" plywood is common. We've usually specified AD plywood (A sur-face on one side, and D on the other) in this book.

Interior or exterior The kind of glue used to laminate the plywood deter-mines whether it is suitable for inte-rior or exterior use. Exterior plywood is somewhat more expensive and it is moisture resistant. The only project in this book that requires it is the darkroom sink.

Supporting the plywood for cutting

Use two or more 6-foot lengths of 2 × 4 to support your plywood for cut-ting. You can set up the 2 × 4's on sawhorses or you can set up on or near the floor so that you can crawl onto the plywood beside the saw. Ei-ther way is fine as long as the sup-ports hold the plywood steady. If part of the plywood starts to tilt, it can cause the saw to bind or buck, or the piece can tear off before you fin-ish the cut.

Instead of thinking of your plywood as one whole sheet when you're ar-ranging the supports, think of the two pieces you will have after you make the cut and place the supports to hold those two pieces. Here are two basic ways to use the supports. Either method can be used on saw-horses or on the floor.

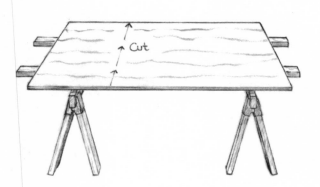

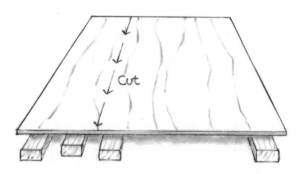

With two supports (left), position the plywood so your cuts go *across* the supports. If you're using a hand saw or saber saw, you will have to stop and move each support over as you get to it. Since a circular saw blade extends only ¼ inch below the ply-wood, you can saw right over the supports—the blade will just make a groove in the tops of the 2 × 4's.

With four supports (right), set up the plywood as shown so the cut goes in the same direction as the supports. On each side of the cutting line, place two 2 × 4's—one close to the cutting line, and the second one far-ther out to keep the plywood from falling.

Cutting the plywood

1 FIND A SQUARE CORNER

1 Check the corners of your plywood with a framing square. If none of them is 90°, trim one end of the plywood to square it off. Mark the right-angle corner so you can find it again.

2 CHECK THE EDGES

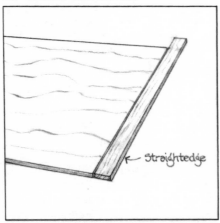

Straightedge

2 Hold a long straightedge against the two edges nearest the square corner. If either one isn't straight, trim it.

3 MEASURE AT TWO POINTS

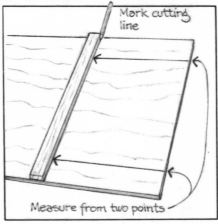

Mark cutting line

Measure from two points

3 Work from one of the straight edges. Use a straightedge or chalk line to mark your cutting line, and mark to indicate which is the leftover piece. Label the piece you are cutting.

4 MARK POSITION OF FENCE

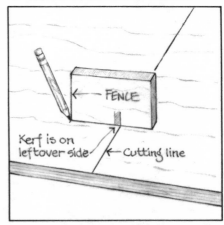

FENCE

Kerf is on leftover side ← Cutting line

4 Make a mark at each end of the cutting line using your saw template (see p. 35). Be sure the saw kerf is on the leftover side of the cutting line.

5 CLAMP FENCE TO PLYWOOD

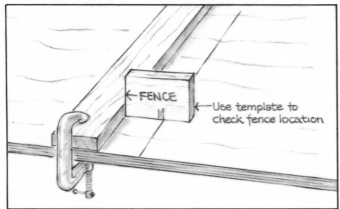

FENCE

Use template to check fence location

5 Have the good edge facing the cutting line and barely covering the pencil marks. Clamp it lightly at first and check both ends with the template. If necessary, adjust the fence

by tapping it lightly with a hammer. Each time you move it, check both ends once more with the template. When it's right, tighten the clamps.

6 If the fence gaps away from the

6 CHECK FOR GAPS

Gap

4d nail

plywood, the saw could slip under it and make a crooked cut. Nail the fence down with a 4d finish nail. Leave part of the nail sticking out so you can remove it.

7 MAKE THE CUT

7 Start your power saw with the front edge of the base resting on the plywood, the side against the fence and the blade about $\frac{1}{4}$ inch away from the plywood. Move only as fast as you are comfortable moving. Concentrate on keeping the side against the fence and the bottom flat on the plywood. If at any time you feel out of control of the saw or have trouble with it, release the trigger, and hold it until the blade stops. If the saw binds, rearrange the supports or add an extra support. Even when the plywood is supported, the pieces might shift as you cut through at the end, so be sure you have a firm grip on the saw.

Buying and cutting plywood

Buying and cutting lumber

Softwood, usually fir or pine, is suitable for building darkroom projects because it is inexpensive and easy to work with. When you buy lumber, you will have to specify the size, length, grade, and whether you want it kiln dried. Check every board you buy to be sure it is straight, not curved or twisted.

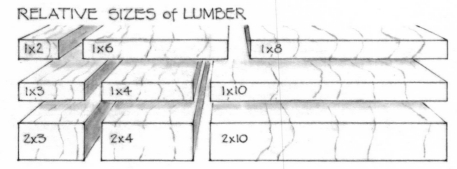

RELATIVE SIZES of LUMBER

1x2 1x6 1x8
1x3 1x4 1x10
2x3 2x4 2x10

Size Lumber is commonly referred to by the size of its cross-section—2 × 4 (two by four), 1 × 6 (one by six), and so on. This is the *nominal size* of the lumber. If you measure, though, you will find that the actual size is a bit smaller. A 2 × 4 is actually $1\frac{1}{2}$ × $3\frac{1}{2}$ inches and a 1 × 6 is $\frac{3}{4}$ × $5\frac{1}{2}$ inches. The nominal size is the size of the rough-sawn board; the actual size is smaller because the rough board is then planed to a smooth, uniform surface.

Length Your lumberyard will stock each size board in several lengths, starting at 6 or 8 feet and moving up in 2-foot increments.

Grade Your choice will be *#2* grade (also called *common* or *construction* grade), or *select* grade (also called *clear*). A #2-grade board will have some knots and surface imperfections, but structurally it is just as good as a better grade. Select lumber has fewer imperfections and costs more. For darkroom building, #2 lumber is adequate; buy select only when appearance is important. Many lumberyards will let you choose your own lumber. Choose the straightest boards with the fewest knots.

Kiln dried or unseasoned?
Always specify that you want kiln-dried lumber. Kiln drying is a controlled seasoning process that makes the lumber less likely to shrink, split, warp, cup, or bend.

Trim pieces

The following kinds of molding will also be useful in darkroom construction:

Parting stop (also called *parting bead* or just *stop*) A small rectangular strip of wood. The exact size varies in different parts of the country. It is usually $\frac{1}{2}$ × $\frac{3}{4}$ inch or $\frac{3}{8}$ × $\frac{3}{4}$ inch. It is useful in your darkroom as a cleat for holding a shelf or work surface, or as a trim strip to cover plywood edges.

Outside corner molding (also called *corner stop* and sometimes abbreviated **OCS**) It comes in different sizes: $\frac{3}{4}$ inch and 1 inch are common. Use it in your darkroom to make runners for print drying racks.

Half-round Comes in several sizes; $\frac{1}{2}$-inch half-round is used to make duckboards (the drainboards) for your darkroom sink.

Supporting a board for cutting

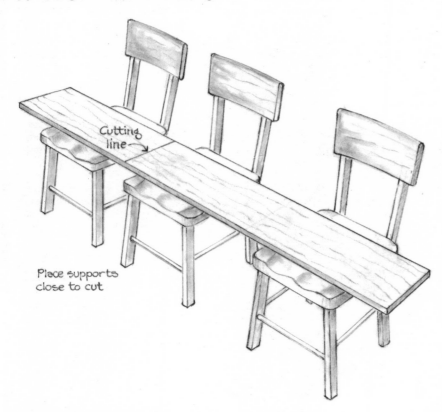

Cutting line →

Place supports close to cut

Use three supports (sawhorses, chairs, or crates), two to hold the board and one for the short piece that you're cutting off. (You may need four supports for a very long board.) Place two of the supports close to the cut as shown. This will keep the boards from falling in on the saw blade as you complete the cut.

Cutting lumber

Square off the board, first checking the end of the board with your combination square. If it's not a right angle, use the square to draw a right angle line about $\frac{1}{4}$ inch from the end. Trim it on the new line.

Measure and double-check your measurements before making any cuts.

Mark the cutting line all the way across the board, using your combination square to be sure it's at right angles to the edge of the board.

Cut on the cutting line, not to one side of it.

Use the first piece as a template to cut others the same size. For each piece you need to cut, set the template on the board with the ends flush and mark your cutting line from the end of the template. If the line is rough, square it off with your combination square. Be sure to use the same piece as the template for all cuts.

Make each cut before measuring for the next one. If you mark off the whole board before making any cuts, each piece will be a little bit shorter than your measurements because the saw cuts a path $\frac{1}{16}$-inch to $\frac{1}{8}$-inch wide. Measure each piece from the end of the board and cut it before measuring for the next piece.

Wiring and grounding

Only simple wiring is called for in building your darkroom projects, and all the skills involved are described below. There are various kinds of switches and plugs; many of them come with instructions for how to attach them. If there are no instructions, ask the salesperson to show you how they work.

TIPS: Grounding

What it is An appliance or power tool will sometimes become electrified because of a loose connection or worn insulation. If the appliance is not *grounded*—that is, if no path is provided for this electricity to discharge to the ground—it can give you an electric shock.

When grounding is important Ideally, all electrical appliances should be grounded. However, the risk of an electrical shock is greatest when the appliance has a metal housing or when you are using the appliance near water. Power tools should be grounded or double-insulated with plastic housings. The portable exhaust fan (Chapter 4) should be grounded because it will be used on the wet side of the darkroom.

How to ground an appliance All you have to do is use a 3-conductor wire for the cord and a 3-pronged plug. Two of the wires carry electricity to the appliance. The third one attaches to a *grounding screw* (or a *mounting screw*) on the metal part of the appliance. This grounding wire simply connects some metal part of the appliance to a grounded outlet, which will transfer any electrical charge to the ground. To avoid confusion, *always use the green wire for grounding.*

A 2-pronged adaptor You can plug a 3-pronged plug into a 2-hole outlet with an inexpensive adaptor (see drawing). Sticking out of it will be a short wire ending in a small metal clamp. This is the *grounding wire.* To ground your appliance, you must attach it to the screw that holds the cover plate on your electrical outlet.

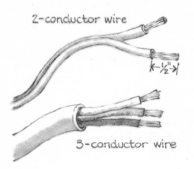

Grounding wire

Adaptor

Working with wire

When you buy the electrical cord for your light box, ventilating fan, or other project, you will have to choose among several different sizes and types. Buy regular lamp cord (also called *zip cord*) for wiring an appliance that doesn't have to be grounded. When you want to ground something, ask for 18-gauge, 3-conductor wire. The gauge tells you the thickness of the wire—a higher number indicates thinner wire. Figure out how long you want the cord to be and buy at least 6 inches extra, since a few inches will be used in making connections.

Stripping wire Before you connect a wire to something else, you must remove some of the insulation. Use a pocket knife or wire stripper to cut off ½ inch of insulation, exposing the end of the wire. A 3-conductor wire will have an outer layer of insulation that must be peeled back before you can get to the individual wires.

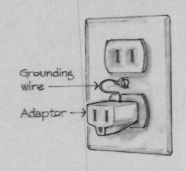

2-conductor wire

½"

3-conductor wire

Using wire nuts A wire nut is a small plastic connector that looks like the cap to a toothpaste tube and has metal threads inside. It is used to connect two or three wires together.

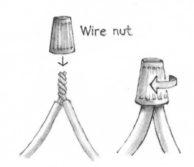

Wire nut

Strip the ends of the wires and twist them around one another a few times in a clockwise direction. Then screw the wire nut on. It will twist the wires together more tightly and it should hold itself in place. If it comes off or if it's loose, unwrap the wires and start over.

Attaching a wire to a screw
The standard way to connect an electrical cord to a plug, switch, or appliance is to attach the individual wires to screw terminals. To do this, loosen the screw a couple of turns, bend the bare end of the wire around the shank of the screw in a clockwise direction, and tighten the screw so that the wire is held firmly under the screw head. Give the wire a tug to be sure the connection is tight.

Plugs

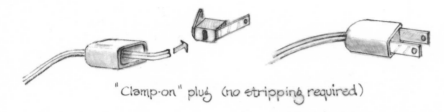

"Clamp-on" plug (no stripping required)

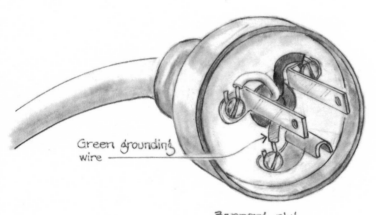

Green grounding wire

3-prong plug

Switches

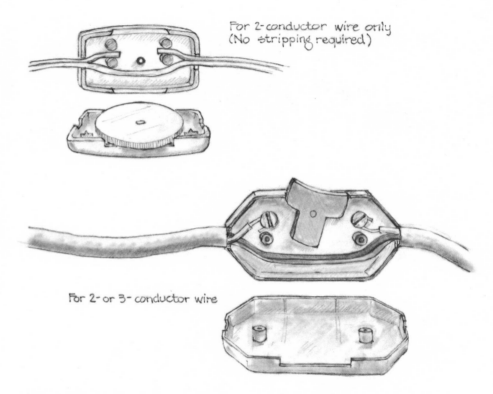

For 2-conductor wire only (No stripping required)

For 2- or 3- conductor wire

Kinds of plugs Two kinds of 2-pronged plugs are available. The common type of plug has two screw terminals inside for attaching the electrical cord.

Another kind that is easier to install simply clamps onto the wire. (Designs for these plugs vary with different manufacturers.) For a grounded appliance, you will need a heavy-duty, 3-pronged plug.

Wiring a plug In a regular 2-pronged plug, attach one wire to each screw terminal. If you have the clamp-on type plug, see the directions with the plug.

In a 3-pronged plug, attach the black (or red) wire to one screw terminal, the white wire to the other terminal, and the green wire to the green grounding screw.

Kinds of switches A switch works by interrupting the current in one wire. For the projects in this book, we've specified *in-line* switches because they are the easiest kind to install. *In-line* means that you install the switch on the electrical cord instead of on the appliance. Place it a few inches from the appliance so that you can find it easily. Switches for 2-conductor and 3-conductor wires are alike except in size.

Wiring a switch For 2-conductor wire, cut one of the wires and connect the two cut ends to the two terminals in the switch. For 3-conductor wire, remove the outer insulation where you want the switch to be. Cut either the black or the white wire and attach the cut ends to the terminals inside the switch. In both cases, the uncut wire bypasses the switch mechanism.

All about lightproofing

Because a darkroom must be dark, lightproofing the windows and doors is essential. Light is a bit tricky and blocking it out requires some patience, but lightproofing isn't difficult. Here is some basic information about lightproofing and lightproof materials. In the rest of the chapter, you will find several ideas for lightproofing windows and doors.

Keeping out the light

When you're lightproofing your darkroom doors or windows, there are two basics to keep in mind:

1 Light travels in straight lines *only*—it doesn't turn corners.

2 Light bounces off any reflective surfaces. By bouncing back and forth it can get around corners.

The steps in lightproofing, therefore, are: first, to obstruct the path of light with some lightproof material (see the list on next page) and second, to use flat black paint or fabric on all surfaces that might reflect light into your darkroom. We found, though, that flat black paint or fabric was still reflective enough that strong light could work its way around the corners of our lightproofing, so a third step is necessary. Make sure your lightproofing extends several inches beyond the door or window and fits snugly against the wall. Actually wrap it around the door or window frame, if possible, so that light can't seep in around the edges. Finally, be prepared to check what you've built and plug up any light leaks.

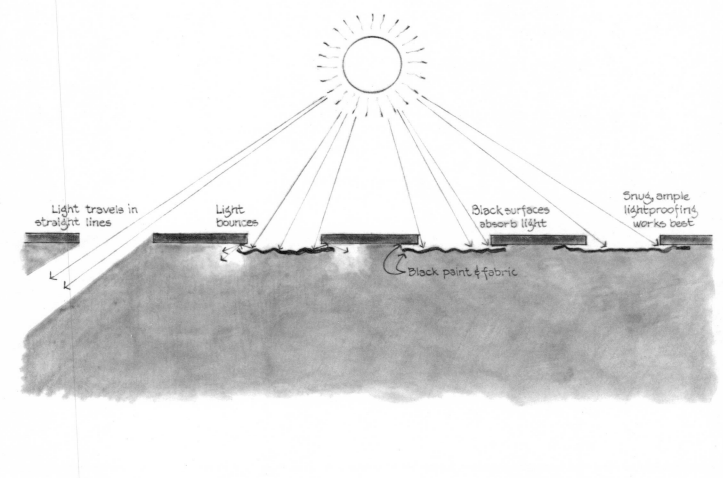

Light travels in straight lines

Light bounces

Black surfaces absorb light

Snug, ample lightproofing works best

Black paint & fabric

Before lightproofing

Window and door designs vary enormously, so before you start lightproofing, check your doors and windows to see if the design you want to use will need to be adapted to cornices, moldings, sills, handles, curtain rods, and so forth.

Decide how you will ventilate your darkroom (see Chapter 4) before you install your lightproofing. Your lightproofing scheme may have to accommodate an exhaust fan or air intake unit.

How dark is dark?

How dark your darkroom needs to be depends on which light-sensitive materials you intend to use. For printing, for example, a small amount of ambient light is acceptable.

Here's a simple test to see if your room is dark enough: turn out the lights and wait several minutes for your eyes to adjust. Then hold a sheet of white paper against a dark background. If you can see it, there's probably enough light in the room to fog your printing paper. Look around to see where the light leaks are, plug up some of them, and try the test again.

Film is more sensitive to light than is printing paper; it can be handled only in complete darkness. *Any* light entering the darkroom could be a problem. If it's too difficult for you to block all light from your darkroom, consider loading film onto the developing reel in a changing bag, building partitions to improve the lightproofing in part of your darkroom, or using a closet for working with film.

TIPS
Lightproof materials

Rubberized black fabric, made for lightproofing, is available through some professional camera stores. It's quite expensive.

Black-Out is a drapery lining fabric made for darkening rooms. It is white and has a coat of white latex on one side. It transmits a little light, but you can easily make it lightproof by adding one or two coats of black latex paint on the painted side. Black-Out is generally available in stores that carry upholstery and drapery fabrics and the cost is quite reasonable.

Tight-weave fabric (medium to heavy weight), such as cotton duck or artists' canvas can be made lightproof by painting one side with two or more coats of black latex.

Other fabrics in your local fabric store may be lightproof. Check the lightweight vinyls and various painted or plasticized costume fabrics.

To find out if a fabric is lightproof, take a small piece home and wrap it around a desk lamp. Then turn off all other lights and see if the fabric transmits any light from the lamp.

Heavy black plastic (6 ml. thick), made for mulching, is lightproof and inexpensive. It won't stand up to rough use because it tears easily. Garden stores sell it.

Building materials such as thin plywood or masonite, sheet metal, or some kinds of builders papers are also lightproof.

Flat black coverings

Paint Some flat black paints are flatter than others. Find one with no sheen to it. Black chalkboard paint works well.

Fabric Black felt is good; so are corduroy, wool, and heavy cotton. If you have a choice, use the fabric that looks dullest (reflects light the least).

Lightproofing your windows

We don't know what your darkroom window looks like. It could have molding around it or it could be punched into the wall with no molding. It might have a projecting sill or cornice. It might open in or out; it might slide up and down; it might have cranks or handles that stick out from the wall. All of these things matter when you have to lightproof that window. Here are several ideas for lightproofing your windows, many of which can be adapted for different situations.

Temporary lightproofing

In many home darkrooms, it is preferable or even imperative to have a temporary method of lightproofing. If you print in the family kitchen, for example, you must be able to convert the room quickly and easily to a darkroom and back again. If your darkroom is also your office or studio, it's desirable to be able to uncover the windows when you're not printing. An easily reversible method of lightproofing might also be desirable if you rent a space or move frequently. Here are four types of lightproofing that are easy to put in place and remove:

1 A fabric and Velcro shade is a homemade lightproof shade that is held in place over your window with Velcro tape. For complete instructions for making one yourself, turn the page.

2 An indoor storm window kit makes it easy for you to snap a thin opaque panel over your window and snap it out again just as easily. For information about these kits and how to make them lightproof, see the next page.

3 A solid panel of very thin plywood or masonite is easy to build, but it's heavy and a bulky item to store when it's not on the window. For details, see the next page.

4 A lightproof roll-up shade for darkrooms is manufactured by Draper Shade Co. We found that it's extremely difficult to build one of these yourself because of the very close tolerances required to lightproof the edge of the shade and still allow it to move up and down freely.

Permanent lightproofing

If you have a darkroom that is not used for other purposes, and you don't expect to move for a while, consider permanent lightproofing. By "permanent," we mean anything that you put over your windows and leave in place as long as that room is your darkroom. The drawing below shows three simple ways to lightproof your windows permanently.

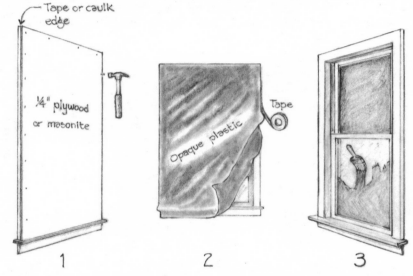

1 Nail a plywood or masonite panel over the window. To keep light from coming through between the panel and the wall, staple some black felt or other heavy fabric onto the panel near the edge, or apply weather stripping or opaque tape after the panel is in place. If you also want to reduce window heat loss, cut a piece of fiberglass insulation to fit the window opening and staple it to the panel on the side facing the window.

2 Tape sheets of opaque black plastic over the windows. Though this is an inexpensive solution, the plastic can tear easily. You might put a cabinet, bulletin board, or other piece of furniture in front of the window to avoid such an accident.

3 Opaque your windows with black paint. (Instead of painting your window panes directly, you can tape pieces of heavy paper over the panes and paint the paper—then your lightproofing can be removed easily.) Then caulk the window to stop light leaks.

A removeable solid panel

Build a 1 × 2 frame that will fit around your window molding and rest on the window sill as shown. Reinforce the outside corners with metal angles. Attach a thin panel of plywood or masonite or a piece of lightproof fabric to the front. Pad the inside of the 1 × 2 frame with strips of fabric so that the panel will fit snugly around the window molding.

Wrap several layers of dark fabric around the bottom edge of the panel and staple it in place. This cushion will keep light from entering between the panel and the sill. You will probably need to putty the seams in your construction or cover them with lightproof cloth tape to stop light leaks.

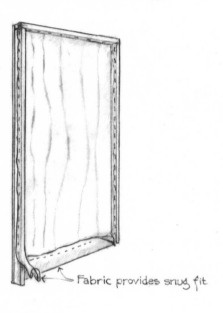

Fabric provides snug fit

Cut away view

Indoor storm window kit

Of all the methods of temporary lightproofing that we mention here, this is the quickest to assemble. All you have to do is cut the pieces to size and stick them in place. Some systems that will work for lightproofing are the Insider (Plaskolite, Inc.), Insul-pane (Baxt Industries), and The Barrier (K.S.H., Inc.). They are available in home supply stores.

Each kit contains four frame pieces with double-stick adhesive on the back and a sheet of thin, clear acrylic. In most places you can buy the pieces separately and buy something opaque instead of the clear plastic. Detailed instructions will come with your materials. Here are the steps involved:

1 Cut the four frame pieces and stick them to your window molding or to the wall around your window. These pieces snap open so that you can insert or remove the panel.

2 Cut the clear panel to size, cover it with opaque black plastic, and snap it in place. Two lightproof substitutions for the clear panel are plastic counter laminate (such as Formica or Textolite) that is approximately the same thickness as the acrylic, or $\frac{1}{8}$-inch masonite (some systems will not accept a panel this thick).

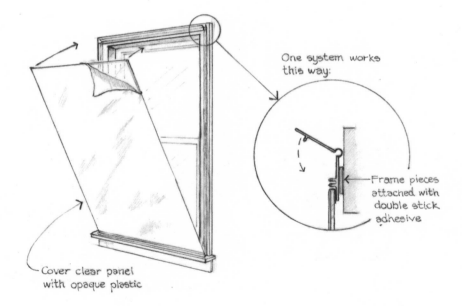

One system works this way:

Cover clear panel with opaque plastic

Frame pieces attached with double stick adhesive

A lightproof window shade

A lightproof fabric shade, attached to the window frame with Velcro, is lightweight; it can be completely removed from the window, folded, and stored. If you prefer, you can build the shade so that it can be rolled up to the top of the window and secured with Velcro tabs.

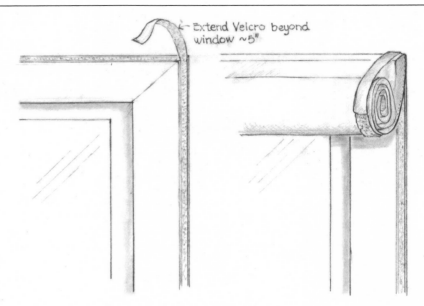

Extend Velcro beyond window ~5"

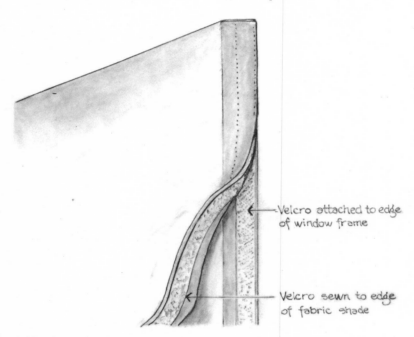

Velcro attached to edge of window frame

Velcro sewn to edge of fabric shade

The shade is hemmed on all four sides and has Velcro sewn on near the edges. The matching Velcro strips can be stapled to the outside of the window molding or attached to the wall around a window that has no molding. (The two sides of the Velcro are different. Put the *prickly* strip on the wall and the *fuzzy* strip on the shade.)

The back side of the fabric should face the window. Turn all hems toward the back of the fabric and sew the Velcro strips onto the back side of the shade.

Alternative: A roll-up shade If you want to roll the shade up instead of removing it from the window, follow the instructions below with this simple change: extend the side pieces of Velcro on the wall about 5 inches above the top of the shade as shown, but don't staple the extension to the wall. When the shade is rolled up, you can fold these pieces down and stick them to the Velcro on the shade to hold it in place.

Materials

Lightproof fabric A piece at least 4 inches longer than your window in each direction. If your window has a molding around it, buy a piece 4 inches larger than the outside of the molding.

¾-inch Velcro Enough to go all the way around your window. Buy *black* Velcro if you can find it.

Thread

Tools

Staple gun and staples or heavy-duty double-stick adhesive tape to fasten the Velcro to the wall.

Sewing machine

Scissors

1 ATTACH VELCRO TO WALL

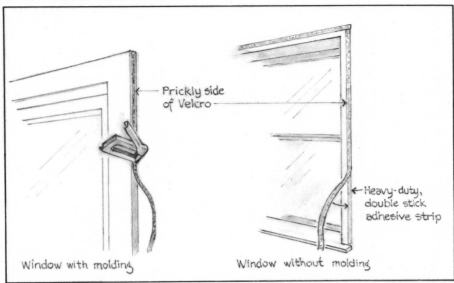

Prickly side of Velcro

Heavy-duty, double stick adhesive strip

Window with molding

Window without molding

2 SEW VELCRO TO TOP EDGE

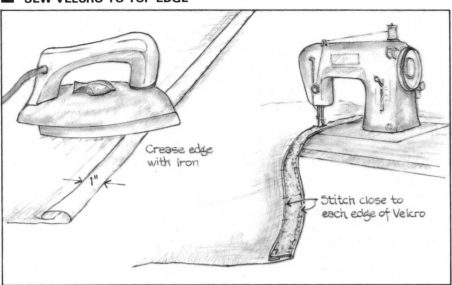

Crease edge with iron

1"

Stitch close to each edge of Velcro

3 SEW VELCRO TO OTHER EDGES

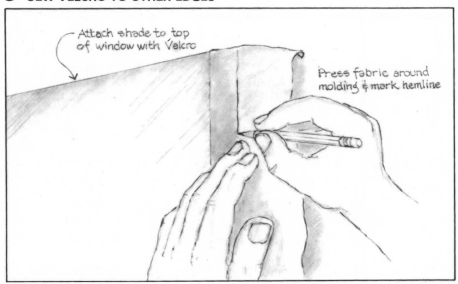

Attach shade to top of window with Velcro

Press fabric around molding & mark hemline

1 Staple the *prickly* Velcro strip to the outside of your window molding or use double-stick adhesive tape to attach it to your wall. Make sure there are no gaps at the corners where light can get through. If you want to be able to roll the shade up, cut the side pieces 5 inches longer (see above).

2 Along the top edge of the shade, turn about 1 inch of fabric under and crease it with a low-temperature iron. Cut a strip of *fuzzy* Velcro the same length as the one you've attached to the wall above the window and pin it to the back of the shade near the edge, as shown. Stitch close to each edge of the Velcro strip. This stitching will hold the Velcro on and stitch the hem in place.

3 Stick the shade up on the wall using the top Velcro strip. Draw a hemming line on the front of the shade by tracing around the outside edge of the Velcro strips that are on the wall. Remove the shade from the wall. Trim it so that the fabric extends only 1 inch beyond the hemming line. Fold under the side and bottom hems and attach the Velcro as before.

A lightproof window shade

Lightproofing your darkroom door

The type of lightproofing that will work best for your darkroom door depends on the kind of entryway you have and the number of people who will be in the darkroom simultaneously.

If you plan for one person at a time to use the darkroom, a single hinged or sliding door or lightproof curtain is adequate. With two or more people using a darkroom at once, it's important to be able to enter and leave the room without letting in light so that everyone else can keep working uninterrupted. For this situation, you need a light-trap entry. Several ideas for lightproof entries are discussed below. Whichever one you choose, make sure it's wide enough for any equipment you will be bringing in (or plan to use a different door).

Lightproofing a hinged door

Nearly all doors will leak light at the bottom. A common solution for this is to put a towel down in front of the door. Or, you can apply weather stripping (such as adhesive-backed 3M weather strip) to the bottom of your door to block out most or all of the light.

To stop light leaks around the top and sides of the door, staple fabric to the inside of the door jamb or use foam weather stripping as shown.

Adhesive backed weather strip

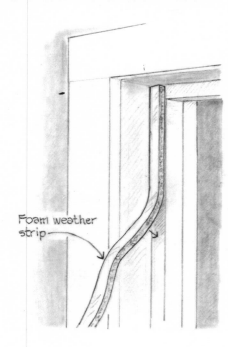
Foam weather strip

Making a lightproof curtain

Curtains are often used to lightproof entryways that don't have doors. They are also used in double-entry light traps because they require less space and cost less than hinged doors. Use lightproof fabric or a piece of dark fabric lined with opaque black garden plastic. To make the curtain:

1 Cut the fabric 10 inches wider and longer than the doorway.

2 Hem the top and sides by folding 1 inch of fabric towards the back of the curtain and stitching it in place.

3 Hem the bottom With the curtain in place, turn up the bottom edge until it just brushes the floor. Sew the hem and put a length of chain inside to hold it against the floor.

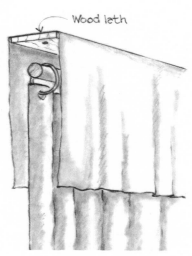
Wood lath

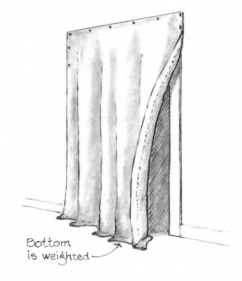
Bottom is weighted

▲ **Hang the curtain over your doorway** with the top edge about 5 inches above the top of the door. Tack it in place along the top and partway down each side to ensure that it closes completely.

◄ **A ceiling-hung curtain** To partition off part of a room or a hallway, you will probably need to hang your lightproof curtain from the ceiling. Use a wood or metal rod. Then lightproof the top of the curtain with a 2-foot wide strip of lightproof fabric attached to the ceiling with a strip of wood as shown.

Curtain hardware and complete curtain systems are available from Photolab Fabrications, 1578 Ferndale Blvd., Central Islip, NY 11722.

Light-trap entries

Here are some basic configurations for light-trap entries. Any of these designs can be modified to fit your situation.

Note that the maze entry takes up a lot of floor space.

A double-entry light trap consists of two lightproof barriers with a space between them so that you can close one before opening the next. This is a natural solution if you have a hallway leading to your darkroom. Make sure that each barrier is lightproof by itself.

If you have no hallway, you can still construct a double-entry trap with a ceiling-hung curtain. Follow the instructions above for lightproofing.

A maze light trap is a curved hallway with no door. Geometry and nonreflective walls keep light out. The S-shaped trap (left) and the U-shaped trap (right) are standard, reliable designs. Be sure the walls from one side of the trap extend about 12 inches past the end of the walls from the other side.

Make the passageway at least 28 inches (preferably 30 inches) wide to leave enough shoulder room.

Paint all surfaces inside the trap black or cover them with black fabric to damp out reflections. Then paint a narrow white line on the wall of the trap to guide people in, since their eyes won't be adjusted to the dark.

DOUBLE-ENTRY TRAPS

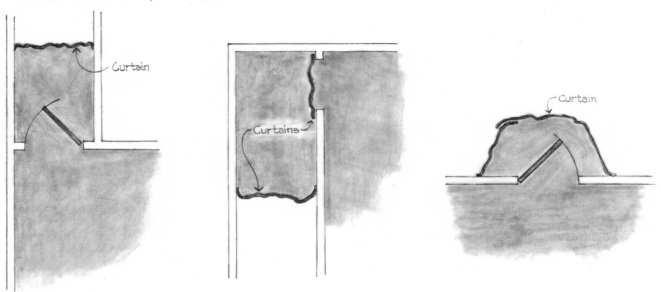

Curtain

Curtains

Curtain

MAZE TRAPS

Ventilating your darkroom

A ventilation system usually calls for some manufactured items (such as an air conditioner, an exhaust fan, or a lightproof vent or fan) and some home carpentry to lightproof or adapt these items to your darkroom. The text below explains how to set up a ventilation system that will work for your darkroom. The rest of this chapter contains plans for building two home-made items for ventilation—a lightproof vent for your darkroom door and a portable exhaust fan unit.

Lightproof wall vent

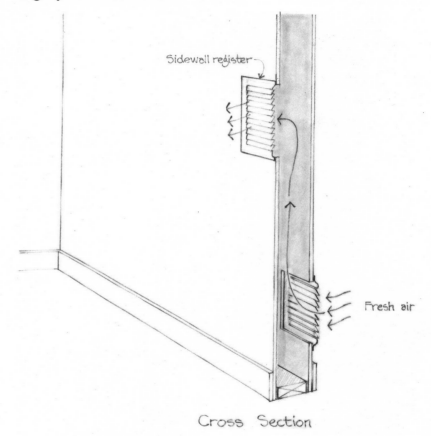

Cross Section

Ventilation

Air flow is best if the air enters on one side of the room and leaves on the opposite side since this allows fresh air to circulate through the whole room. If possible, design your ventilating system so that the air enters on the dry side of the darkroom and exits on the wet side near the chemicals. This way, chemical fumes won't circulate through the space, and you will be less likely to inhale them.

To control the air flow you will need to use a fan for either the air intake or the air exhaust, depending on what is easiest in your situation. Use a vent on the other side.

A fan for air intake Using a fan as the air intake is good because it will maintain a positive pressure in the room—dust won't be sucked in when you open the door. Mount an intake fan in the window to pull in fresh air or in a wall or door to pull in air from the rest of the house. A window air conditioning unit for your air supply gives you the added benefits

of filtering, dehumidifying, and cooling the air. (Be sure you get one that can be set on "fan only" for the times when the room doesn't need to be any cooler.) Install an exhaust vent as close to the sink as possible. This can be a vent in a wall or door, a partially open window with a light trap in front of it, or an exhaust fan.

A fan for exhaust The advantage to using a vent for air intake and a fan for exhaust is that a fan near your chemicals is the most efficient way to get the fumes out without circulating them through the room. Mount a standard bathroom exhaust fan in the wall or ceiling above the sink (for size see p. 59), or build a portable case for the fan with a hose to carry the exhaust out (described below). Put a lightproof vent in your wall or door to pull air from the rest of the house or light-trap a partially open window to pull in air from outside.

If you have a hollow stud wall between your darkroom and the rest of your house, there is a very simple way to put a lightproof vent in that wall for air intake: buy two wall vents (called *sidewall registers*—they're about 6 × 10 inches). Install one on the darkroom side of the wall near the ceiling and the other one

near the floor on the other side of the wall. Air will flow through the wall cavity from the house into your darkroom. (*Caution*: After you cut the first hole, check inside the wall for obstructions between that hole and the location of your other vent.)

Lightproof door vent

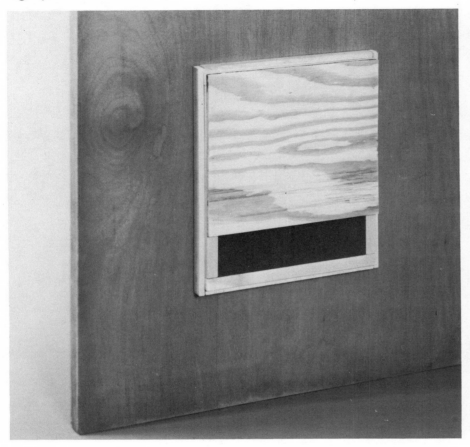

Portable exhaust fan

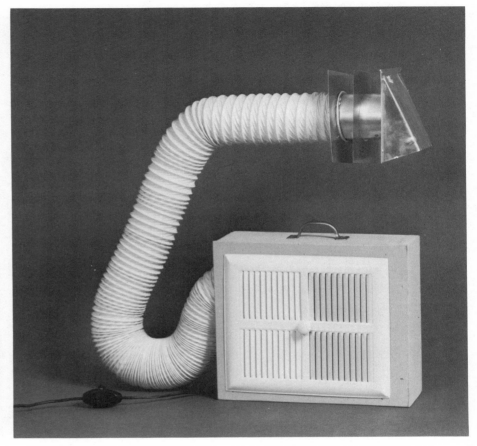

This air vent is actually a box with openings on both sides to let air through and a center baffle to keep light out. The vent is designed to fit in a hole in your darkroom door, but the basic design can be modified for a wall or window vent. You can put an air filter inside the vent to help keep dust out of your darkroom. The size of the air vent is 12 inches wide by 13½ inches tall. You can change the size or shape to fit a particular situation. The vent can be located anywhere on the door as long as the hole you cut doesn't interfere with the structural frame of the door. A vent near the bottom of the door will let in cooler air and will be less noticeable than one near eye level. Assembly instructions are on pages 54–57.

If you don't want to install an exhaust fan in your wall or ceiling or if it's just not possible to locate one near the sink, this portable fan is easy to build. The wooden fan housing has a handle on it and a length of flexible venting hose that can connect to a window, a dryer vent, or some other existing vent.

This small unit can sit on a shelf above your chemical trays, right where the fumes are the worst. When you move to another darkroom, just pick it up and take it with you. The portable fan can be used whenever you are dealing with fumes and need ventilation, when painting the equipment you're building for your darkroom, for example. Assembly instructions are on pages 58–61.

Ventilating your darkroom

Building a lightproof door vent

Here are plans for a lightproof air vent to go in a door. The
same design could be modified for use in a window or wall.

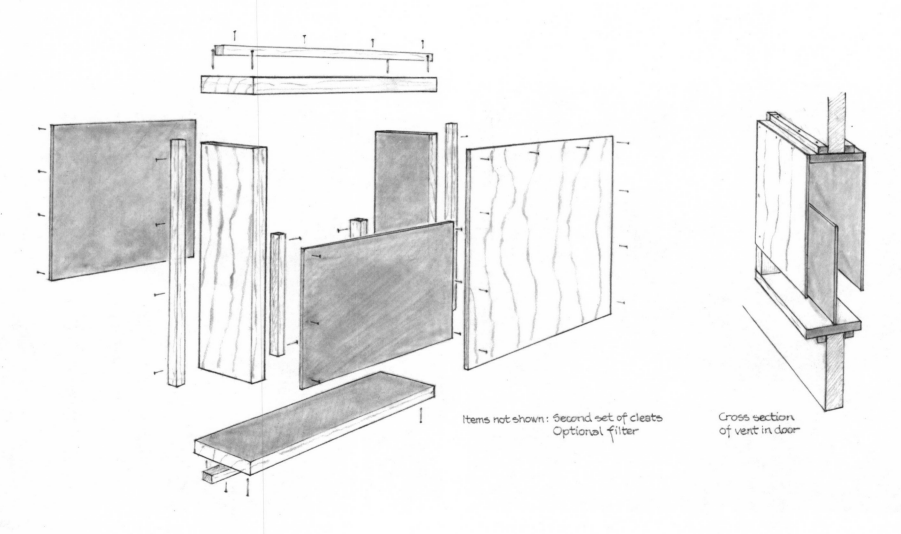

Items not shown: Second set of cleats
Optional filter

Cross section
of vent in door

TIME: Less than 4 hours
COST: Very low
DIFFICULTY: Easy

Materials for this project are readily available and inexpensive, and the techniques involved are straightforward. There are small, inexpensive lightproof vents on the market. Check to see what's available before building one yourself.

Tools

- Pencil
- Straightedge
- Tape measure
- Combination square
- Saber saw
- Hammer
- Drill
- Corner clamp (optional)
- Paintbrush
- Small putty knife
- Scissors (to cut the filter)

Materials and supplies

1 × 4 lumber one 6-foot length

$\frac{1}{4}$-inch plywood $\frac{1}{8}$ sheet

Parting stop ($\frac{1}{2} \times \frac{3}{4}$ inch or $\frac{3}{8} \times \frac{3}{4}$ inch) two 6-foot lengths

4d nails

1-inch wire brads

$\frac{3}{4}$-inch #6 roundhead screws (nine)

Glue

Flat black paint

Latex caulk

For the optional filter:

Air conditioning filter the aluminum mesh type

Thumb tacks

1 CUT THE PIECES

1 (A) From 1 × 4 lumber, cut four sides each 12 inches long. (B & C) From $\frac{1}{4}$-inch plywood, cut two panels each 12 × 10 inches, and a baffle 7 × 10$\frac{1}{2}$ inches. (D & E) From parting stop, cut two cleats 7 inches long, and four cleats 12 inches long. Wait to cut the other cleats until the vent is assembled.

Kinds of doors

The door on your darkroom is most likely to be a hollow-core door, but it could be a solid-core or a panel door. Before you start building your vent, figure out which kind of door you have so you'll know how to cut it.

Hollow-core and solid-core doors look alike on the outside. Both have flat smooth surfaces and both are called *flush* (or *flat*) doors. You can tell the difference by knocking—a knock on a hollow-core door will echo inside the door and sound loud. A solid-core door, since it is solid all the way through, will muffle your knock and sound solid.

A hollow-core door isn't exactly hollow. The space between the surface veneers is filled with a lightweight honeycomb material and it's fairly easy to cut with a saber saw.

A solid-core door is made up of laminated blocks of wood or particle board covered with a face veneer on each side. It's difficult to cut (although it can be done with a circular saw). If yours is a solid-core door—or any other door that you wouldn't want to put a hole in—remove it and buy an inexpensive hollow-core door for your darkroom.

A door with one or more indented panels in it is called a *panel* door. If the panels are large, cut a hole through one the same way you would cut through a flush door. If the panels are small, you may not have to do any cutting. You may be able to pry off the molding around the edge of a panel and lift the panel out.

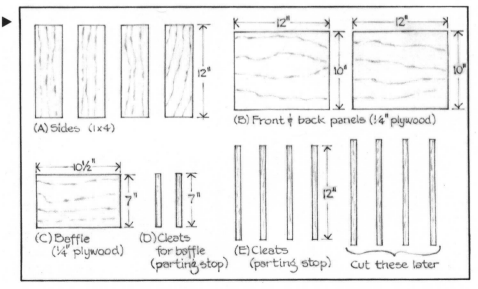

(A) Sides (1×4)

(B) Front & back panels (¼" plywood)

(C) Baffle (¼" plywood)

(D) Cleats for baffle (parting stop)

(E) Cleats (parting stop)

Cut these later

Building a lightproof door vent (cont.)

2 ASSEMBLE BOX

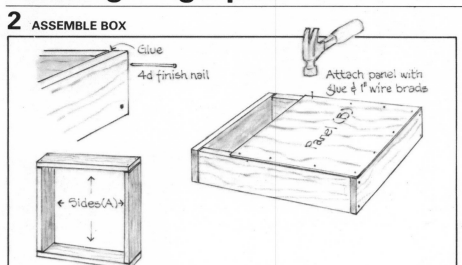

Glue

4d finish nail

Attach panel with glue & 1" wire brads

Panel (B)

← Sides (A) →

3 CUT HOLE IN DOOR

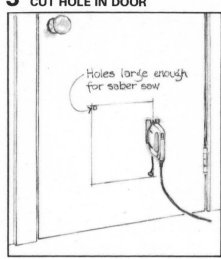

Holes large enough for saber saw

2 Glue and nail the four sides (A) together as shown. (This will be easier if you have a corner clamp.) Glue and nail a plywood panel (B) to one side of the box, making sure the edges of the plywood are flush with three sides of the box.

3 Hold the box in place and draw the outline of the vent on your door. Drill two starter holes in the door in opposite corners of the vent outline. Cut with a saber saw. Slip the box into the hole to check the fit.

4 PAINT INSIDE

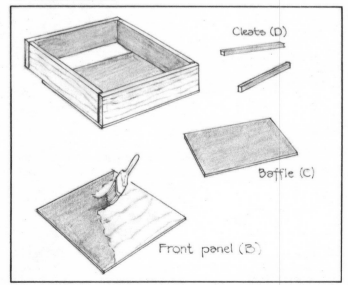

Cleats (D)

Baffle (C)

Front panel (B)

5 INSTALL BAFFLE

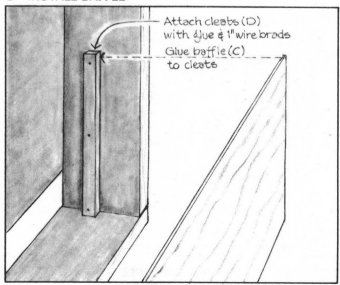

Attach cleats (D) with glue & 1" wire brads

Glue baffle (C) to cleats

4 Paint the inside of the box, both sides of the baffle, the two short cleats, and one side of the plywood panel with flat black paint. This will minimize reflections inside the vent.

5 Glue and nail the 7-inch cleats (D) to the inside of the vent 2 inches from the open edge as shown. Glue the plywood baffle (C) to the cleats. Be sure the baffle is at the same end of the box as the opening.

6 INSTALL FILTER (optional)

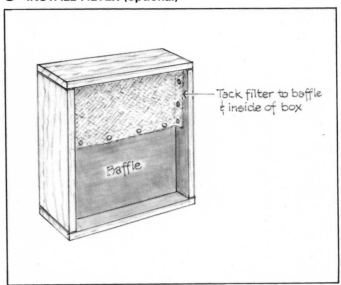

Tack filter to baffle & inside of box

Baffle

7 ATTACH OTHER PANEL

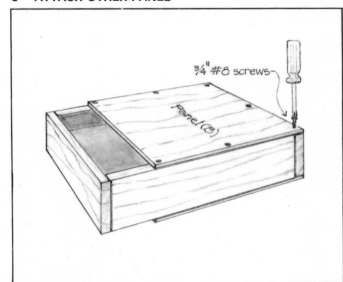

¾" #8 screws

panel (B)

6 Cut the filter 1 inch larger in each direction than the space above the baffle. Bend the sides of the filter and tack it to the sides of the vent and the baffle as shown with thumb tacks.

7 Drill and screw the second panel (B) in place (no glue) so that you can remove it to change the filter. Put the opening at the same end as the opening on the other side of the vent.

8 MARK CLEAT LOCATION

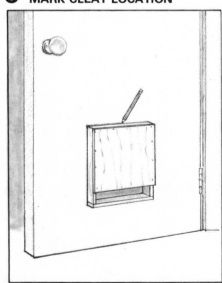

9 CUT AND ATTACH CLEATS

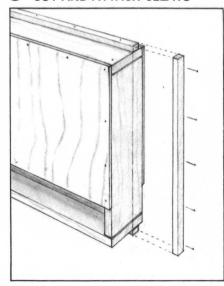

10 INSTALL VENT

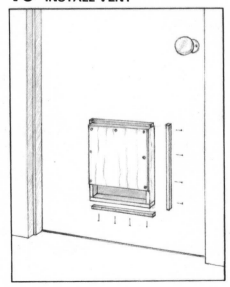

8 Slip the box into the door and position it so that it projects an equal distance inside and out. Draw a line around the box where it meets the door. Remove the box.

9 Glue and nail two of the 12-inch cleats to the top and bottom of the box along the line as shown. Cut four side cleats (long enough to cover the ends of the top and bottom cleats). Glue and nail two of these in place.

10 Put the box back in the door and glue and nail cleats to the other side of the box as well. Use latex caulk to fill any seams in the vent that are letting light through.

Building a portable exhaust fan

A typical bathroom fan (designed to go in a wall or ceiling) becomes a portable fan when you encase it in a wood box and add a cord and an exhaust hose. This portable unit is especially good for evacuating chemical fumes because it can be placed wherever the fumes are the worst.

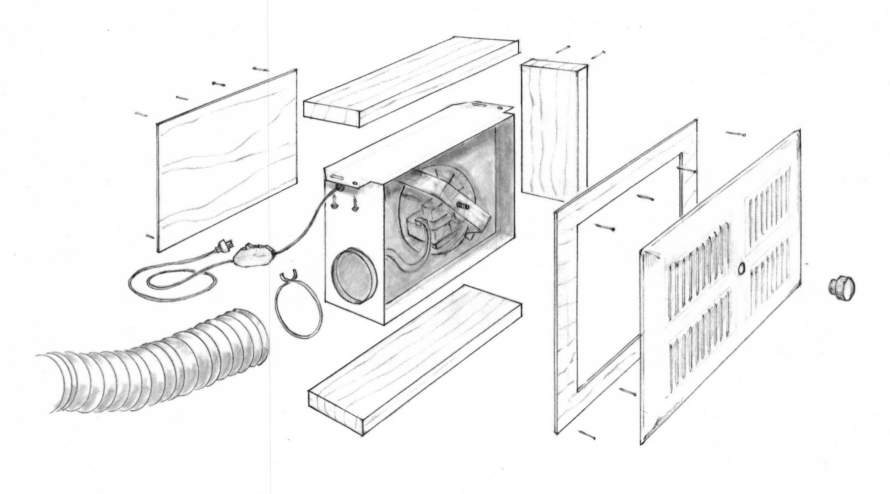

Materials and supplies

1 × 4 lumber one 4-foot length

¼-inch plywood ¼ sheet

Ventilating fan wall or ceiling type. See "Buying a fan" (right) for size.

¾-inch #8 roundhead screws for mounting the fan (four)

Flexible vent hose (The size depends on your darkroom. You'll probably need 6 to 8 feet.)

Round wire connectors (2 of them for the hose)

Cabinet handle (optional) and screws for mounting it.

3-conductor wire (Grounding your fan is necessary because you will be using it near water. For more about grounding, see p. 42.)

Wire nuts (two)

3-pronged plug

Switch for 3-conductor wire.

4d finish nails

Glue

1-inch wire brads

If you don't already have a vent in your darkroom for the fan you will also need:

Through-wall venting piece with two metal plates

¼-inch plywood (large enough to replace a window pane or fill the space under an open window)

TIME: Less than 4 hours
COST: Low
DIFFICULTY: Easy

Materials for this whole project cost a little less than a small lightproof fan made for darkroom use. The biggest advantage to building it yourself is that you'll have a portable fan that you can use with any project that produces fumes.

Tools

- Tape measure
- Pencil
- Straightedge
- Saber saw
- Combination square
- Screwdriver
- Drill
- Hammer
- Pliers
- Knife (for cutting and stripping electrical wires)

The pieces The parts of the box are: three short lengths of 1 × 4 lumber, 2 pieces of ¼-inch plywood, and a cabinet handle (optional). The dimensions will depend on those of the fan you bought. Other parts shown here are: the fan, a length of vent hose, 2 round wire connectors, and a through-wall venting piece needed to vent the fan through a window.

Buying a fan

For adequate ventilation, your fan must change the air in your darkroom about every 6 minutes. Fan capacity is expressed in cubic feet per minute (cfm) and fans usually come in two sizes: 50 cfm and 100 cfm.

To figure out which size fan you need, measure the length, width, and height of your darkroom and multiply the 3 numbers. This will give you the number of cubic feet in your darkroom. Divide this number by 6 for your fan size. For example, if your room measures 6 feet × 7 feet and has an 8-foot ceiling, your calculations would be:

$6 \times 7 \times 8 = 336$ (cubic feet in the room)
$336 \div 6 = 56$ (cubic feet per minute)

Your fan must have a capacity of about 56 cfm to ventilate your darkroom, so buy a 50 cfm fan. For a very large room, you may need two fans.

Venting your exhaust fan

An exhaust fan moves air out of your darkroom, so when you install one you will have to figure out *where* you want to expel that air. Venting through a wall into another room in your house isn't a good idea—the rest of your house will then smell like your chemicals.

Here are three feasible solutions in order of preference:

1 Use a length of flexible hose to carry the exhaust to an existing vent or window in your darkroom.

2 Vent into an attic, basement, or crawl space that is vented to the outside. (This may mean installing vent pipe inside a wall or ceiling.)

3 Install a new vent in an exterior wall of your house as close as possible to your darkroom. This is not an easy task and requires expert help.

Only the first option is described.

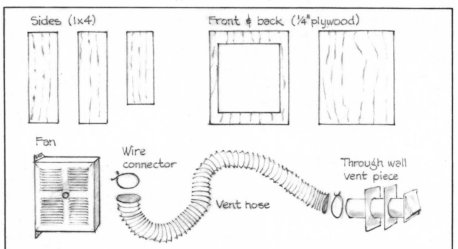

Sides (1x4) Front & back (¼"plywood)

Fan Wire connector Vent hose Through wall vent piece

Building a portable exhaust fan

Building a portable exhaust fan (cont.)

1 CUT ALL THE PIECES

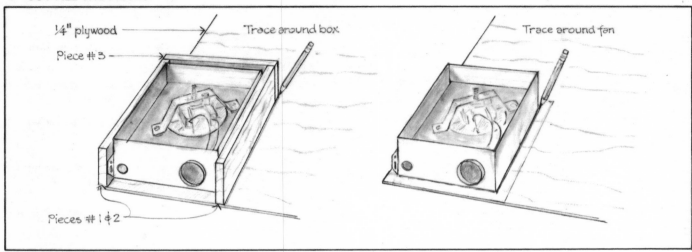

¼" plywood

Trace around box

Piece #3

Trace around fan

Pieces #1 & 2

1 Remove the louvered grill from the fan. Cut two pieces of 1 × 4 the same length as the two sides of your fan and a 1 × 4 to go at the end of the fan opposite the duct outlet. With all pieces on the corner of your plywood (left), trace the outline of the wood box for the size of the front panel. Remove the wood pieces (right) and trace the fan housing for the size of the cutout in the front panel. Cut the front panel and a back panel the same size. Cut the center out of the front panel.

2 ASSEMBLE BOX

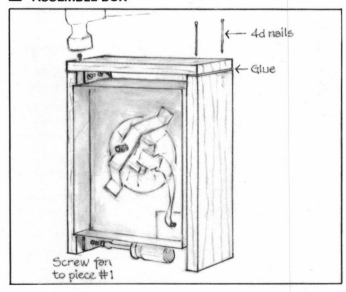

4d nails

Glue

Screw fan to piece #1

3 ATTACH FRONT AND BACK

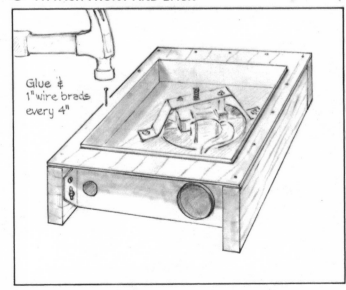

Glue & 1" wire brads every 4"

2 Screw the flanged side of the fan to piece #1. Then stand the fan on end with the duct pointing down and prop up the unsupported side. Glue and nail the two corners together as shown. Handle carefully—the corners are fragile until the plywood is attached.

Construction note: If there are screws or spindles sticking out of the fan housing right where you need to put a piece of wood, just drill a large shallow hole (recess) into the wood to leave room for them.

3 With the box face up, attach the front (cutout piece) with glue and 1-inch wire brads. Then replace the louvered grill. Turn the box over and glue and nail the back.

4 WIRE THE FAN

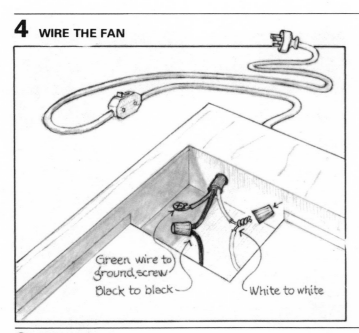

Green wire to ground screw

Black to black

White to white

5 ATTACH VENT HOSE

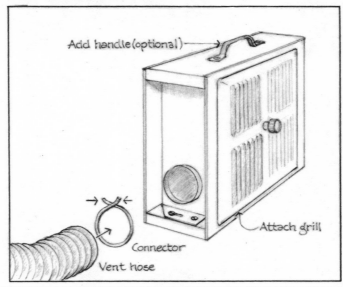

Add handle (optional)

Attach grill

Connector

Vent hose

4 Attach one end of your 3-conductor wire to the fan (see pp. 42–43 for wiring and grounding information). Decide how long you want the cord to be. Install a switch on the cord close to the fan and a 3-pronged plug at the end of the cord.

5 Put the round wire connector on the hose first and then put the hose onto the duct outlet as shown.

Optional Attach a handle to the top of the box.

6 VENT THE FAN

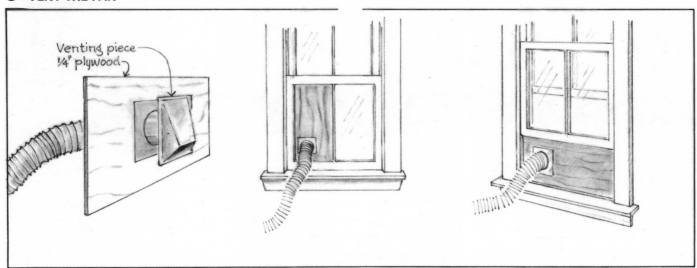

Venting piece ¼" plywood

6 Attach the exhaust hose to an existing vent if you have one. Otherwise vent it through a window. The best way to do this depends on the kind of window you have. Here is an idea that can be adapted for different situations:

Cut a piece of ¼-inch plywood the right size to fill in the space when the window is partly open. Fit a through-wall venting piece through a hole in the plywood. Use latex caulk and two metal plates to hold the venting piece in place and to lightproof it. Put the plywood in place with the vent hood to the outside and nail it to the window frame. Lightproof with latex caulk or weather strip. Attach the vent hose with a round wire connector. Or, you can replace one window pane with ⅛-inch plywood.

A work table

A sturdy work table or counter is essential for several aspects of darkroom work. You will use a table for your enlarger and dry side counter space, for dry mounting and matting, and for working at the light table. You may need to build more than one, each a different size for specific jobs. The design in this chapter can be adapted to meet different requirements.

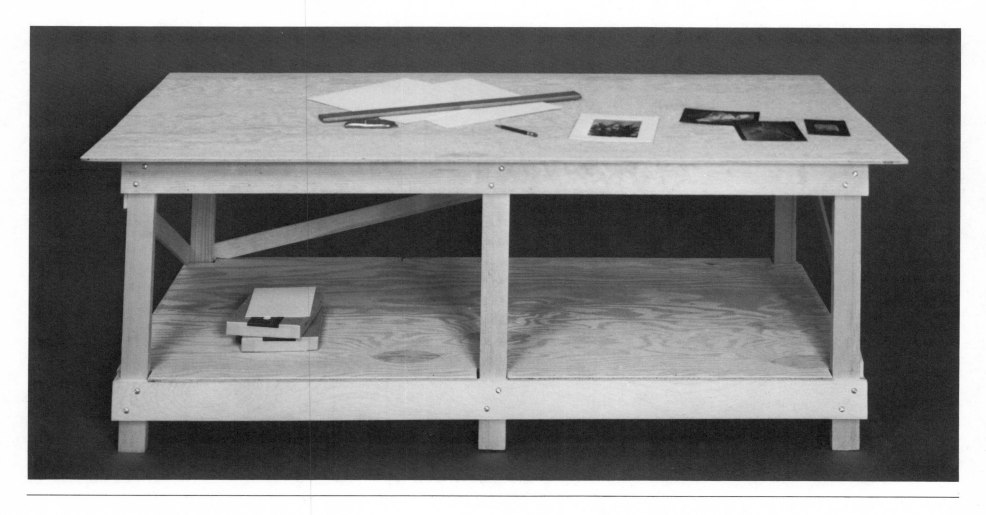

Size

The table shown above measures 4 × 8 feet and uses a full sheet of plywood for the top. This is a very large table—you can't reach across it easily. It is designed to be placed in the center of a room or with one end against the wall so that you can work at both sides.

If you will have access to only one side of the table, make it only 3 feet wide. Of course, the space available in your darkroom will dictate the final width and length of your work table.

No matter what size table you want, you can use the designs in this chapter. Simply change the measurements. If your table is 3 feet or less, you can use ½-inch plywood for the top.

Standard counter height is 36 inches, and that is the height of this table. Find the work height that is comfortable for you and adjust the dimensions. The table may also be built at desk height which is 29 inches.

Storage

The shelf below the tabletop provides a large open storage area. Build in additional storage if you need it.

Disassembly

The tabletop can be removed and the base disassembled for moving. If you ever disassemble the base, be sure to label both pieces of each joint with an identifying mark so that you will be able to reassemble it easily.

If you don't build the table in the room where you plan to use it, check to be sure you will be able to get it through the door.

Bracing

The wide top and bottom rails give the joints a lot of stability—you may not need to add braces. But if your table is not as sturdy as you want it to be, diagonal braces between the legs will make the structure rigid.

A table against a wall can be bolted to the wall rather than braced. Do this before you drill the tabletop.

Use ¼ × 4-inch lag bolts, three or four through the top back rail and the same number through the bottom rail. Be sure to bolt into the wall studs (see "Locating wall studs," p. 71, and "Drilling for lag bolts," p. 33).

Finishing the table top

There are several ways to finish the surface of your worktable. Here are some ideas:

- Paint it with two or three coats of alkyd paint, which forms a tough washable surface.

- If you've used a hardwood veneer plywood, coat it with clear polyurethane and glue strips of hardwood veneer on the edges.

- A very tough durable work surface is plastic counter laminate (such as Formica). You can buy it in sheets at a home supply store and glue it on yourself.

- In areas where you will be cutting with a mat knife, protect the surface of the table with ¼-inch chipboard (a dense cardboard available at art supply stores).

- A framing or drymounting table might be covered with carpet. This soft work surface won't scratch frames or other materials.

- For messy projects such as gluing and painting, mount a wide roll of brown paper at one end of the table. All you have to do to clean this area of the table is put down clean paper.

Alternative solutions

Chances are you will need to supply more than one table or cabinet for your darkroom. Although it's not especially difficult or time-consuming to build your own, you may find that using ready-made items is more practical than building a table from scratch for every work counter you need. There are also "quick and easy" solutions. Measure the space available and figure out what kind of space you need under the counter. Do you want drawers? Cubby holes? Cabinets with doors? Large open storage? Deep shelves for large paper or matboard? Space to store your print drying rack? Do you want a free-standing unit or a built-in one? Here are some alternative ways to build your work table.

Using ready-made items Look at ready-made kitchen cabinets at a home supply store. They come finished or unfinished with different combinations of drawers, shelves, and cabinet space. Counters are about 22 inches deep, often just what you need for a dry side counter or enlarging table. Put two cabinets back to back with plywood on top for a large work table. When the plywood is screwed to the cabinets, the table will be extremely sturdy.

Other possible supports for a plywood tabletop are old desks, sturdy chests of drawers, file cabinets, and ready-made shelving units.

A "quick and easy" table can be made from sawhorse brackets, 2 × 4's and plywood. It's fine for a desk or general work table, but it's too shaky to be used for an enlarger. Build two sawhorses as shown on p. 26. Set up your plywood on the sawhorses and nail it in place.

Building a work table

Decide what height and size you want your table to be and adjust the measurements in step 1 before cutting anything. When you assemble the base pieces, be sure all the joints are square and tight—this is what makes the table sturdy.

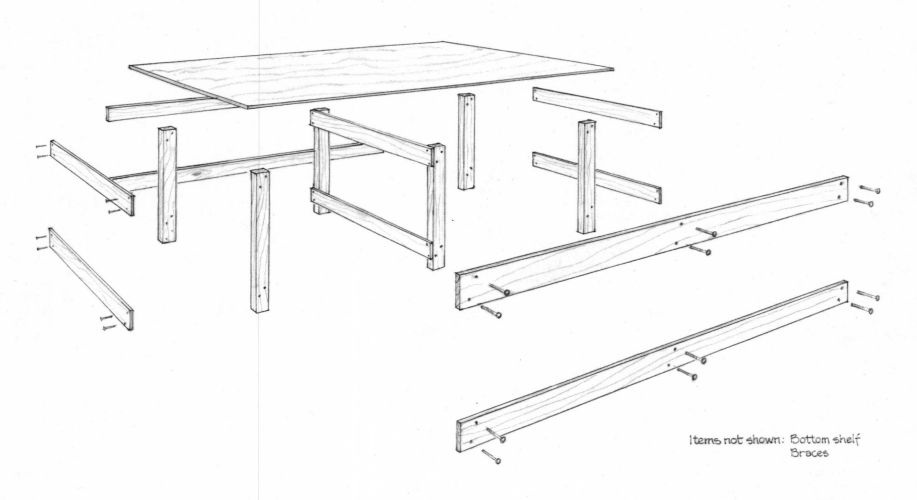

Items not shown: Bottom shelf
Braces

TIME: Less than 4 hours
COST: Medium
DIFFICULTY: Easy

This is not a difficult project. All materials are readily available and the assembly is straightforward. Take extra care as you assemble the base to be sure all joints are square. This will keep the table from wobbling.

Tools

- Tape measure
- Pencil
- Combination square
- Framing square
- Saber saw (You may also want a circular saw since it will be faster for cutting the plywood.)
- C-clamps (2)
- Drill and bits
- Phillips-head screwdriver or drill attachment
- Hammer

Materials

¾-inch AC plywood (A 4 × 8-foot sheet)

2 × 4 lumber (three 6-foot lengths—if your tabletop is to be higher than 36 inches, buy 8-foot lengths instead.)

1 × 6 lumber (seven 8-foot lengths)

½-inch AC plywood (A 4 × 8-foot sheet. Omit this if you don't want a bottom shelf.)

Glue

¼ × 2½-inch carriage bolts (24 with washers and nuts)

1 × 2 lumber (Two 6-foot lengths and one 8-foot length for optional braces)

1 CUT THE PIECES

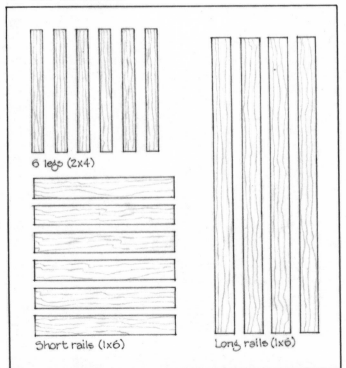

6 legs (2x4)

Short rails (1x6)

Long rails (1x6)

2 ASSEMBLE END AND MIDDLE SECTIONS

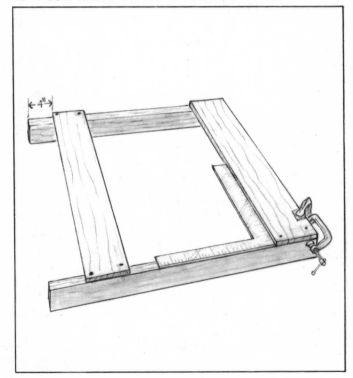

←4″→

A Cut the plywood top to the size you want it. (Measurements below are for a 4 × 8-foot top.)
B Cut six legs from 2 × 4 lumber, ¾ inch shorter than your table height.
C Cut four long rails 88 inches long (or 8 inches shorter than the long dimension of your table). Mark the center of each rail.
D Cut six cross rails 40 inches long (or 8 inches shorter than the short dimension of your table).
E Wait to cut the bottom shelf until the table is assembled.

2 Place two of the legs on edge with two of the short rails across them as shown. Clamp one joint together and square it up with a framing square. Drill for two drywall screws (see "Drilling for screws," p. 32). Stagger these holes so the screws won't split the wood. Put glue in the joint and screw it together. Repeat for the other three joints. Assemble the other end section and the middle section the same way.

Building a work table (cont.)

3 ATTACH FRONT AND BACK RAILS

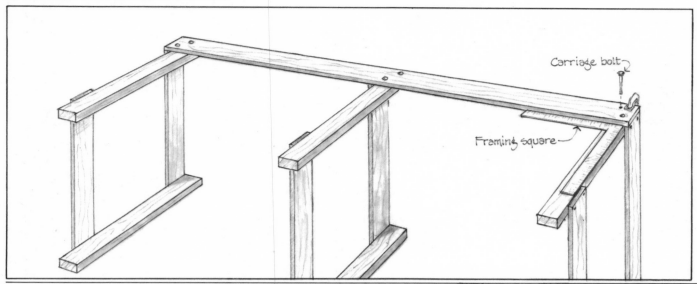

Carriage bolt

Framing square

3 Place the end sections on edge with the back sides down as shown. Clamp one end of one rail in place. Make sure the end of the rail is flush with the face of the cross rail. Check the corner for square. Drill for two carriage bolts using a $\frac{1}{2}$-inch bit (see "Drilling for carriage bolts," p. 33). Stagger the holes and locate them so the bolts won't hit the screws. Insert the bolts and tap them with a hammer to set them. Attach washers and nuts. Repeat for the other three front corners and attach the middle section in the center of the front rails the same way. Turn the base over and attach the back rails.

4 DRILL TOP

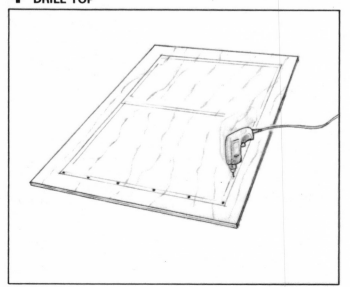

5 ATTACH TOP

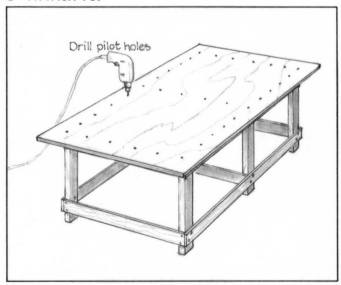

Drill pilot holes

4 Place the plywood tabletop on the floor and put the leg structure top side down on it, equally distant from all the edges. Mark the positions of all the top rails on the plywood. Remove the leg structure. Drill *shank* holes for the drywall screws about every 8 inches as shown.

5 Put the tabletop in place on the base and make sure the pencil marks line up with the top rail. Use the shank holes as guides to drill the pilot holes into the top rail. Then put the screws in place.

6 CUT BOTTOM SHELF

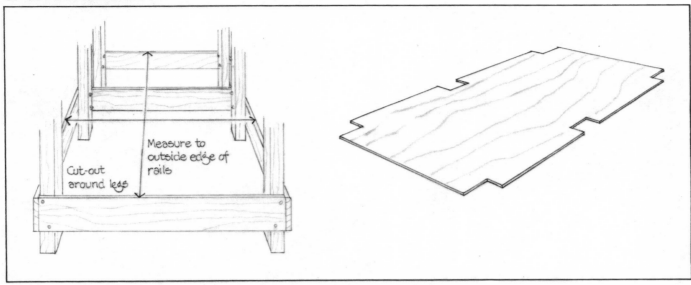

Measure to
outside edge of
rails

Cut-out
around legs

6 Cut the bottom shelf large enough to extend to the outside of the bottom rails. Cut out the corners so that the shelf will fit around the legs. Make cutouts for the center legs also. Make all cutouts about $\frac{1}{8}$ inch larger than needed for an easy fit.

7 ATTACH BOTTOM SHELF

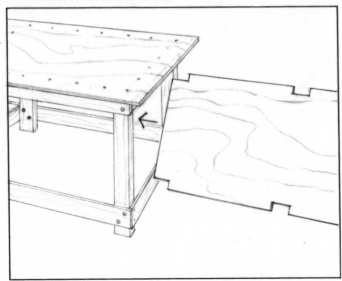

8 ADD BRACES (optional)

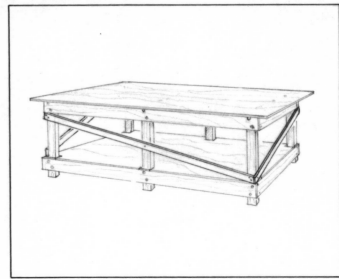

7 To put the shelf in place, turn it diagonally and slip it in from the end. Drill and screw it to the bottom rails about every 12 inches.

8 Cut lengths of 1 × 2 to fit diagonally between the legs as shown. Fasten them in place with two drywall screws at each end. You may want to leave the braces off the front so that you can reach the bottom shelf more easily.

Building a work table (cont.)

An enlarger wall mount

An enlarger wall mount provides a solid support for attaching your enlarger to the wall. The standard design shown here can be modified to fit your darkroom. Many manufacturers make wall mounts for their enlargers at reasonable prices, so check and see what's available for your enlarger before building a mount yourself.

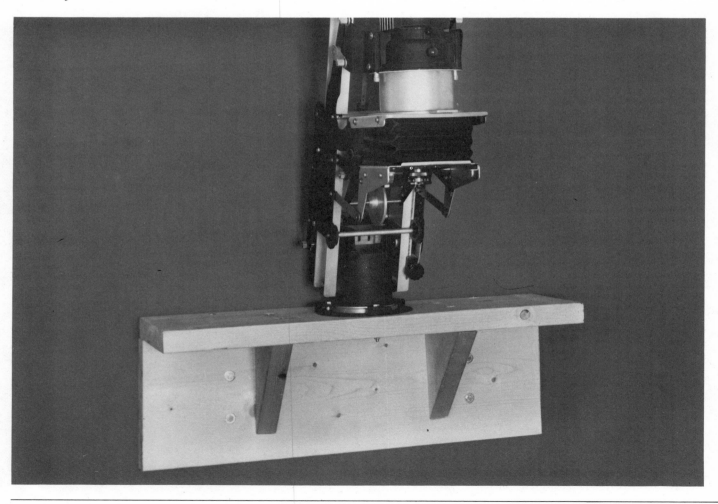

The wall mount

Most enlarger columns lean out from the wall, putting a heavy off-balance load on the mounting bracket. Because an enlarger must be held absolutely still for good printing results, the main considerations in designing a wall mount are strength and stability.

The shelf itself must be sturdy—it must not bend or vibrate and the wall attachments must be firm. We've made the shelf out of 2 × 10 lumber and braced it to keep it from sagging or tilting forward. The shelf is assembled and attached to the structural part of the wall with long lag bolts.

Guy wires

An enlarger wall mount is not necessarily any more sturdy than a built-in cabinet or a solidly built desk, so you may find that vibrations in your enlarger column are making your prints fuzzy. You can avoid this problem by stabilizing the top of the enlarger column with guy wires to the wall. This technique, described on p. 75, also works to stabilize a table-mounted enlarger.

Size

The wall mount is 30 inches long. This is an arbitrary length chosen because you can build it out of one 8-foot length of lumber and because, in most of the locations you might choose for an enlarger, you would be able to tie into the structural part of the wall twice in the 30-inch span of the shelf. Measure the space available in your darkroom. You can make the wall mount shorter if you need to.

Next, check to be sure your shelf will be long enough to tie into your wall structure at two points (see "Locating the wall studs" on the following page).

Choosing a suitable wall

The walls in your darkroom are most likely to be hollow stud walls. A stud wall is built of vertical pieces of 2 × 4 lumber (called *studs*) at intervals inside the wall; it is covered with wallboard, plaster, or paneling. The instructions in this chapter assume that you are attaching your wall mount to a stud wall. The first step, locating the studs, is described on the next page.

If your wall is brick or concrete, consider changing your darkroom plan so that you can mount the enlarger on a stud wall. It is possible to mount onto a brick or concrete wall using lag bolts and expansion shields. However, you will need special tools for drilling into the wall, and the skills involved are beyond the scope of this book.

Shelf height

You can mount your enlarger shelf right above your counter or higher on the wall for making larger prints, but remember that as you raise the shaft of the enlarger above the counter you're also increasing the size of the smallest prints you can make. The table on page 77 tells you the lens-to-easel distance required for different-size prints. Before you mount your shelf to the wall, check to be sure that your enlarger head can go high and/or low enough to make prints the sizes you want. Also check to see if you will be able to reach the enlarger controls when the head is raised for large prints.

If necessary, you can build an adjustable enlarger baseboard to increase the range of print sizes (see Chapter 6) and you can raise your printing easel by putting a dictionary under it when you want to make very small prints.

Getting ready

A wall mount requires only a few pieces, the skills involved in building it are basic, and the materials are readily available. The only difficulty you may find is that you will be working with large pieces of lumber and large bolts, and it takes some muscle to put them together.

The wall mount has only four pieces, all cut from 2 × 10 lumber. The triangular braces are laid out with the grain running along the lines of stress for greatest strength.

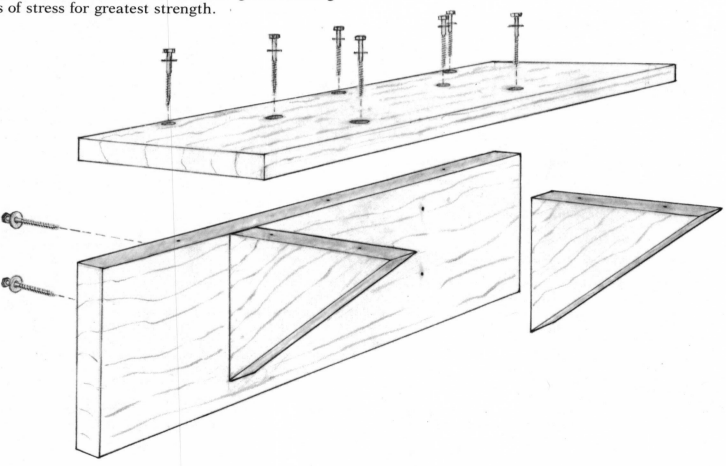

TIME: Less than 4 hours
COST: Low
DIFFICULTY: Moderate

Materials and supplies

2 × 10 lumber (one 8-foot length. Be sure to get kiln-dried lumber so it won't warp.)

$3\frac{1}{4}$ × $\frac{1}{4}$-inch lag bolts with $\frac{1}{2}$-inch washers (11)

$4\frac{1}{2}$ × $\frac{1}{4}$-inch lag bolts with $\frac{1}{2}$-inch washers (4)

Braided picture-hanging wire (at least 4 feet)

Small turnbuckles 2 or 3 inches long (2)

Large screw eyes with a shank about 3 inches long (2)

Bolts, nuts, and washers to mount your enlarger. (The size and number required depends on your enlarger. See "Buying mounting bolts," right.)

Tools

- Tape measure
- Pencil
- Combination square
- Saber saw
- Drill and bits
- Wrench (preferably a socket wrench)
- Level (preferably a long level, but the one on your combination square will work)
- Pliers

TIPS: Buying mounting bolts

This project involves removing your enlarger from its baseboard and remounting it on the wall mount. Before you start building the wall mount, check to see how your enlarger is mounted to the baseboard. You will be mounting it to the wall mount the same way.

Remove your enlarger from the baseboard. (Remove the enlarger head first to reduce the weight or ask a friend to hold the enlarger column while you remove the bolts.) In doing this, you will remove three or four bolts that held it in place.

Since the wall mounting shelf is $1\frac{1}{2}$ inches thick and your baseboard is probably $\frac{3}{4}$ inch thick, you will need longer bolts for mounting it to the shelf. Take one bolt to the hardware store and ask for bolts that are the same diameter and at least 1 inch longer, since the bolt must go all the way through the shelf and extend far enough below for you to attach a washer and nut. You will need the same number of bolts that were used to hold your enlarger to the baseboard.

Remember to buy a nut and washer for each bolt.

Locating the wall studs

Studs are nearly always 16 inches apart. (However, in an exterior or load-bearing wall they may be 12 inches apart and, in an old house, they could be 20 inches or 24 inches apart.)

Here are two ways to locate the studs: First look for telltale indentions or nail heads that will show you where the wall covering is nailed to a stud. If these aren't evident, then tap on the wall in several places. It will sound hollow between the studs and solid when you're right over one.

When you think you've found one, drive a long nail into the wall. You will be able to tell whether you've hit a stud by the amount of resistance to the nail and by how easily you're able to pull it out of the wall.

Once you find a stud, drive the nail in a little to the left and to the right to locate roughly the edges of the stud. Mark the approximate center of the stud on the wall. The next stud will probably be 16 inches away. Find two studs to support your wall mount.

Ideally, the spot you've chosen for your enlarger will turn out to be halfway between two studs and the wall mount will be centered between the studs as in the drawing opposite.

More likely is the situation in the bottom drawing, where the enlarger location is closer to one stud than the other. In this case, just make sure that the wall mount will span the distance between the two studs. You can mount the enlarger off center on the wall mount as long as it is between the two supporting studs.

Getting ready

Building the wall mount

1 CUT THE PIECES

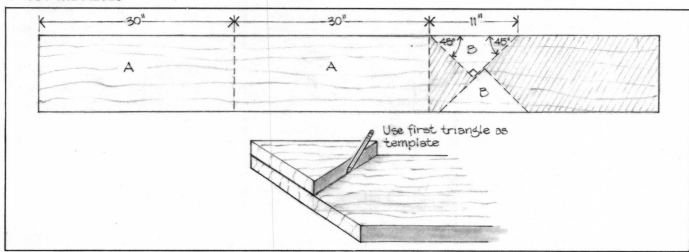

Use first triangle as template

1 Cut two 30-inch lengths (A). On the leftover piece, measure in ½ inch from the end and mark the first corner of the triangle. From that point, measure 11 inches and mark the second corner. Use your combination square to draw the 45° lines. When these lines intersect, they should be exactly the same length (about 7½ inches). Cut the first triangle (B) and use it as a template to draw the second one.

2 MARK BOLT LOCATIONS

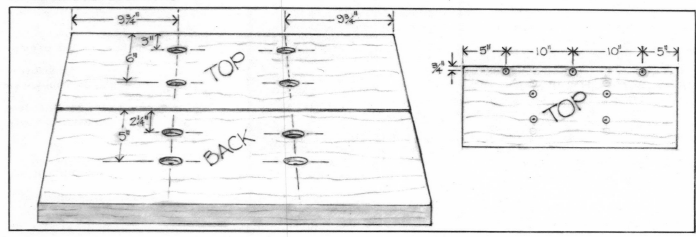

2 Mark the location of eight bolts on the top and back according to the drawing. (These bolts will fasten the top and back to the braces.) Mark three more bolts on the top only, as shown in the drawing. (These bolts will fasten the top to the back.)

3 DRILL FOR BOLTS

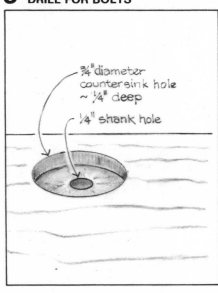

¾" diameter
countersink hole
~ ¼" deep

¼" shank hole

4 MARK AND DRILL BACK

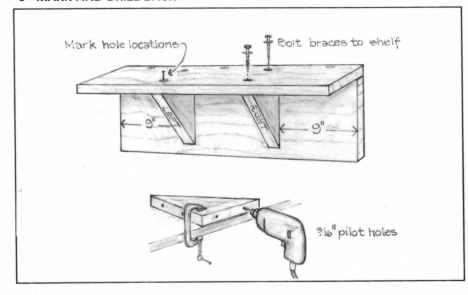

Mark hole locations

Bolt braces to shelf

9"

9"

³⁄₁₆" pilot holes

3 Drill countersink holes for all eleven bolts using a ¾-inch drill bit and drilling ¼ inch into the wood. Then drill shank holes all the way through the wood using a ¼ inch bit.

4 Hold the top in place on the back, making sure the countersunk ends of the holes face outward on both boards. Transfer the location of the three back holes to the top edge of the back as shown. Remove the top and drill the holes in the top edge of the back with a ³⁄₁₆-inch bit.

5 BOLT TOP AND BACK TOGETHER

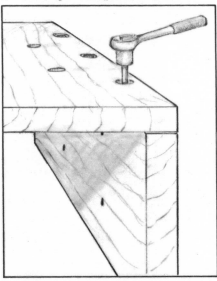

6 BOLT BRACES IN PLACE

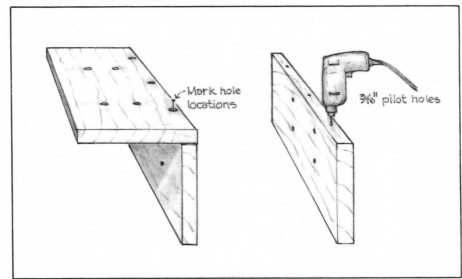

Mark hole
locations

³⁄₁₆" pilot holes

5 Bolt the top and back together with $3\frac{1}{4} \times \frac{1}{4}$-inch lag bolts. A socket wrench works best for seating the bolts in the countersunk holes, but you can use a crescent or open-end wrench.

6 Hold each brace in place 9 inches from the end of the shelf as shown and mark them by sticking a pencil through the holes in the top and back. Label them *left* and *right*. Drill the holes, four into each brace, using a ³⁄₁₆-inch bit. It's easiest to get the hole straight if you clamp the brace to the table as shown and hold the drill level. Bolt the braces to the shelf assembly with $3\frac{1}{4} \times \frac{1}{4}$-inch lag bolts.

Building the wall mount

Attaching the wall mount to the wall

When you attach the wall mount to the wall and remount your enlarger, there are two overriding concerns: making sure the enlarger is *stable* and making sure it is *level*.

Remounting your enlarger

Enlargers come with different kinds of columns and different mounts, but most are fastened to the baseboard with three to six bolts. Mount your enlarger to the shelf the same way it is mounted to the baseboard, using longer bolts since the shelf is thicker than the baseboard.

Some enlargers have a metal mounting plate that stays attached to the baseboard after the enlarger is removed. It is often attached with a screw in the center. You must remove it and attach it to your mounting shelf before you can remount the enlarger.

When you're ready to mount the enlarger, hold it in place first (with the help of a friend) and check to be sure you've left enough room behind it for all cranks and knobs to be turned freely when the enlarger head is at its lowest point.

Levelling

The enlarger and the printing counter must be parallel. Otherwise you will not be able to focus all parts of the print simultaneously. The easiest way to be sure they are parallel is to make sure both are level side-to-side and front-to-back.

When you first position the mounting shelf on the wall, check it for level. Keep checking it while you're fastening the shelf in place. This will give you a shelf that is level side-to-side. After you mount the enlarger, check the lens board with a small level. You may need to put a strip of thin cardboard under one side of the mounting plate to make the lens board level.

Guy wires

Two guy wires, running from the top of your enlarger column to the wall, will help prevent vibrations that make your prints fuzzy. Put a turnbuckle in the center of each wire so that you can tighten it to exactly the right point. Use long screw eyes to attach the wires to your wall.

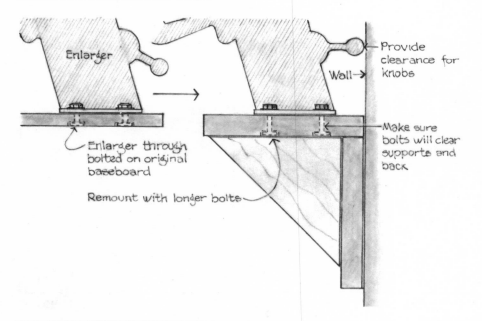

Enlarger

Provide clearance for knobs

Wall

Make sure bolts will clear supports and back

Enlarger through bolted on original baseboard

Remount with longer bolts

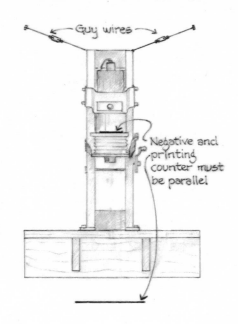

Guy wires

Negative and printing counter must be parallel

1 POSITION SHELF

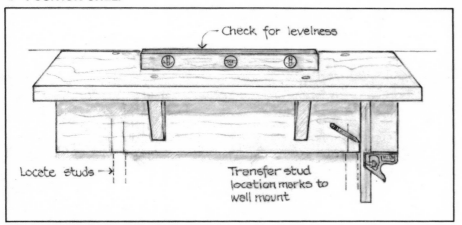

Check for levelness

Locate studs →

Transfer stud location marks to wall mount

1 Mark a *level* line on the wall where you want the shelf to be. Hold the shelf in place. Mark the ends of the shelf on the wall and transfer the markings of your wall studs to the shelf as shown.

2 DRILL FOR BOLTS

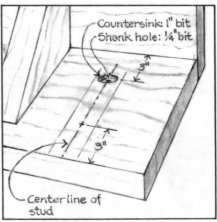

Countersink: 1" bit
Shank hole: ¼" bit

3"

3"

Center line of stud

Mark wall for drilling through holes

2 Put the shelf on your work table. Mark the locations of the four lag bolts on the center lines of the studs as shown. Then drill the countersink and shank holes for the bolts.

Hold the shelf in position again and carefully mark the wall for drilling. Put the shelf aside and drill into the wall studs with a $\frac{3}{16}$-inch bit.

3 MOUNT SHELF

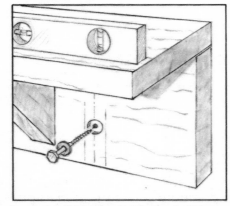

3 Ask a friend to hold the shelf in position. Put in the top bolts first. Before tightening the bolts, check the shelf for level. Tap it lightly with a hammer to adjust it. Put in the remaining bolts.

4 MOUNT ENLARGER

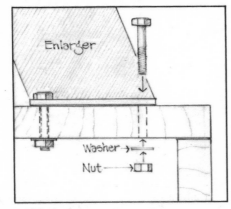

Enlarger

Washer →
Nut →

4 Mark the locations of the mounting bolts on the shelf. Drill all the way through the shelf with a bit slightly larger than the bolts and bolt the enlarger in place (see "Remounting your enlarger," above).

5 ATTACH GUY WIRES

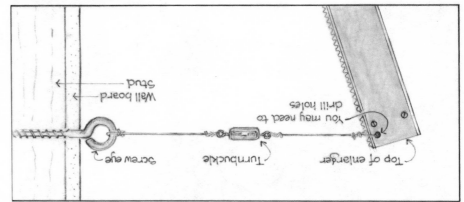

Wall board
Wall stud

Screw eye

Turnbuckle

You may need to drill holes

Top of enlarger

5 Fasten wire to both ends of the turnbuckles as shown. Attach one end of each turnbuckle assembly securely to the enlarger (drill two small holes in the top of your enlarger column if necessary), and fasten the other end to the wall using a long screw eye. Tighten the turnbuckles just far enough to steady the enlarger. Level the enlarger lens board (see "Levelling," above).

Attaching the wall mount to the wall

An adjustable enlarger baseboard

An adjustable enlarger baseboard is simply a cabinet with moveable shelves. The enlarger is mounted on the back of the cabinet (or it can be mounted on the wall above the cabinet—see Chapter 6). The shelf holding the printing easel can be placed at any height in the cabinet according to the size print you want.

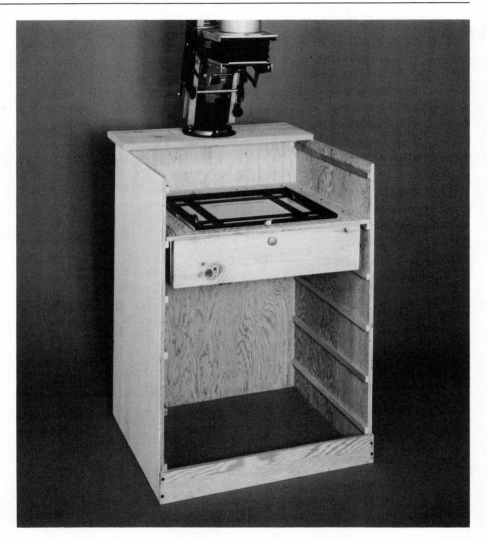

How an adjustable baseboard works

The distance from the negative to the printing easel determines how large a print you can make with a given negative size and lens. Raising the enlarger head will give you larger prints, but you are limited by the height of your enlarger shaft.

Because it has a moveable printing shelf, the adjustable baseboard gives you two options that you wouldn't otherwise have:

1 It enables you to make larger prints than you could otherwise make with your enlarger, simply by placing the shelf low in the cabinet.

2 It enables you to print with the enlarger head low on the shaft, thereby reducing enlarger vibration for sharper pictures.

Should you buy one or build it yourself?

Building a homemade adjustable baseboard is much less expensive than buying an adjustable enlarging table, but the homemade one is not as flexible or as easy to adjust as the manufactured variety. Likewise, building the lightproof compartment will save quite a bit over buying a small tabletop paper safe, but the paper safes can hold several different grades of paper, while your homemade compartment has room for only one or two kinds (depending on the size of the paper).

Size

The size baseboard you need depends on the maximum size print you intend to make. The shelf size must be large enough to accommodate the easel for that size print with a little bit of space around the edge for working.

The one detailed in this chapter has shelves 20 × 24 inches, large enough for making 16 × 20 prints. The overall size is 20½ inches deep, 25 inches wide, and 35 inches high. (The standard 35-inch counter height may be changed to be comfortable for you or to match other counter heights in your darkroom.) The plywood pieces for this size adjustable baseboard can all be cut from one sheet of ½-inch plywood.

For prints larger than 16 × 20, make your shelf size at least 4 inches larger in each direction than the print size. (You may also have to move your enlarger farther out from the wall for large prints.) These larger cabinets should be built from ¾-inch plywood to ensure stability.

Lightproof compartment

An optional feature of the adjustable baseboard is the lightproof compartment for storing paper while you're printing. The one detailed here has inside measurements of 16½ × 20½ inches so that it can hold paper up to 16 × 20. It is attached to the bottom of the printing shelf so it's always handy, no matter which level you use for printing.

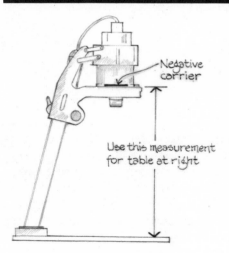

Negative carrier

Use this measurement for table at right

Do you need an adjustable baseboard?

This table tells you the distance needed between the negative and the printing easel for several standard print sizes. Find the distances required for the largest and smallest prints you intend to make with the lens and film format you're using. Then, by measuring the distance from the negative carrier to the easel with the enlarger head at its highest and lowest points, you will be able to tell whether you need the adjustable baseboard for larger prints.

Print size desired	If your film format enlarging lens combination is:			
	35mm film 50mm enlarging lens	2¼ × 2¼ film 75mm lens	2¼ × 3¼ film 100mm lens	4 × 5 film 150mm lens
8 × 10	18 inches	15 inches	17 inches	18 inches
11 × 14	26 inches	20 inches	22 inches	23 inches
16 × 20	34 inches	27 inches	30 inches	30 inches
20 × 24	37 inches	33 inches	36 inches	36 inches

An adjustable enlarger baseboard

Getting ready

The adjustable baseboard is built in two parts—the baseboard cabinet with the adjustable shelves and the (optional) lightproof compartment for paper storage. Cutting and assembling this project are not difficult. However, measuring the cleat locations and attaching the cleats is exacting because the shelves must be level to get good sharp prints. This part of the project may take extra time.

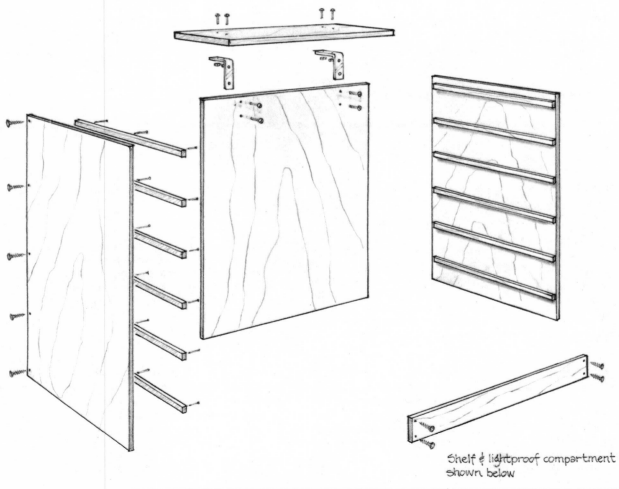

Shelf & lightproof compartment shown below

TIME: 4 to 8 hours
COST: Medium
DIFFICULTY: Moderate

Tools

- Tape measure
- Pencil
- Framing square
- A long straightedge (see p. 37)
- 4 C-clamps or 2 C-clamps and a corner clamp
- Sawhorses or other supports for cutting (see p. 38)
- Saber saw (A circular saw will also be useful since it will cut the ½-inch plywood more easily and more quickly.)
- Drill and drill bits
- Hammer
- Phillips-head screwdriver or Phillips-head attachment for the drill
- Wrench
- Small putty knife

Materials and supplies

THE BASEBOARD CABINET

½-inch AD plywood A 4 × 8-foot sheet

Parting stop (⅜ × ¾ inch or ½ × ¾ inch) Four 6-foot lengths

1 × 10 lumber A piece at least 25 inches long (The other project in this book that requires 1 × 10 is the small light box. An 8-foot length is enough for both projects.)

2½-inch steel angles (2)

1-inch stove bolts Buy 8 bolts the right size to fit through the holes in the angles. Buy 1 nut and 2 washers for each bolt.

1⅝-inch drywall screws

¾-inch wire brads

Glue

THE LIGHTPROOF COMPARTMENT

1 × 6 lumber One 8-foot length

Parting stop One 2-foot length

Spring-loaded hinges Two small ones for the door to the compartment

Drawer knob

A piece of felt 6 inches × 21½ inches

Latex caulk

1⅝-inch drywall screws

Glue

¾-inch wire brads

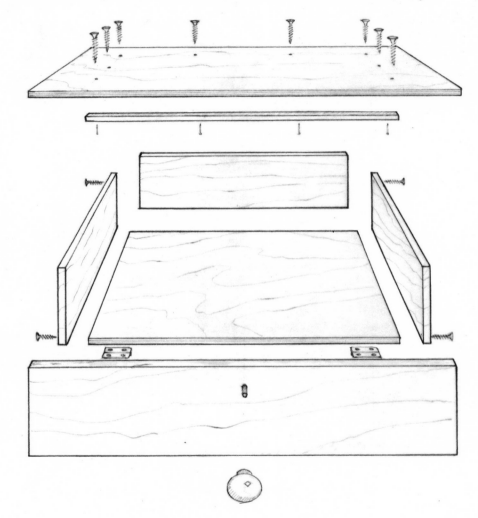

LIGHTPROOF COMPARTMENT (OPTIONAL)

Cutting the plywood

The major pieces of the enlarger baseboard can be cut from one sheet of plywood. If you are unfamiliar with cutting plywood, read "Cutting plywood" (pp. 38–39) and "Using a power saw" (p. 35) before you start. If your baseboard is to be a different size from the one shown here, be sure to change the measurements in the cut diagram (right) before you begin cutting.

Here's how to cut all the pieces of your baseboard out of one sheet of plywood. Make the cuts in the order they're numbered to avoid awkward cutting situations. Keep the leftover piece for building your lightproof compartment.

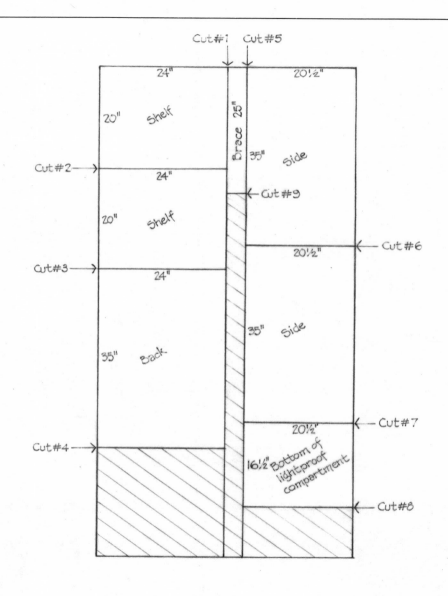

TIPS: Cutting plywood

Turn the plywood good side down for cutting. Measure for only one cut at a time. (If you measure for several at once, the width of your saw cut will throw your measurements off.) Make sure the piece you are cutting off is supported (or ask someone to hold it for you). Each time you make a cut, follow these steps, which are explained in detail on p. 39:

1 Check for a square corner and straight edge to measure from.

2 Measure for the cut (and double-check).

3 Use your template to position the fence (be sure the width of the cut falls on the leftover piece, *not* on the piece you just measured).

4 Clamp the fence in place and use it as a cutting guide.

1 CUT #1

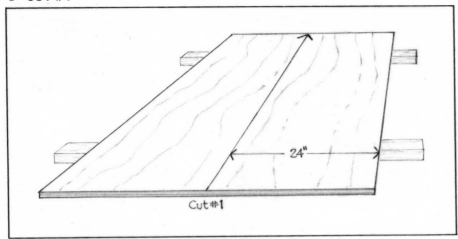

24"

Cut #1

1 Measure 24 inches from a long edge of the plywood for the first cut. You will then have two pieces that are almost exactly the same size. Put aside the piece that measures slightly less than 24 inches. Keep the one that is exactly 24 inches on your supports for the next cuts.

2 CUTS #2, #3, and #4

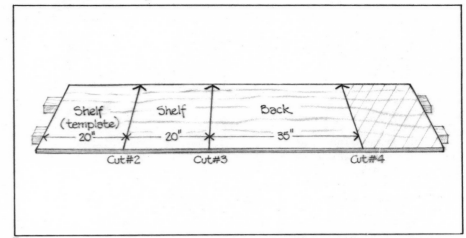

Shelf (template) 20" Shelf 20" Back 35"

Cut#2 Cut#3 Cut#4

2 Measure in 20 inches from one end of your plywood for cut #2. Label this piece *shelf* (template). Since the other shelf is exactly the same size as the first one, use this piece as a template to draw the cutting line for cut #3. Label this piece *shelf* also. Trim the remaining piece to 35 inches long. Label it *back*.

3 CUT #5

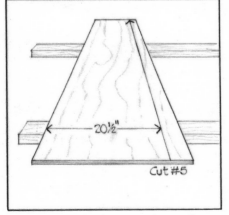

20½"

Cut #5

3 Put the other long piece of plywood on the supports. Trim the width to 20½ inches as shown.

4 CUTS #6, #7, and #8

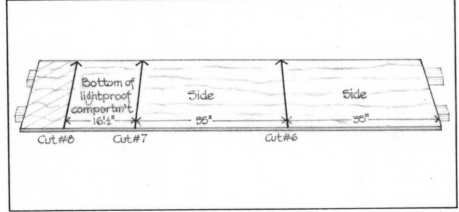

Bottom of lightproof compartm't 16½" Side 35" Side 35"

Cut #8 Cut #7 Cut #6

4 Use the back as a template to measure 35 inches from the end of the piece for cut #6, and again for cut #7. Label both of these pieces *side*. Measure 16½ inches for cut #8.

5 CUT #9

Cut #9

25"

Brace

5 From the long narrow strip of plywood, cut a piece 25 inches long. Label it *front brace*.

Building the baseboard cabinet

The adjustable baseboard must be sturdy to minimize vibration. However, since the top and sides must be open for printing, the cabinet can twist easily. To add rigidity to the structure there are two braces—the *front brace* that ties the two sides together across the bottom front, and the *enlarger mounting shelf* that braces the top. Both are attached to the cabinet with screws. In addition there are two metal angles under the back of the mounting shelf that anchor it against the forward pull of the enlarger. If you plan to mount your enlarger on the wall instead of the baseboard, replace the mounting shelf with a 1 × 2 or 1 × 3 brace.

Assembly

Decide which way you want the best side of your plywood to face. On most cabinets, you would want the best face outward, but in this case, since you will be working inside the cabinet, you may want the best side to face in.

To avoid confusion, label the side pieces *left* and *right* and label the top edge of the side and back pieces. This will help you when you are drilling pilot holes and attaching the cleats.

After the baseboard is assembled, try all the shelves to make sure they fit. If there are any warps in the plywood sides, the shelves will fit better in some positions than in others. Plane down the edges of tight-fitting shelves with a block plane or a surform tool.

1 CUT THE PIECES

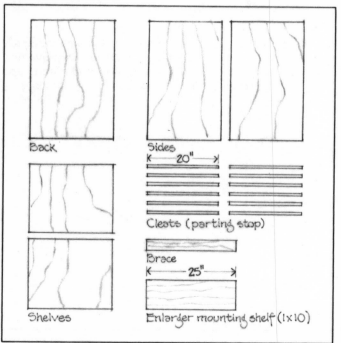

Back

Sides
|← 20" →|

Cleats (parting stop)

Brace
|← 25" →|

Enlarger mounting shelf (1×10)

Shelves

2 DRILL PILOT HOLES

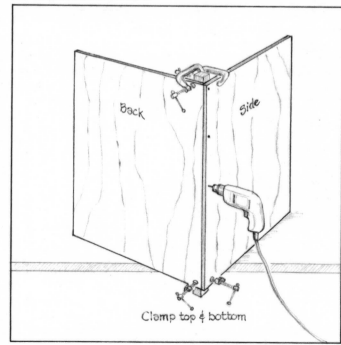

Back

Side

Clamp top & bottom

1 Shown here are all the pieces for the adjustable baseboard. To cut the cleats, first cut one 20-inch length of parting stop. Use it as a template to cut eleven more the same size, three from each stick. Cut a 25-inch length of 1 × 10 for the enlarger mounting shelf.

2 Clamp one side to the back as shown (make sure the side piece covers the edge of the back.) Drill pilot holes and then shank holes for the screws about 8 inches apart. Repeat for the other back corner. (Drilling for screws is explained in detail on p. 32.)

3 ATTACH CLEATS

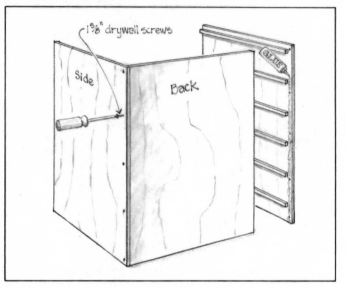

1⅝" drywall screws

Side

Back

GLUE

4 ASSEMBLE CORNERS

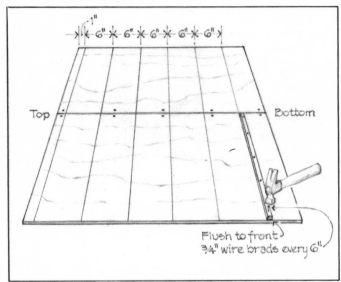

1"

6" 6" 6" 6" 6"

Top

Bottom

Flush to front
¾" wire brads every 6"

3 Lay out the two side pieces with drilled edges together and the *inside surface up*. Measuring from the top, mark the locations of the cleats as shown. (Take extra care to measure accurately since the shelves must be level to make sharp prints.) Glue and nail the cleats in place with the top edge of the cleat on a line and one end flush with the front edge of the board.

4 Glue and screw the two corners together using the drywall screws.

5 ATTACH FRONT BRACE

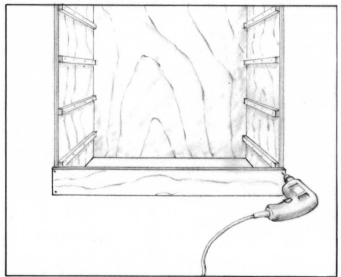

6 ATTACH MOUNTING SHELF

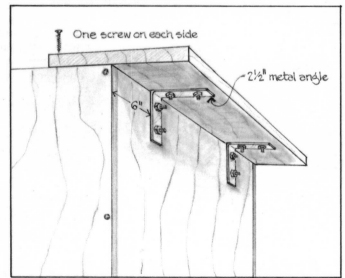

One screw on each side

6"

2½" metal angle

5 Hold the brace in place on the front of the cabinet as shown. Drill pilot holes and shank holes for two screws at each end. Glue and screw the brace onto the cabinet.

6 Put the 1 × 10 shelf on the cabinet with about half the width of the board extending past the back of the cabinet as shown. Bolt it to the back of the cabinet with stove bolts. (Drill as for carriage bolts, p. 33.) Screw the shelf to the sides of the cabinet (using two drywall screws) for extra stability. Then mount your enlarger to the shelf (see "Remounting your enlarger," p. 74).

Building a lightproof compartment

The lightproof compartment is attached to the bottom of one of the printing shelves. Because it is attached several inches from the edge of the shelf the drilling procedure (described below) is slightly different from the usual one.

1 Shown here are the pieces you will need to build the lightproof compartment. Cut the sides, back, and front from your 8-foot length of 1×6 and label each piece. Be sure the back is exactly the same length as the plywood bottom. Cut the small light baffle from parting stop.

1 CUT THE PIECES

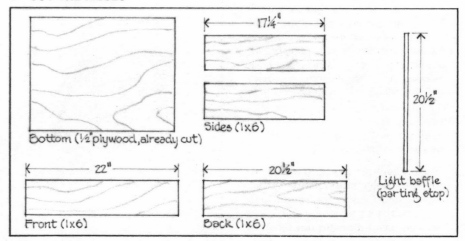

Bottom (½"plywood, already cut)

17¼"

Sides (1x6)

20½"

Light baffle (parting stop)

22"

Front (1x6)

20½"

Back (1x6)

2 ASSEMBLE BACK CORNERS

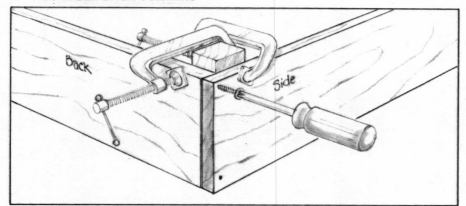

Back

Side

2 Drill pilot holes and shank holes for two screws at each back corner. (See "Drilling for screws," p. 32.) Glue and screw the two corners together.

3 ATTACH BOTTOM

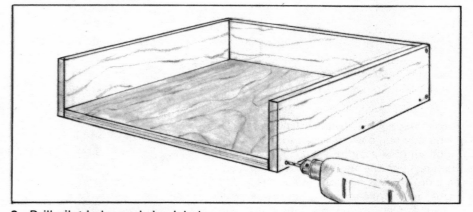

3 Drill pilot holes and shank holes about 6 inches apart as shown. Glue and screw the bottom in place.

4 DRILL THROUGH SHELF

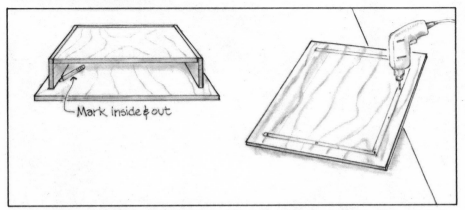

4 Place one shelf top side down on your work table and position the box top side down in the center of the shelf. Draw the outline of the box.

Then reach inside and draw around the inside of the box, too. Remove the box and drill *shank* holes through the shelf about 6 inches apart.

5 ATTACH BAFFLE

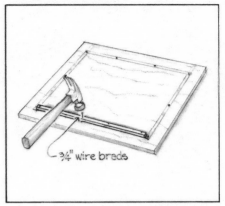

5 Glue and nail the baffle to the shelf between the front edges of the box outline. (Use wire brads.)

6 DRILL PILOT HOLES

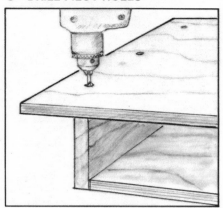

6 Turn the box right side up and put the shelf right side up on it. Line up the box with the outline on the bottom of the shelf. Drill pilot holes into the top edge of the box.

7 ATTACH BOX TO SHELF

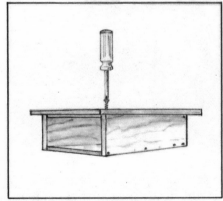

7 Remove the shelf and drill *pilot* holes into the box. Attach the box to the shelf with glue and drywall screws.

8 ATTACH DOOR TO BOX

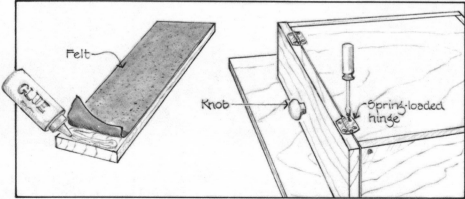

8 Glue a piece of felt on the inside of the door to help lightproof the box. Put a handle on the door. Then attach the door to the box with spring-loaded hinges as shown.

9 PUTTY JOINTS

9 Set the lightproof compartment aside for 24 hours to let the glue cure completely. Then fill all joints with latex caulk to lightproof them. Before you begin using the compartment, test it to be sure it is light-tight. To do this, leave one sheet of photographic paper in the compartment for a couple of days. Then develop it as you would an exposed print. If it shows dark streaks, then some light is getting into your drawer.

Building a lightproof compartment

Two kinds of light boxes

A light box may be used in a darkroom or studio for evaluating negatives and transparencies. This chapter contains detailed instructions for building a large light box and a small one. Choose the one that fits both your needs and the space you have available.

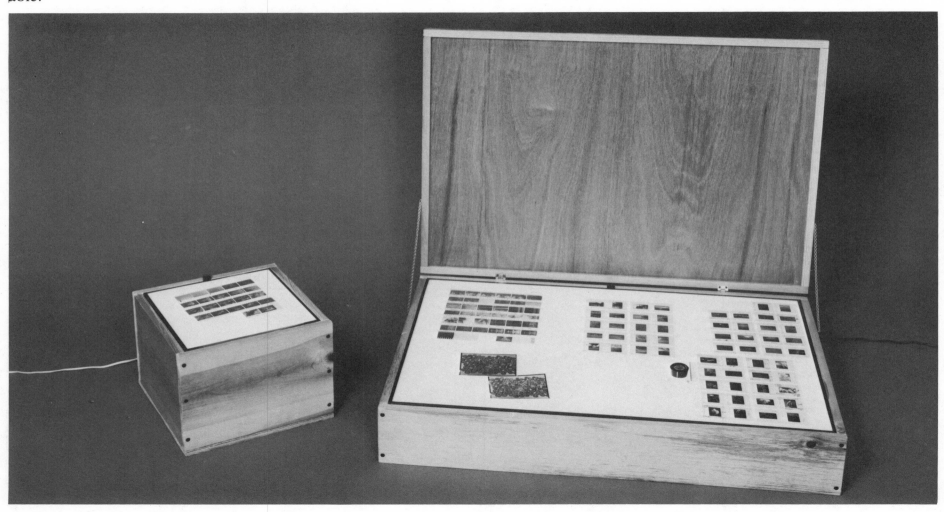

Small light box

The small light box, shown on the left, was designed for evaluating negatives while printing. Set it up near your enlarger or recess it into your counter with the viewing surface at counter-top level.

Size The viewing surface is 12 × 12 inches—large enough for inspecting one 9 × 12 sheet of negatives. The outside dimensions are 13⅜ × 13⅝ inches, and it is 9¾ inches deep. The small box is deeper than the large light box because the circular fluorescent fixture used here stands several inches above the bottom of the box.

Light The box is lit by one circular fluorescent tube that screws into a regular incandescent socket. The inside of the box is painted white to reflect the light evenly. This light box will not render the *color* of transparencies accurately because the circular fluorescent tube emits a slightly yellowish light.

Viewing surface The viewing surface has two parts. A sheet of ⅛-inch white acrylic (such as Plexiglas or Lucite) diffuses the fluorescent light evenly over the viewing area. A sheet of 3⁄16-inch glass on top provides a durable work surface and protects the acrylic from scratches and dirt that would shortly mar the surface.

Large light box

A large light box like the one on the right is used for evaluating, sorting, and viewing transparencies or negatives. The viewing surface is evenly illuminated from below by fluorescent tubes. Since the light is balanced to be the same color as daylight, the box can be used for accurate evaluation of color slides. This is the same kind of light box used by artists and graphic designers for layout, paste-up, animation, and other work. It is so large and provides so much light that it is usually used in the studio rather than inside the darkroom.

Size The illuminated area is 24 × 36 inches. That is the standard glass size that will accommodate eight 9 × 11-inch vinyl slide protectors. The outside dimension is 25⅝ × 37⅞ inches. The depth (5½ inches outside) allows enough space between the fluorescent tubes and the viewing surface for even illumination and still maintains the proper light level.

Lights The color of light is measured on a color temperature scale that runs from very warm, reddish-yellow light to very cool, bluish light. A small part of this spectrum, known as *photographic daylight*, is considered best for viewing color slides. This light table contains two 36-inch fluorescent fixtures (or three 24-inch ones) with tubes that emit light the same color temperature as daylight. All the fixtures are mounted on the sides of the box and the bottom is covered with highly reflective Mylar for bright, evenly reflected light.

Viewing surface The large light box has the same 2-part viewing surface as the small light box—translucent white acrylic underneath as a diffuser and heavy glass on the top as a work surface.

Base The light box is designed so that you can use it on a counter or desk. Put handles on the ends if you expect to move it often.

Lid Another useful option on a light box is a hinged lid. Whenever you need to leave your project, close the lid to protect your negatives or transparencies from dust, wind, or pets.

The large light box: Getting ready

Building your own light box will save you a considerable amount—the materials cost will probably be one-third the cost of a manufactured one. Plan to spend several hours on this project. Buying materials may take longer than usual because the special fluorescent tubes are often hard to find. The electrical wiring may also take a long time if you're not accustomed to doing it. The project must be done in stages to allow glue and paint to dry.

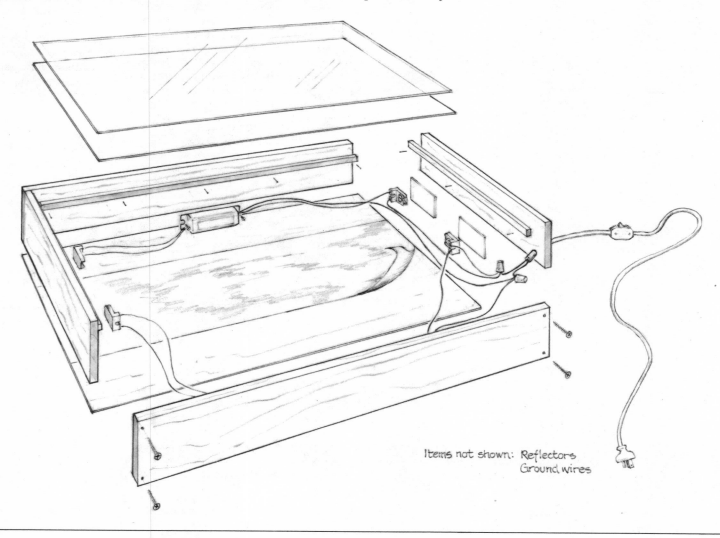

Items not shown: Reflectors
Ground wires

TIME: 4 to 8 hours
COST: High
DIFFICULTY: Moderate

Tools

- Tape measure
- Pencil
- Combination square
- Saber saw
- Sandpaper
- C-clamps (2)
- Drill and bits
- Phillips-head screwdriver or drill attachment
- Hammer
- Paintbrush
- Knife or wire stripper
- Wire cutters
- Pliers
- Flat-head screwdriver
- Straightedge

Materials and supplies

1 × 6 lumber Two 6-foot lengths

$\frac{1}{4}$-inch plywood A piece at least $25\frac{5}{8}$ × $37\frac{5}{8}$ inches

Parting stop ($\frac{3}{8}$ × $\frac{3}{4}$ inch or $\frac{1}{2}$ × $\frac{3}{4}$ inch) Two 6-foot lengths

$\frac{1}{8}$-inch translucent white sheet acrylic (A 24 × 36-inch piece. Ask for Plexiglas 2447, or the equivalent.)

$\frac{1}{8}$-inch double-weight glass A 24 × 36-inch piece

Mirror film (See "tips," right. A 24 × 36-inch sheet.)

Fluorescent tubes (Daylight balanced—see "tips" on "Buying fluorescent lights." Buy two 36-inch tubes if you can find them. Otherwise buy three 24-inch tubes and follow the alternate instructions on p. 99 for installing the fixtures.)

Fluorescent strip fixtures (Buy "rapid-start" fixtures. For 36-inch tubes, buy two single fixtures. For 24-inch tubes, buy one single fixture and one double fixture.)

White matboard or cardboard or scraps of plywood or masonite for reflectors. Two pieces 8 × 35 inches. (For the alternate plan you need two pieces 8 × 23 inches.)

3-conductor wire a few inches longer than you want the cord to be

3-pronged plug plus an adaptor if needed (see "Grounding," p. 42)

In-line switch for a 3-conductor wire

1$\frac{5}{8}$-inch drywall screws or 1$\frac{3}{4}$-inch #8 flat-head screws (8)

Glue

1-inch wire brads

White paint

16-gauge, insulated single-strand copper wire (2 yards)

Wire nuts (8)

Tape Aluminum, stainless steel, or cloth tape, 1 to 1$\frac{1}{2}$ inches wide

$\frac{3}{4}$-inch #8 round-head screws (4 for mounting the ballasts)

TIPS

Buying the fluorescent lights Various kinds of fluorescent tubes give off light of different colors (you can see the difference when the tubes are lighted side-by-side). For each kind of tube, manufacturer's information specifies the color temperature in degrees Kelvin and the color rendering capacity on a scale from 0 to 100. For accurate evaluation of color transparencies, you need light that is between 5000 and 5500 degrees Kelvin (the color of "photographic daylight"), with a color rendering index of 80 or higher.

Three fluorescent tubes that meet these criteria are the Sylvania Design White, the GE Chroma 50, and the Westinghouse Ultralume. This kind of tube is a specialty item and may be hard to find. Try an electrical supply store.

If you can't locate 36-inch tubes, switch to our alternate design and buy three 24-inch tubes and fixtures. These are not as desirable because you'll have to spend more on fixtures and there's more wiring involved.

In case you're tempted to try one of the more widely available tubes, here's some information: "Cool White" tubes are 4300 degrees Kelvin, which is a little warmer (that is, yellower) than you need, and the color-rendering properties are not good unless you can find the deluxe variety. Plant grow lights may simulate a natural daylight color, but they are generally deficient in part of the spectrum and are therefore not very satisfactory for light boxes.

Mirror film Mirror film is technically "metallized polyester film." It's best known by the trade name Mylar. It is sold with or without the mirror coating, so be sure to get the mirror kind. A plastics dealer or a glass store that handles plastics is likely to carry it.

The same sort of material is also sold as a reflective energy-saving window film in home supply stores. You can use it in your light box without removing the protective backing. It seems to work just as well as Mylar even though it doesn't appear to be as bright.

Aluminum foil may seem like an obvious substitute, but it's actually less satisfactory than the two materials listed above because it's not as reflective and the reflections have a bluish tint.

Note: Both the Mylar and the window film are translucent. In the light box, a white surface behind the film will increase its reflectivity.

The large light box: G ready

Building the box

The wood box that holds the fluorescent fixtures and electrical wiring is made of 1 × 6 lumber with a plywood bottom and cleats to hold the viewing surface in place. It's painted white inside and it has mirror film in the bottom so that all the inside surfaces will be reflective.

Before you begin

Before cutting anything, check the measurements of your glass and acrylic. If the glass is larger or smaller than 24 × 36 inches in either dimension, adjust the cutting measurements below by the amount it's off. You can file the acrylic sheet to the size of the glass if necessary, using a metal file like the one described on p. 24. Leave the protective coating on the acrylic to keep from scratching it while you build the box.

Examine the 1 × 6 lumber for knotholes or bad spots in the edges. Make sure that any problem areas are at the bottom facing the inside when you put the box together.

1 CUT THE PIECES

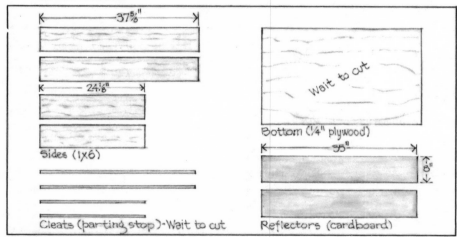

1 *The sides* are from 1 × 6 lumber. Cut two pieces 24⅛ inches long (or ⅛ inch longer than the short dimensions of the glass), and two pieces 37⅝ inches long (or the length of the glass plus 1⅝ inches). *The cleats* are cut from parting stop. Wait to cut them until the box is assembled (see step 5). *The bottom* is a piece of ¼-inch plywood. Wait to cut it until the sides are assembled (see step 3). *The reflectors* are thin pieces of wood or cardboard. Cut two of them 8 × 35 inches. (If you're using the alternate plan with 24-inch fixtures, cut them 8 × 23 inches.) Paint them white when you paint the inside of the box.

2 JOIN CORNERS

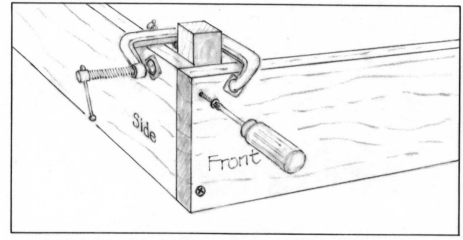

2 Clamp one corner of the box together with the front covering the edges of the side as shown. Drill for two screws (see "Drilling for screws," p. 32). Put glue in the joint and screw it together. Repeat for the other three corners.

3 CUT AND ATTACH BOTTOM

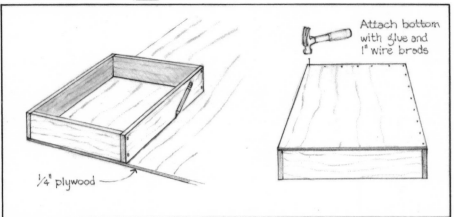

3 Place the box at the corner of the plywood. (Make sure that the corner is square and that the sides of the box are flush with the edges of the plywood.) Draw around the box and cut out the bottom. Glue it in place and attach it with 1-inch wire brads about 4 inches apart.

4 MARK CLEAT LOCATION

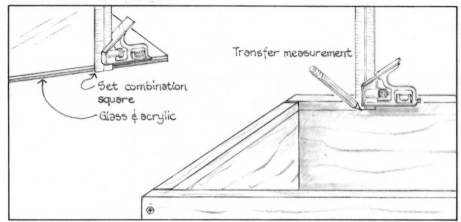

4 Set your combination square to the thickness of your glass and acrylic as shown. Then use it to mark the cleat location at several points around the inside of the box.

5 CUT CLEATS

5 Cut the two short cleats to fit inside the ends of the box. Then cut two long cleats to fit *between* the short ones as shown.

6 ATTACH CLEATS

6 Start 1-inch wire brads into the cleat about every 8 inches. Glue the cleat in place with the top edge on the pencil line and hammer the brads in all the way. Wipe off any glue that squeezes out.

7 FINISH INSIDE

7 Allow the glue to set up overnight. Then paint the inside of the box with two coats of white paint. If your reflectors are not already white, paint them also. Painting the sides of the box eliminates dark areas at the ends of the fluorescent fixtures and in the corners. Painting the bottom of the box increases the reflectivity of the mirror film which will cover the bottom.

When the paint is dry, cut a piece of mirror film slightly smaller than the bottom of the box and stick it in place with double-stick tape or a few dabs of glue.

Installing the fluorescent fixtures

The location of the fluorescent fixtures inside the light box is the most important factor in getting even light on the viewing surface. The instructions on this page are for mounting and wiring two 36-inch fixtures. The layout and instructions for 24-inch fixtures are on p. 99.

Fixture layout

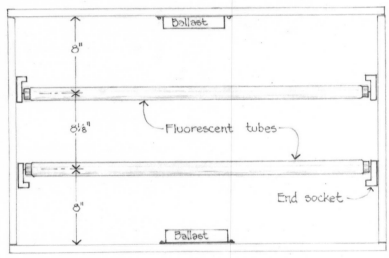

8"

8⅛"

— Fluorescent tubes —

End socket —

8"

Ballast

Ballast

Note: Wiring not shown

Here's how to lay out the fixtures in your light box. The end sockets are mounted inside the ends of the box and the tubes run the length of the box. (The alternate layout for 24-inch fixtures is on p. 99.)

TIPS

Fluorescent fixtures A fluorescent fixture is made up of a ballast, a pair of end sockets, a fluorescent tube, and the wiring that provides power to the unit. The *ballast* transforms the voltage and regulates the electric current that feeds your fluorescent lights. It is essential for starting the fixtures and keeping them lighted. The *end sockets* hold the fluorescent *tubes* in place and connect them to the flow of electricity.

Placing the fixtures For maximum reflection and even illumination on the viewing surface, the fluorescent tubes must be placed very close to the reflective bottom surface of the box. Otherwise, you will see bright stripes over the tubes and darker areas in between that will make it difficult to evaluate the density of your transparencies. We found it best to place the tubes about $\frac{1}{4}$ inch above the floor of the box. To get the tube this far down in the box, you have to turn the sockets sideways. The best spacing between the fixtures is shown in the diagram to the left.

Shimming The tools and techniques you're using for these projects are not absolutely precise. When you cut a 36-inch board or build a 36-inch box, it will nearly always be a little longer or a little shorter than 36 inches. Your light box must accommodate a 36-inch fluorescent fixture, so if the box happened to be a little short, you would have a problem.

We've resorted to an old carpentry trick: we made the box slightly longer—$36\frac{1}{8}$ inches. Now we want you to fill in the extra space at the end of the fixture with a thin piece of wood or cardboard called a *shim.* This shim gives you some margin for error and still guarantees that you can make the fixture fit. Your shim will need to be $\frac{1}{16}$ to $\frac{1}{4}$ inch thick depending on how accurate you were. Possible shim materials are $\frac{1}{4}$-inch or $\frac{1}{8}$-inch plywood or masonite or a couple of thicknesses of matboard or cardboard.

1 DISASSEMBLE STRIP FIXTURES

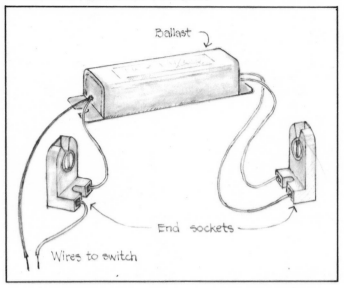

Ballast

Switch & plug

End sockets

Wires to switch

2 MOUNT BALLASTS

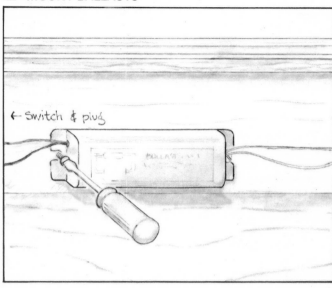

← Switch & plug

1 A fluorescent fixture comes partially assembled. Open the metal box and remove the screws holding the ballast in place. You will need only the ballast and sockets with the wires that connect them.

2 Put the end of the ballast that has loose wires toward the end of the box where the plug will be. Use ¾-inch #8 wood screws to mount the ballasts inside the front and back of the box. Be sure to keep the ballasts low in the box so the reflectors will fit over them. (Instructions for 24-inch fixtures differ—see p. 99.)

3 INSTALL TWO SOCKETS

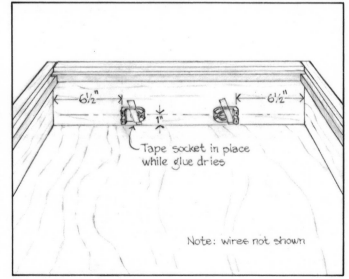

6½" 1" 6½"

Tape socket in place
while glue dries

Note: wires not shown

4 SHIM OTHER SOCKETS

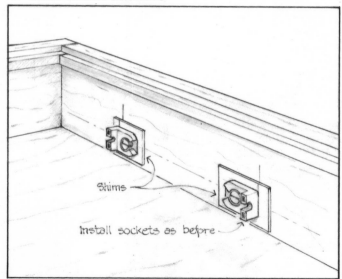

Shims

Install sockets as before

3 Inside the box, at one end, draw a line 1 inch above the bottom as shown. This is the center line for the sockets. From each corner, measure in 6½ inches along this line and make a vertical mark to locate the bottoms of the sockets. (For 24-inch fixtures, see p. 99.) Glue two sockets in place at one end as shown. Tape them in place while the glue dries. Leave the tape on for at least an hour.

4 Find a shim material just thick enough that the fluorescent tube won't be loose but will still slip into the sockets easily (see tips on "Shimming," above). Cut a strip of the shim material 2 inches or 3 inches wide and glue it into the box. Repeat step 3 to install sockets.

Installing the fluorescent fixtures

Wiring

There will be a wiring diagram on the ballasts, but if you've never tried to work from one before, it will probably look like spaghetti to you. Here is an overall view of the wiring in your light box and step-by-step instructions telling you which wires to connect.

Wiring diagram

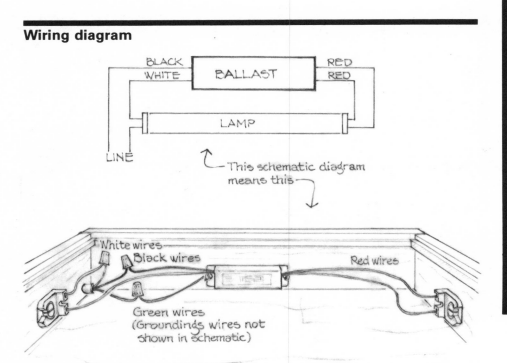

The wiring diagram at the top is similar to the one on your ballasts, while the drawing shows you what the wiring will actually look like for this fixture. In your light box, there will be two fixtures, so an additional wire from the second fixture will join each wire nut connection. Wiring the fixtures is simple and is explained in the step-by-step instructions below.

TIPS

Grounding Many electrical devices are grounded so that a short in the system will not give you an electric shock. Fluorescent lights are even more finicky. If they're not grounded, they might not light up (or they might start sometimes but not other times). To ground your light box, use a 3-conductor wire and a 3-prong plug, as explained below. Grounding is discussed in greater detail on p. 42.

Wiring The three wires inside a 3-conductor electrical cord are white, black, and green. Use *wire nuts* to join these wires to the fixtures as described on the next page (steps 1–4). As you go, staple or tape the wires to the sides of the box to keep them out of the way. (Be sure the staples go *across* the wires, not through them.) If any of the wires aren't long enough, extend them using extra wire and wire nuts (see p. 42 for detailed information about working with wire).

If the lights don't work If the tubes glow faintly at the ends but don't light up or if there's no response at all when you turn the switch on, then there are two possibilities: the fixtures are not adequately grounded or you have a loose connection somewhere.

Unplug the cord from the wall socket each time you investigate the wiring. First, check to make sure the ground wire is firmly connected to both the ballast and the plug. If that doesn't solve the problem, check all the wire nut connections to make sure they are tight. Also check that all wires are connected. There should be no loose ends.

1 ATTACH CORD

1 Drill a hole (just large enough for your wire) through one end of the box near the front and put the end of your 3-conductor wire through the hole. Strip the outer covering from the last 3 inches of the wire.

2 WIRE SOCKETS

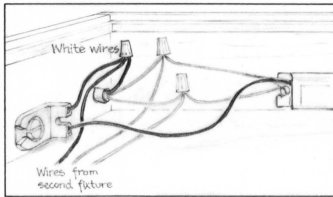

2 One socket from each fixture will have an unconnected wire sticking out of it. Join both of these wires to the *white* wire from the cord.

3 WIRE BALLASTS

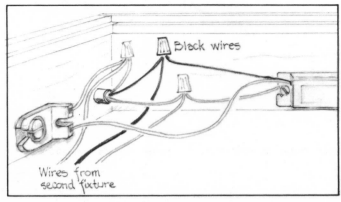

3 Each ballast will have an unconnected wire sticking out of one end. Join both of these wires to the *black* wire from the cord.

4 ADD GROUND WIRES

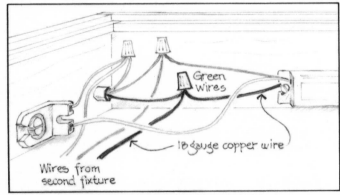

4 Cut two wires: a short one for the near ballast and a long one for the far ballast. Join both wires to the *green* wire from the cord. Attach the other ends to the screws holding the ballasts in place.

5 ATTACH PLUG AND SWITCH

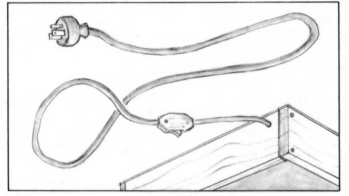

5 Decide how long you want the cord to be and cut it. Attach the plug at the end and the switch near the box. For more about wiring plugs and switches, see p. 43.

6 TEST FIXTURES

6 Insert the tubes and turn on the fixtures to see if everything works. If not, see "If the lights don't work" opposite. Then remove the tubes for the next step.

Finishing touches

The reflectors will hide the wiring inside the box and ensure that the light is even all the way out to the edges. This sequence will show you how to install them. Then clean and install the viewing surface and your light box is ready to use. Taping the glass and acrylic together makes the two pieces easier to handle. After they're in place, they are not easy to remove, so add a tab of cloth tape to help you lift them out of the box.

Handling glass

To put a piece of glass down, place the center of the glass on the edge of the table, rotate the glass until it's horizontal, and slide it onto the table.

TIPS

Handling glass To save return trips to the glass shop, handle your glass slowly and carefully. It can break unexpectedly. Carry it vertically, holding it by the top and bottom. *Never* hold it over your head. Put it down as shown in the drawing. Do not pick it up by a corner—the corners break off easily.

Cleaning glass For cleaning the glass, mix 3 or 4 teaspoons of glass cleaner (such as Windex) with about a pint of water in a spray container. (Full-strength glass cleaner may leave a film on the glass.) Spray the glass and wipe it clean with a piece of newspaper (it cleans well and doesn't leave lint) or a paper towel.

Leave the glass resting flat on the work table while you clean it. If you move around until the glare from an overhead light shines on the surface, you'll be able to see whether it's clean. *Don't* stand it on edge and scrub it! Move slowly when you clean near the edges—they may be sharp.

Cleaning acrylic Special cleaners for sheet acrylic are available in hardware stores or places that sell acrylic. As a substitute, you can use diluted dishwashing liquid—$\frac{1}{2}$ teaspoon to a pint of water. *Don't use glass cleaner*—it's too harsh. You will also need a soft, lint-free cloth—a Photowipe or clean, soft cotton rag will be fine.

Because the acrylic scratches easily, use gentle pressure when cleaning. Clean it slowly—vigorous motions will generate static electricity that will attract dust to the acrylic.

1 INSTALL REFLECTORS

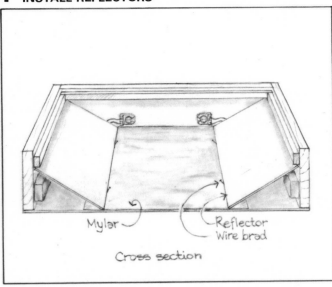

Mylar

Reflector
Wire brad

Cross section

2 CLEAN GLASS AND ACRYLIC

Place glass flat (not on edge)
for cleaning

3 TAPE GLASS AND ACRYLIC

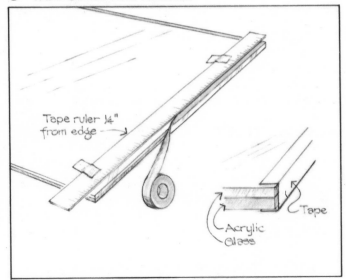

Tape ruler ¼"
from edge

Acrylic
Glass

Tape

4 INSERT GLASS AND ACRYLIC

Attach tape tab

1 Remove the fluorescent tubes. Put the reflectors in place on both sides of the box as shown. Make sure the top edge of the reflector is pushed up underneath the cleat and tack a couple of wire brads into the floor of the box to keep the reflector from slipping. Put the fluorescent tubes back in place.

2 Remove the protective coating from the acrylic and clean it with a soft, lint-free cloth and plastic cleaner. See tips on cleaning acrylic, facing page. Clean the glass with diluted window cleaner and a piece of newspaper or paper towel. (*Caution*: large sheets of glass break easily. See tips on handling and cleaning glass.)

3 Place the glass on top of the acrylic. Making sure the surfaces that are touching are dust free, tape them together at the edges with cloth or metal tape. (An easy way to do this is to tape a ruler onto the glass $\frac{1}{4}$ inch in from the edge as a guide to position the tape.) Taping makes the glass easier and safer to handle and keeps dust out.

4 Attach a tab of heavy cloth tape in the center of the back edge of the glass and acrylic. This tab is for lifting the viewing surface out of the box. Put the glass and acrylic in the top of the light box with the glass up.

Alternate designs

As a variation on the original design, you can add a lid or handles to your light box. If you were unable to find 36-inch color corrected tubes, the sequence below will show you how to install 24-inch fixtures.

Adding handles to your light box

The light box should always be carried in a horizontal position so that the glass and fluorescent tubes don't slip out of place. It is a clumsy item to move and handles will make it much easier to carry.

Buy two cabinet handles and screw them onto the ends of the light box as shown.

Adding a lid to your light box

A lid on your light box allows you more flexibility because you can leave negatives or slides in place on the box and just close the lid to protect them. The lid is recessed so it won't rest on your pictures.

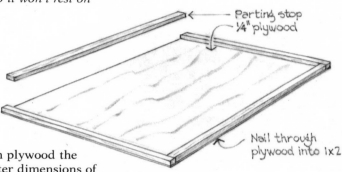

Parting stop ¼" plywood

Nail through plywood into 1x2

Cut a piece of ¼-inch plywood the same size as the outer dimensions of the box. Cut lengths of parting stop to go along the edges as shown, attaching them with glue and ½-inch wire brads. (If your parting stop is ½ × ¾ inch, use ⅝-inch wire brads.)

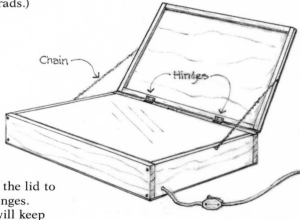

Chain

Hinges

After the glue dries, attach the lid to the back of the box with hinges. Small chains at the sides will keep the lid from falling back when you open it.

Using 24-inch fixtures

The light box is the same size for 24-inch fixtures as for 36-inch fixtures. Build the box according to directions on pp. 90–91. Then follow these steps to put in the fixtures and finish the box.

1 MOUNT BALLASTS

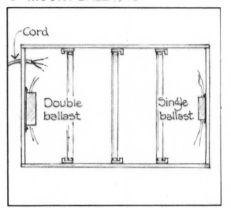

1 Disassemble your strip fixtures (see p. 93, step 1). Mount the double ballast at the end of the box where the cord will be and the single ballast at the other end (see p. 93, step 2).

2 MOUNT SOCKETS

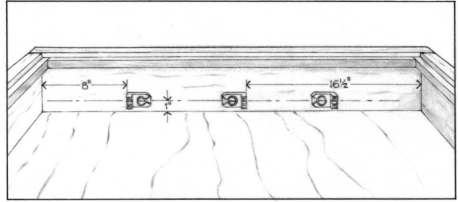

2 Inside the front and back, draw a line 1 inch from the bottom. This is the center line for the sockets. Measure and mark the socket locations as shown. On one side of the box, glue the sockets in place, taping them to the box until the glue dries. Shim the sockets on the other side and glue them in (see p. 93, step 5).

3 WIRE FIXTURES

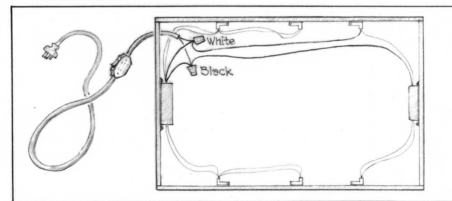

3 The drawing above shows the wiring you will have to do. It is simply a matter of connecting the white wires from the ballasts to the white wire from the cord, and likewise with the black. You will also have to add a ground wire, not shown here. Follow steps 1–5 on p. 95 for a step-by-step description of wiring and attaching the switch and plug.

4 FINISH BOX

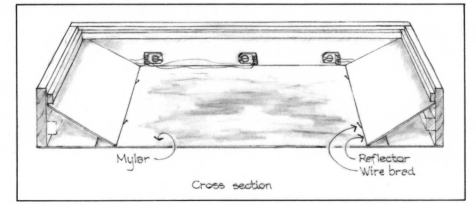

4 Install two 8 × 23-inch reflectors at the ends of the box as shown (see p. 97, step 1 for details). Follow steps 2–5 on the same page to finish the box.

Alternate designs

The small light box: Getting ready

This small darkroom light box is inexpensive and takes much less time to build than the larger one. All materials are readily available and the wiring involved is minimal.

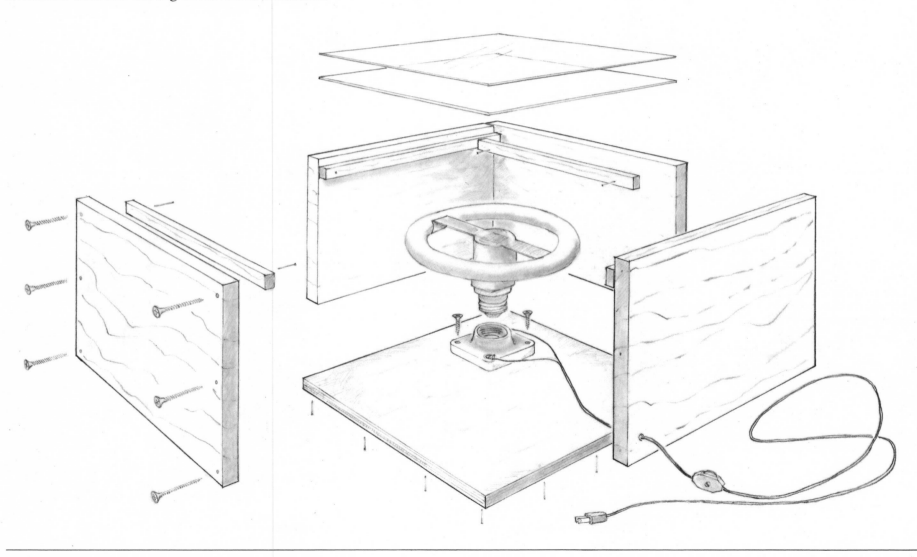

TIME: Less than 4 hours
COST: Low
DIFFICULTY: Easy

Tools

- Tape measure
- Pencil
- Combination square
- Saber saw
- Sandpaper
- C-clamps (2)
- Drill and bits
- Phillips-head screwdriver or drill attachments
- Hammer
- Paintbrush
- Knife or wire stripper
- Wire cutters
- Flat-head screwdriver
- Pliers

Materials

1 × 10 lumber A 6-foot length

$\frac{1}{2}$-inch plywood ($13\frac{3}{8} \times 13\frac{3}{8}$ inches). The other project that requires $\frac{1}{2}$-inch plywood is the adjustable baseboard (Chapter 7). The leftover plywood from that project may be used here.

Parting stop A 4-foot length. This can be $\frac{3}{8} \times \frac{3}{4}$ inch or $\frac{1}{2} \times \frac{3}{4}$ inch.

2-conductor wire About 6 feet

2-pronged plug

In-line switch

Incandescent socket (Bottom-mounting, with mounting screws)

8-inch round fluorescent tube with a screw-in base to fit an incandescent socket

$\frac{1}{8}$-inch white translucent sheet acrylic (12 × 12 inches. Get Plexiglas 2447, Polycast 2447, or the equivalent.)

$\frac{1}{8}$-inch double-weight glass (12 × 12 inches)

White paint

Glue

$1\frac{5}{8}$-inch drywall screws or $1\frac{3}{4}$ inch #8 flat-head screws (12)

1-inch wire brads

Tape Aluminum tape, stainless steel tape, or cloth tape 1 to $1\frac{1}{2}$ inches wide

TIPS: Buying the fluorescent light

Round fluorescent tubes with screw-in bases are commonly available for use in lamps or ceiling fixtures. We found that the 8-inch diameter fixture worked best for this light box, but a smaller one can be used if the 8-inch is unavailable. Look for it in the lighting section of your home supply store.

Building the small light box

The small light box is made from 1 × 10 lumber with a plywood bottom and cleats to hold the viewing surface. The inside is painted white to reflect as much light as possible.

1 CUT THE PIECES

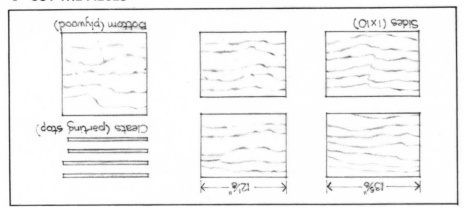

1 From the 1 × 10 board, cut two pieces 12⅛ inches long, and two pieces 13⅝ inches long. (It's helpful to use a straightedge when cutting the 1 × 10 because it's so wide.) Wait to cut the parting stop cleats and the ½-inch plywood bottom until they are called for in the instructions below.

2 JOIN CORNERS

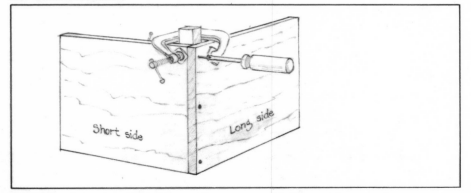

2 Clamp one corner together with the long side covering the end of the short side as shown. Drill pilot holes and shank holes for three drywall screws. (See "Drilling for screws," p. 32.) Glue and screw the corner together. Repeat for the other three corners. The box should measure 12⅛ × 12⅛ inches inside.

3 CUT AND ATTACH BOTTOM

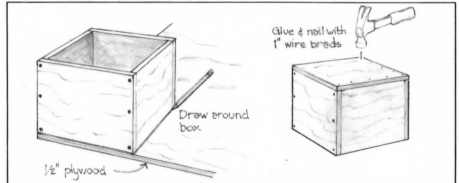

Glue & nail with 1" wire brads

Draw around box

½" plywood

3 Place the box on the corner of a piece of ½-inch plywood and make sure the sides are flush with the edges of the plywood. Draw around the box and cut out the bottom. Glue and nail it to the box as shown.

4 MEASURE FOR CLEATS

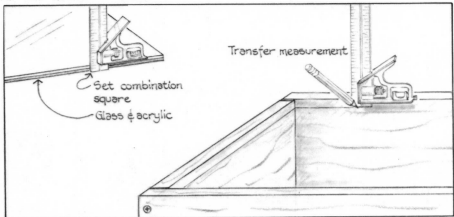

4 Set your combination square to the depth of your combined glass and acrylic as shown. Then use it to mark the location of the cleats at several places inside the top of the box. Draw a line connecting your marks.

5 CUT AND ATTACH CLEATS

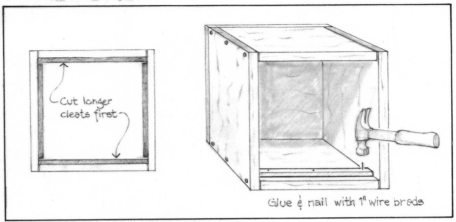

Glue & nail with 1" wire brads

5 From parting stop, cut four cleats to fit inside the box as shown. Glue and nail the cleats into place with the top of the cleats on the line.

6 PAINT BOX

6 Give the inside of the box two coats of white paint. This provides maximum reflection so that the viewing surface will be bright.

7 INSTALL AND WIRE SOCKET

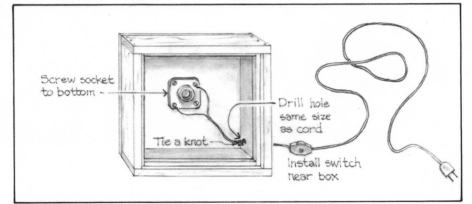

7 Center the socket in the bottom of the box and screw it in place. Drill a hole through one side of the box near the bottom front corner. Put one end of the electrical cord through the hole and tie a knot to keep it from pulling out. Attach the wires to the two terminals on the socket. Put a switch and plug on the cord (see p. 43 for wiring).

8 FINISH BOX

8 Screw the fluorescent fixture into the socket. Plug in the box and turn it on. If it doesn't light, check your wiring. Clean the glass and acrylic (see detailed instructions on p. 96), tape the edges (see p. 97), and put them into the box with the glass on top.

A darkroom sink

Darkrooms differ so widely and photographers work with so many different processes and print sizes that there is no standard size or design for a darkroom sink. Stainless steel or fiberglass sinks are made in a few sizes and are quite expensive. For a lot less money you can build a plywood sink that is tailored to fit your darkroom and to handle the kinds of printing you do most often. The sink shown here will fit in most darkrooms and will be adequate for basic printing. Below are several points to consider as you adapt this design for your darkroom.

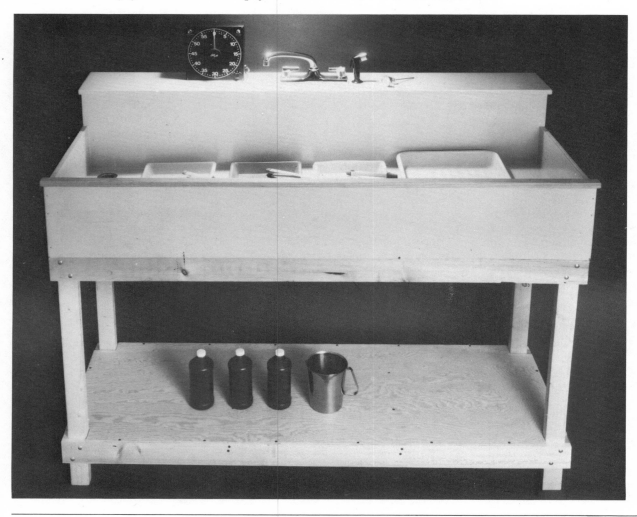

Size

Sinks are generally designed to hold a minimum of three trays (developer, stop, and fix) and a print washer. More sink space is desirable for a second tray of fixer, for extra solutions such as toners or Hypo Clearing Agent, and for mixing chemicals.

To figure out what length sink you need, count the number of trays you normally use and measure them. Allow at least 3 inches between the trays (6 to 12 inches is better because it reduces the chance of splashing chemicals from one tray to another). For the width of the sink, add at least 6 inches to the long dimension of the trays (12 inches is better—it leaves you more room to work).

Draw a diagram like this one and add up the measurements to get the inside dimensions of your sink. Then add 1½ inches (two thicknesses of plywood) to get the outside dimension. Now compare the size sink you need with the space available in your darkroom. If you have enough room, you'll probably want to build a larger sink because extra sink space is always useful. If space is tight, a tray rack that holds two or three trays one above the other can help you use a very small sink efficiently.

The sink detailed in this chapter is 66 inches long and 22 inches wide inside. It has room for five trays for 8 × 10 prints or four trays for 11 × 14 prints. It is small enough to fit in most darkrooms and all the major pieces can be cut from one sheet of plywood. Alternate designs for a smaller sink and for an 8-foot sink are diagrammed on p. 129.

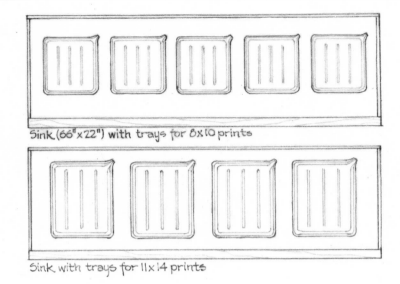

Sink (66" x 22") with trays for 8x10 prints

Sink with trays for 11 x 14 prints

Slope

Decide whether you want the sink to drain at the left or right end. Your primary considerations should be the location of your darkroom plumbing and the work pattern in your darkroom. The sink drain must be within a few feet of the house plumbing into which it will tap so that it can be vented properly (more about this on page 124).

It's also helpful if the deep end of the sink is the developer end. That way, when you use the sink for a water bath, you will have the most control over the developer temperature.

The bottom of the sink is put in at a slant from side to side. Front-to-back slope is accomplished by raising the front of the sink when you install it.

Faucet location

Your water supply needs to be convenient both to the print washer and to the area where you intend to mix chemicals. Put the faucet at the center of the sink or toward the high end and attach a hose long enough to reach all parts of the sink. In a very long sink, you may want two faucets.

Height

A comfortable height for the sink bottom is generally between 34 inches and 40 inches depending on the height of the person using the sink. The height of the leaning rail is also important, though, since you will be leaning against it for long hours and reaching over it to process your prints. The best way to determine a comfortable height is to build the sink and then test it at various heights.

Backsplash

The back of the sink is higher than the front and sides to keep chemicals from splashing the wall, to support the faucets, and to support a shelf if you want one.

Shelf

A shelf above the sink is very handy for mounting the faucet; for holding a timer, tongs, squeegee, and other gadgets; or for storing freshly mixed chemicals, which can be poured directly into the processing trays.

Leaning rail

A leaning rail along the front of the sink keeps the plywood edge from cutting into your arms while you're working. You can use 1 × 2 fir or pine for this, or you can add a nice touch by using a wide molding with rounded edges or a piece of mahogany, walnut, or oak.

Storage space

The shelf in the sink base can be used to store chemicals and/or trays.

Disassembly

The sink and the base are two separate units, and the base can be disassembled for moving or storage. Since many darkrooms are entered through smaller-than-usual (closet, attic, or basement) doors or curved passageways, it's wise to check and be sure that what you're going to build will fit through the door.

Getting ready

This is a long project. You will have to stop for several hours to let the caulk set up and again to let the paint dry, so plan to spread out your sink building over several days. Care and accuracy are required to build a sink that will be watertight, but no new skills are involved.

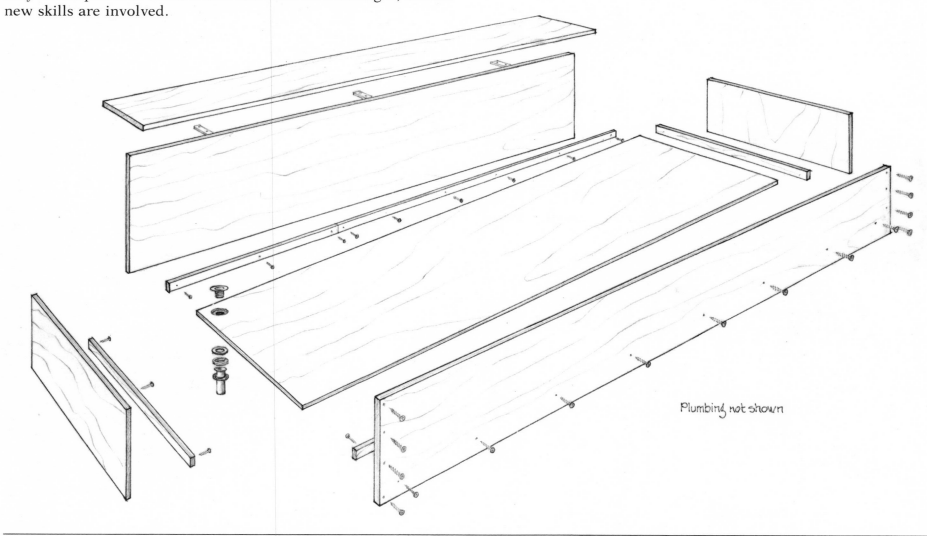

Plumbing not shown

TIME: Over 8 hours
COST: Medium
DIFFICULTY: Moderate

Tools

- Tape measure
- Pencil
- Framing square
- 8-foot straightedge (See p. 37. A 4-foot one will also be useful.)
- Saber saw (You may also want a circular saw since it will be faster for cutting the plywood.)
- Sawhorses or other supports (2)
- Scrap pieces of 2 × 4 about 6 or 8 feet long (2)
- C-clamps (2) and a corner clamp (or 4 C-clamps)
- Surform tool or plane
- Drill and bits
- Phillips-head screwdriver
- Caulking gun
- Small knife (for trimming excess caulk)
- Chisel (half inch is preferable)
- Hammer
- Combination square
- Wrench (the right size for the faucet nuts)
- Paintbrushes (Buy a good one for painting the outside of the sink and sink base, and three cheap sponge brushes or throw away brushes to use with the epoxy paint.)

Materials and supplies

FOR THE SINK

¾-inch exterior-grade AC plywood (one 4 × 8-foot sheet)

1¼-inch drywall screws (24)

1⅝-inch drywall screws (36)

Silicon rubber caulk with adhesive properties (It may not say it's adhesive, but it will have directions for gluing on the back.)

Drain (See "Buying a drain," right.)

1 × 3 lumber (or a piece of molding or hardwood for the leaning rail. A piece the same length as your sink.)

Glue

4d finish nails

Epoxy paint (1 quart. See p. 120)

Latex caulk or wood filler

Sandpaper

FOR THE SINK BASE

1 × 4 lumber (five 8-foot lengths)

2 × 3 lumber (two 6-foot lengths)

¼-inch × 2½-inch carriage bolts with nuts and washers (16)

¼-inch plywood (a piece about 24 × 68 inches)

1⅝-inch drywall screws (40)

Alkyd paint

FOR THE TOP SHELF

1 × 10 lumber (same length as sink)

3-inch metal angles (3) with screws

Faucet (See "Buying a faucet," right.)

TIPS

Buying a faucet Buy a simple kitchen faucet that mixes hot and cold water. Faucets vary quite a bit in cost, so shop around before you buy one. Look for one that has threads around the nozzle so that you can attach a hose for getting water to exactly the part of the sink where you want it. To be sure it fits, buy the hose when you buy the faucet. Check the instructions with the faucet to be sure you have the drill bits you will need to install it.

Buying a drain There are many different sizes and kinds of drains. Buy a kitchen sink drain or washtub drain similar to the one in the drawing. (A lavatory drain with overflow holes in the sides will not work.) Don't buy a brass or copper drain—it will corrode quickly. Buy a stainless steel or plastic one.

Drains were not designed to fit plywood sinks, so take a small scrap of ¾-inch plywood with you to the store. Screw the drain pieces together, putting your plywood scrap in where the sink bottom would be. The large nut and washer underneath should fit snugly against the bottom of the plywood. Below the nut and washer there should be threads for attaching a 1½-inch diameter tail piece (a section of pipe several inches long). Buy the tail piece, too.

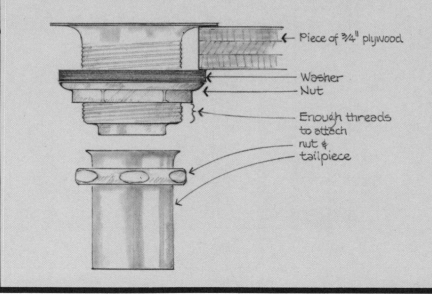

Piece of ¾" plywood
Washer
Nut
Enough threads to attach nut & tailpiece

Getting ready

Cutting the pieces

The major pieces of your sink are cut from one sheet of plywood. If you are unfamiliar with cutting plywood, read "Cutting plywood" (p. 39), and "Using a power saw" (p. 35), before you start. If your sink is to be a different size from the one shown here, be sure to change the measurements in the cut diagram (right) before you begin cutting. Cutting diagrams for a larger sink and a smaller sink are on p. 129.

Here's how to cut all the pieces of your sink out of one piece of plywood. Make the cuts in the order they're numbered to avoid awkward cutting situations. ▶

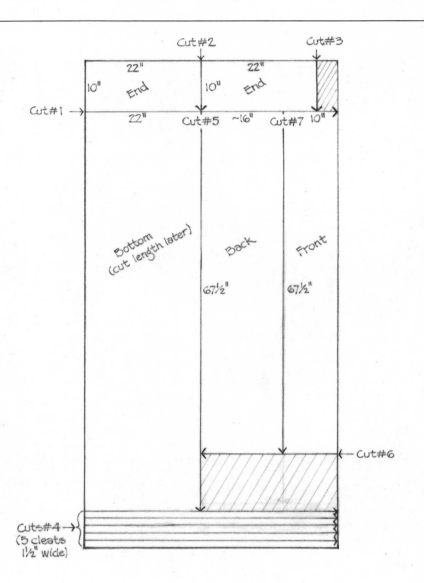

TIPS: Cutting plywood

Turn the plywood *good side down* for cutting. Measure for only one cut at a time. (If you measure for several at once, the width of your saw cut will throw your measurements off.) Make sure the piece you are cutting off is supported (or ask someone to hold it for you). Each time you make a cut, follow these steps, which are explained in detail on p. 39:

1 Check for a square corner and a straight edge to measure from.

2 Measure for the cut (and double-check).

3 Use your template to position the fence (be sure the width of the cut falls on the leftover piece, *not* on the piece you just measured).

4 Clamp the fence in place and use it as a cutting guide.

1 CUT #1: THE ENDS

1 Measure in 10 inches from the good end of the plywood for cut #1. Make the cut.

2 CUTS #2 AND #3: THE ENDS

2 Set the large piece of plywood aside and turn the small piece lengthwise on the supports. Measure 22 inches from the end and make cut #2. Label this piece *end (template)* and use it as a template to mark the cutting line for cut #3. Make cut #3. Label this piece *end* also.

3 CUT #4: THE CLEATS

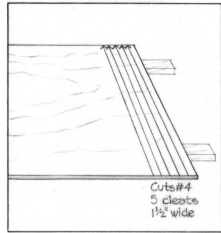

3 Place the large piece of plywood on the supports again. From one end, cut five cleats, each 1½ inches wide, as shown.

4 CUT #5: THE BOTTOM

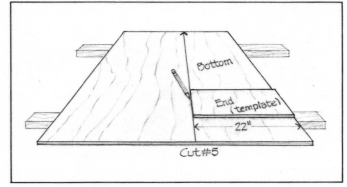

4 Turn the plywood on the supports as shown. Then use the end (template) piece as a template to measure 22 inches from the long edge for cut #5. Make the cut and label this piece *bottom*. Wait to cut the length of the bottom to size until after the sides are assembled.

5 CUT #6: THE FRONT AND BACK

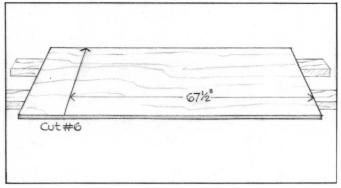

5 Measure 67½ inches from the end of your plywood for cut #6. Make the cut.

6 CUT #7: THE FRONT AND BACK

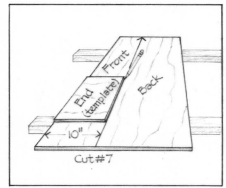

6 Use the end (template) piece as a template to measure 10 inches from one of the long edges. Make cut #7. Label the 10-inch-wide piece *front*. Label the wider piece *back*.

Cutting the pieces

Cutting and attaching the cleats

Your sink fits together as shown here, so that the front and back pieces cover the edges of the end pieces. Cleats are attached near the bottoms of all four sides. They provide extra support and waterproofing and are used to determine the slope and exact placement of the bottom.

The bottom of the sink slopes ¼-inch per foot toward the drain end. Consequently the cleats on the front and back are put in at a slant and the cleat at one end is higher than the cleat at the other end. If you are building your sink to different measurements than this one, calculate the slope and substitute your own measurements in step 1, below.

Since the sink is designed to overlap the base (so it can't slip off), there is ½ inch of space below the lowest cleat.

Before you begin, check the edges of the front, back, and end pieces with your straightedge. Use a surform or a plane to smooth any large irregularities.

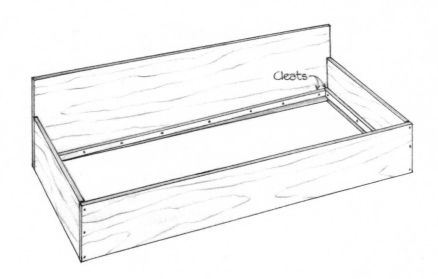

1 MEASURE FOR END CLEATS

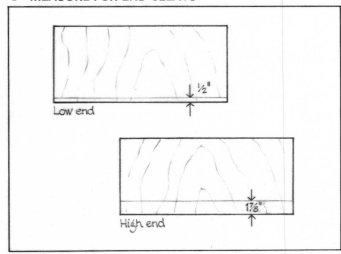

Low end ½"

High end 1⅞"

2 CUT AND ATTACH END CLEATS

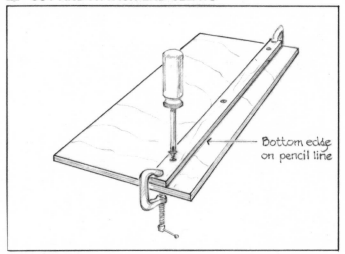

Bottom edge on pencil line

1 On each end piece, draw a pencil line (on the *good* side of the plywood) to mark the bottom of the cleat. If you changed the length of the sink in your design, substitute your own measurement for the cleat at the high end.

2 Cut cleats exactly the same length as each end piece. Clamp the cleats in place with the bottom edge on the pencil line. Drill pilot holes every 8 inches (be very careful not to drill all the way through the end pieces), and attach the cleats with 1¼-inch drywall screws (see p. 32 for complete drilling instructions). If the cleat extends slightly past the edge of the plywood, use a surform tool to file it even.

3 LAY OUT SIDES

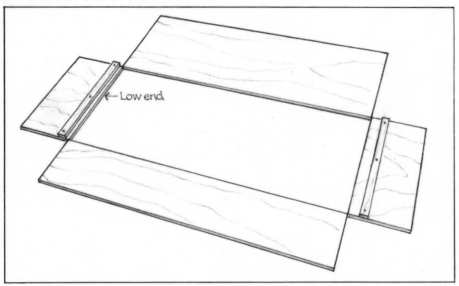

Low end

4 TRANSFER CLEAT LOCATIONS

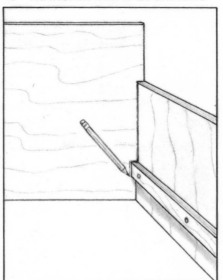

3 Lay out the four sides of the sink with the *inside* (good side of the plywood) facing *up* and the bottom edge of each piece toward the center as shown. Look at your design and note which end of the sink you designated for the drain or deep end. Put the end with the lower cleat at that end. (Our drawings are for a sink that drains to the left.)

4 One at a time, hold the corners together (making sure the outside corner and the bottom edges are flush). Trace the outline of the end piece and cleat onto the front or back.

5 MARK FOR FRONT AND BACK CLEATS

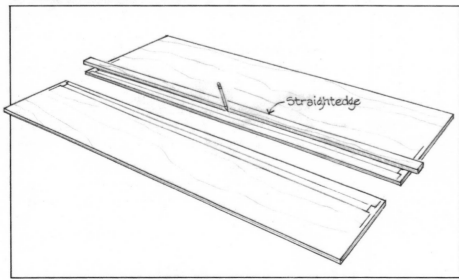

Straightedge

6 ATTACH FRONT AND BACK CLEATS

Make a smooth joint

5 On the front and back pieces, draw a straight line connecting the tops of the cleats and another line for the bottoms of the cleats by joining the marks made in the preceding step. These lines will slope. Look at the back to be sure it slopes in the right direction for your sink.

6 You'll need to use two or more cleats placed end-to-end on each of the front and back pieces. Clamp the cleats in place, drill pilot holes, and screw them on using $1\frac{1}{4}$-inch drywall screws. Be sure that joints between cleats are flush at the top edge. (This precaution makes the bottom fit more smoothly and therefore makes waterproofing easier.)

Cutting and attaching the cleats

Assembling the corners

The corners are held together with adhesive caulk and screws. We found that it worked best to clamp the corners together without the caulk in them when we drilled for the screws. (If you put the caulk in the joints before drilling, it's hard to align and clamp the joints properly because they keep slipping.)

While you have the corners screwed together on a dry run (step 3), cut the bottom to size and slip it in to be sure it fits. At this point, you can still trim either the bottom or a couple of the sides if it doesn't fit just right.

Next, remove the front and then the back to apply caulk and screw the corners together. This assembly procedure is detailed step-by-step below.

Caulk

Even a pinhole leak in your sink can cause you a *lot* of trouble (both in clean-up time and trying to locate and repair the leak). It's better to be sure it's watertight when you build it. That's why we tell you to put caulk in the joints when you put the sink together and then seal all the inside corners *again* after the sink is assembled.

1 DRILL PILOT HOLES IN BACK CORNERS

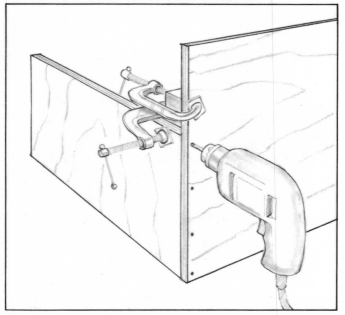

2 DRILL PILOT HOLES IN FRONT CORNERS

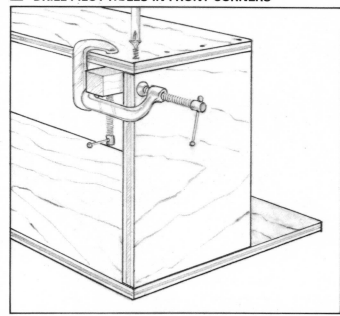

1 Clamp one back corner together (see "Clamping," p. 34). Drill holes for the screws about 3 inches apart and $\frac{3}{8}$ inch from the corner (see "Drilling for screws," p. 32). Put in the top and bottom screws. Repeat for the other back corner.

2 Put the back on the floor with the sides sticking up and put the front in place. Clamp the corners, drill, and put in the top and bottom screws.

3 CUT AND FIT BOTTOM

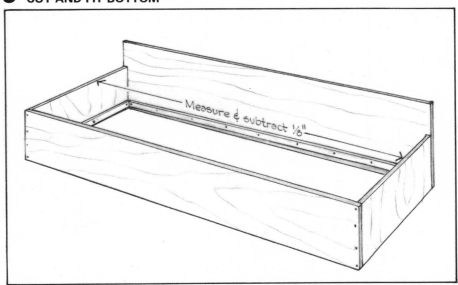

Measure & subtract ⅛"

4 MARK DRAIN

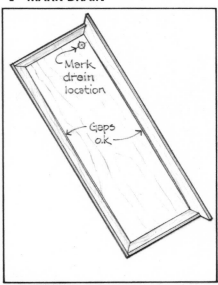

Mark drain location

Gaps o.k

3 Stand the sink upright and measure the length inside the sink as accurately as possible. Subtract $\frac{1}{8}$ inch from this measurement to find the length of the sink bottom. Cut the bottom to size and slip it into place with the good side of the plywood up. If it won't fit in easily, remove it and use the surform tool to file down the tight spots until it fits. The front and back may gap away from the bottom in the center. This will be corrected when you put in the screws. It doesn't mean the bottom is too small.

4 While the bottom is in place, label the left and right ends and mark the back corner at the low end where the drain will be. Then remove the bottom and set it aside.

5 CAULK AND JOIN CORNERS

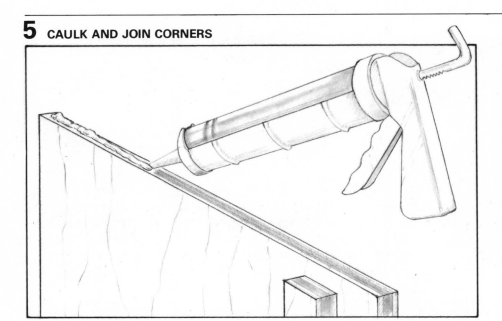

5 Remove the front. Apply a bead of caulk to the front and back edges of both end pieces (including the end of the cleat), and replace the front. Put all the screws in place. If you have put enough caulk in the joint, some will ooze out when you screw it together. Don't scrape it off. Later, after it has dried completely, cut off the excess with a sharp knife or razor. Turn the sink over, remove the back, caulk the back joints, and put in all the screws. (You can do this immediately after putting the front on—you don't have to wait for the caulk to set up.)

Assembling the corners

Installing the drain and sink bottom

The drain hole is a couple of inches in from the corner of the sink bottom so that you'll have enough working room underneath to connect the trap, and also to leave a wide-enough strip of wood around the drain hole that the corner won't break off. For the sink to drain properly, the drain must be recessed so that the top edge is flush with, or slightly lower than, the surface of the plywood.

1 CUT DRAIN HOLE

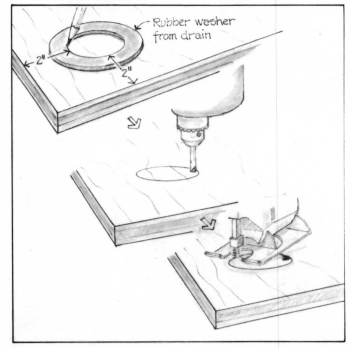

2 RECESS DRAIN

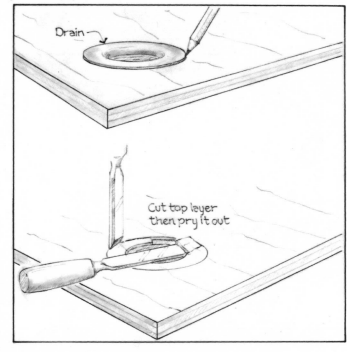

1 Find the corner of the sink bottom that you marked earlier for the drain. Measure 2 inches from each edge to locate the drain hole. Draw the circle for cutting by tracing around the inside of the rubber washer that comes with your drain. Drill through the plywood anywhere within the circle with a large bit. Then cut the hole out with a saber saw.

2 With the drain in place, draw around the top outside edge. On this line, cut through the top layer of plywood with your hammer and chisel. Then turn the chisel flat and use it to lift off the top layer. Replace the drain. If the top edge isn't flush with or lower than the wood surface, cut a little deeper. Wait to install the drain until after you paint the sink.

The bottom rests on the cleats and is held tightly in place by drywall screws that are put in from the outside of the sink. Caulk on top of the cleat waterproofs the joint. After the sink is painted another bead of caulk will be added as an extra precaution.

3 DRILL FOR SCREWS

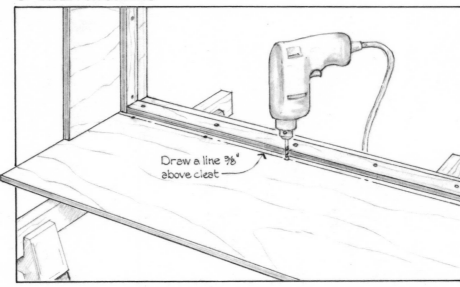

Draw a line ⅜" above cleat

3 Place the sink on a couple of sawhorses with the back down as shown. Draw a line on the inside ⅜ inch above the cleat. Along this line, drill *shank* holes (see "Drilling for screws," p. 32) every 8 inches. Draw line and drill the other three sides the same way.

4 CAULK THE CLEATS

5 INSTALL SINK BOTTOM

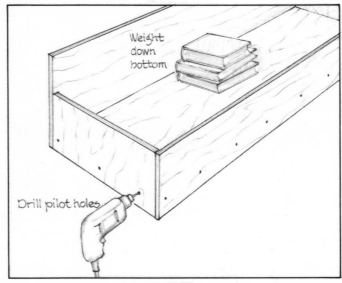

Weight down bottom

Drill pilot holes

4 With the sink upright, run a bead of caulk on the top of the cleats all the way around the sink. Make sure the caulk is in the corner where the cleat meets the sink so that it will squish *out* under the sink bottom and *up* alongside the edge when the bottom is put in.

5 Drop the sink bottom into place and press on it to be sure it is resting on the cleats. Weight it with some books or tools to keep the joint tight. Drill *pilot* holes and put in the 1⅝-inch drywall screws. Allow the caulk to set up and then trim off with a knife any excess that squeezed out of the joints. Trim around the drain, too.

Installing the drain and sink bottom

Building the sink base

The base shown here is very sturdy, with 2 × 3 legs and 1 × 4's for cross-rails. The sides of the sink rest directly on the top rails. The legs extend ½ inch higher and lock the sink in place. The bottom rail is several inches off the floor so you can clean underneath the sink easily; it will support a shelf for chemical storage. You can also build in a tray rack or other storage under the sink.

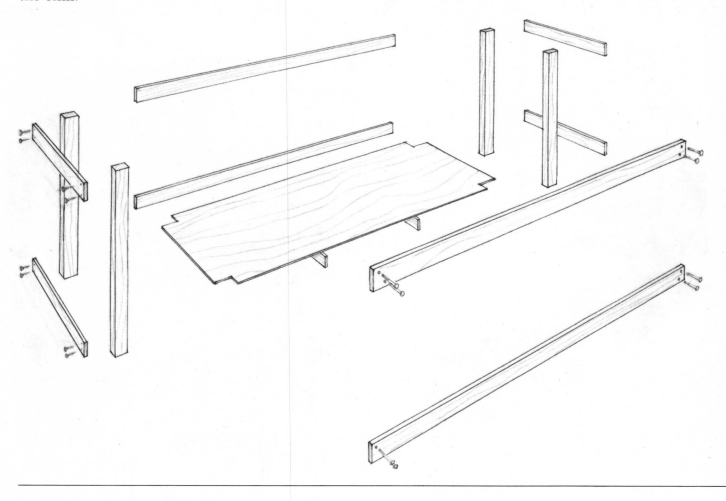

TIPS

Sloping the sink front to back When setting up your darkroom, shim the front legs (by slipping a small piece of ¼-inch plywood under each one) so that the sink slopes toward the back for better drainage. Or, you can use self-levelling *furniture glides* if you can find them. These glides are on threaded shafts so that the legs can be raised or lowered individually.

Determining the sink height A sink that is too high or too low for you will quickly be quite uncomfortable, so it's important to find your own comfortable working height. To do this, put your sink on a countertop or table. Put a tray in it and go through the motions of developing a print. Set the leaning rail in place on the front edge and try leaning on it. If the height isn't right, move the sink to a different table or jack it up with books until you find a height that is. Often the sink will be at a comfortable working height if you put the leaning rail an inch or two below the level of your elbow. Measure from the floor to the bottom edge of the sink for the length of the sink legs.

The base pieces

You will need four long rails (two front and two back) and four short rails for the ends. From each 8-foot length of 1 × 4, cut one long rail and one short rail. Sight down each board. If one end is a little crooked, use th.. end for the short rail so that the long rails will be as straight as possible.

Since the base must fit the sink as closely as possible, we haven't given exact measurements for length and width. Instead, hold the rails up to the sink and mark them for cutting following these instructions.

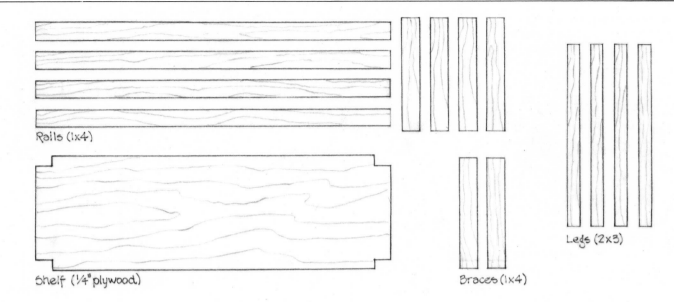

Rails (1x4)

Shelf (¼" plywood)

Braces (1x4)

Legs (2x3)

1 CUT RAILS

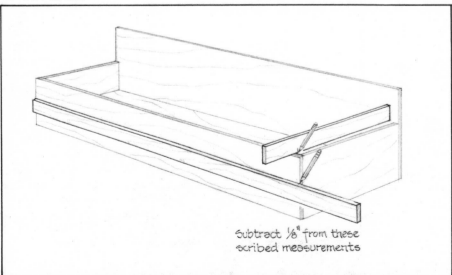

Subtract ⅛" from these scribed measurements

2 CUT AND MARK LEGS

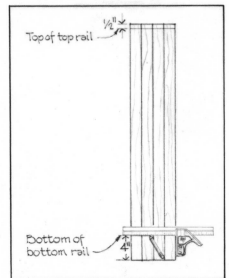

Top of top rail — ½"

Bottom of bottom rail — 4"

1 From the 1 × 4's, cut four rails (two front and two back) that are ⅛ inch shorter than the overall length of the sink. Next, cut four end rails that are ⅛ inch shorter than the *inside width* of the sink.

2 Square off one end of each 2 × 3 and cut the four legs. (For the length, see "Determining the sink height," above.) Set all four legs on your work table with bottom ends flush as shown. Measure 4 inches from the bottom and draw a line all the way across all four legs. This marks the bottom edge of the bottom rails. Measure ½ inch from the top (if the tops are uneven measure from the longest one) and mark a line across all four legs. This is the top edge of the top rail.

Building the sink base (cont.)

The sink is one of the largest items in a darkroom. If you ever move to new quarters, you will probably want to disassemble it for moving. That's why the sink and the base are separate. That's also why our instructions tell you to assemble the end sections of the base permanently with glue and screws and then to attach the front and back rails with bolts that can be removed. (Any time you disassemble the base, remember to label both pieces of each joint with an identifying mark so you can tell exactly how to put it back together.)

3 ASSEMBLE END SECTIONS

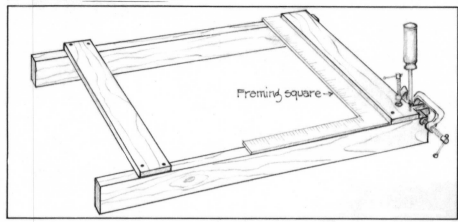

Framing square →

3 Place two legs on edge with the end rails across them. Clamp one joint together, making sure the end of the rail is flush with the side of the leg. Use a framing square to square up the corner. Drill for two drywall screws. Stagger these holes so the screws won't split the wood. Put glue in the joint and screw it together. Repeat the process for the other three joints. Assemble the other end section the same way.

4 ATTACH FRONT AND BACK RAILS

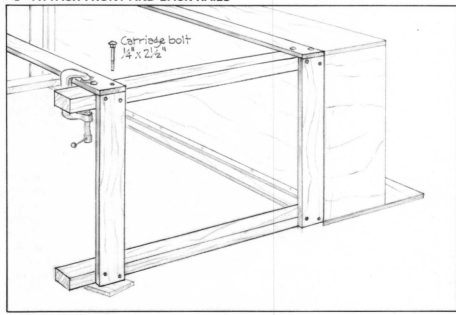

Carriage bolt
¼" x 2½"

5 BEVEL THE LEGS

Bevel with plane

4 Place the sink on the floor with the back side down as shown. Put the end sections of the base in place with a scrap of 1 × 4 under the back legs. Clamp one end of the front top rail in place, making sure the end of the rail is flush with the face of the cross-rail. Check the corner with the framing square. Drill for the carriage bolts using a ¼-inch bit. Stagger the holes, locating them so that the bolts won't hit the screws. Insert the carriage bolts and tap them a couple of times with a hammer to set them. Then put on the washers and nuts from underneath. Attach the lower front rail the same way. Then turn the sink and base over and bolt the two back rails in place.

5 If the sink won't slip onto the base easily, use your plane to bevel the top edges of the legs as shown.

The bottom shelf

A shelf beneath the sink is essential for storing chemicals, trays, developing tanks, beakers, and anything else that's used on the wet side of the darkroom. But don't plan to use space under the sink for dry storage. Drips from wet objects and possible chemical contamination make it unsatisfactory.

The bottom shelf is a sheet of ¼-inch plywood that rests on the bottom rails of the sink base. Braces across the center keep it from sagging.

6 CUT AND ATTACH BRACES

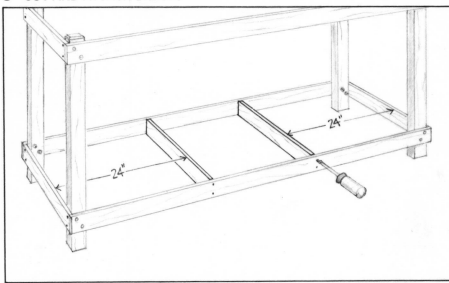

24"
24"

6 Measure and cut two 1 × 4 braces to fit across the short dimension of the sink base between the base rails. Position them as shown. Drill and put two drywall screws through the rails into the ends of the braces.

7 Cut a piece of ¼-inch plywood to the outside dimensions of your sink base (measuring to the *outside* of the rails). This piece will be approximately 23½ × 67½ inches if you followed our design. Cut out the corners so that the shelf will fit around the legs of the sink. Make the cutouts about ⅛ inch larger than needed for an easy fit.

8 Drop the shelf into place good side up. Drill and fasten with drywall screws about every 24 inches.

7 CUT SHELF

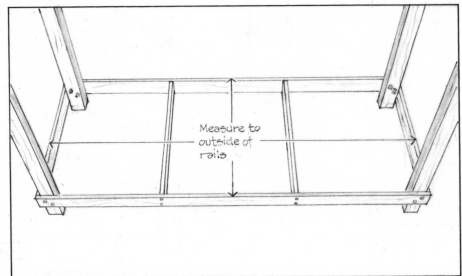

Measure to outside of rails

8 ATTACH SHELF

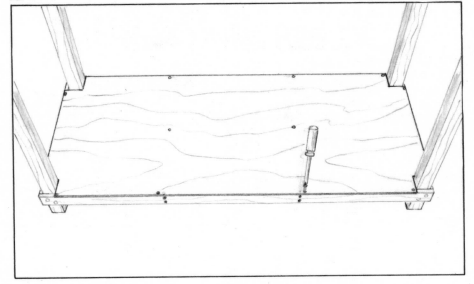

Building the sink base (cont.)

Finishing touches

Painting and caulking

The finish you use on the inside of your sink should be both waterproof and chemical resistant. Some commonly used finishes are polyester resin, epoxy paint, and marine enamel. The resin forms an effective coating, but the fumes when you apply it are noxious and the resin tends to crack if you move or twist the sink. After talking with photographers and boatbuilders, we recommend using three coats of a heavy-duty epoxy paint (such as PPG's Coal Tar Epoxy), or an initial coat of epoxy waterproof sealer (such as Gluvit) followed by two or three coats of marine enamel. Your sink will have to be repainted occasionally. Use any color you want.

If you are building wooden *duck-boards* (pp. 126–127), or a *water supply panel* (Chapter 10), plan to paint them at the same time you paint the sink to make the best use of the epoxy paint (which must be mixed ahead of time and then used within a certain number of hours).

For the outside of the sink and the sink stand, less-expensive alkyd paint is sufficient. If you're concerned about the appearance of the outside of the sink, fill the cracks and knot-holes with latex caulk and sand the surface before painting.

After the paint has dried completely, seal all joints on the inside of the sink with silicon caulk (the same caulk used to build the sink).

1 PAINT AND CAULK SINK

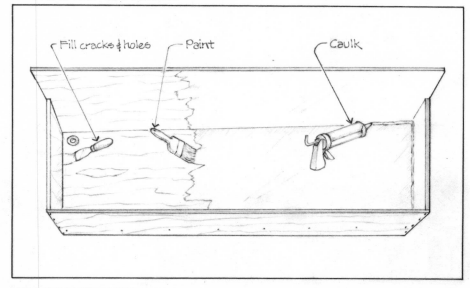

Fill cracks & holes — Paint — Caulk

1 Cut off any caulk that squeezed out of the inside joints when you built the sink, and sand off caulk that may have smeared on the inside surfaces of the sink. (Paint will not stick to this caulk.)

Use latex caulk or wood filler to fill any gouges, cracks, or imperfections on the inside surfaces of the sink. Also fill the top edges of the sink. Allow to dry, then sand any rough edges. Wipe with a damp cloth to remove dust before painting.

Apply three or four coats of epoxy or marine paint to the inside of the sink, the backsplash, and the top shelf, following the instructions with your paint. Finally, caulk all joints on the inside of the sink.

2 ATTACH LEANING RAIL

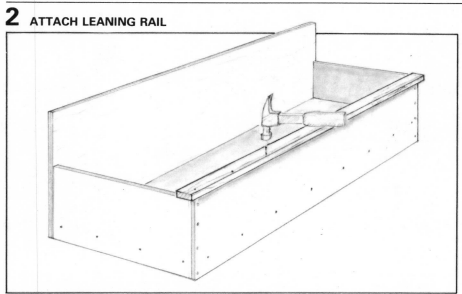

2 Cut your leaning rail about 1 inch longer than your sink. Plane it to remove sharp edges and corners. Then sand it smooth. Finish it with polyurethane or the same paint you used inside the sink. Attach the leaning rail to the front of the sink with glue and 4d finish nails. The front edge of the rail should extend past the front of the sink $\frac{1}{4}$ to $\frac{1}{2}$ inch.

The top shelf and faucet

A shelf above the sink supports the faucet and holds other paraphernalia. However, if you plan to have a temperature control unit, water filters, and additional faucets, you will probably want to attach them to a *water supply panel* on the back of your sink (see Chapter 10). In this case, it's best to wait and see how a shelf will fit in.

3 INSTALL FAUCET

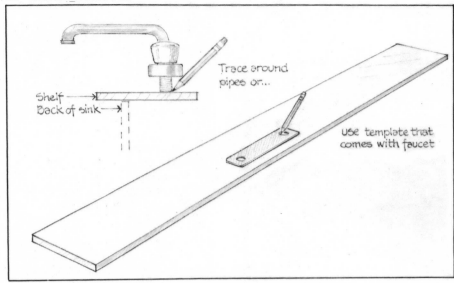

3 Hold the faucet in place on the shelf with the nozzle extending a couple of inches beyond the front edge of the shelf. Trace around the pipes (or the template that comes with most faucets) to determine where to drill. Drill holes for the faucet. Put it in place and attach the nuts below the shelf.

4 INSTALL SHELF

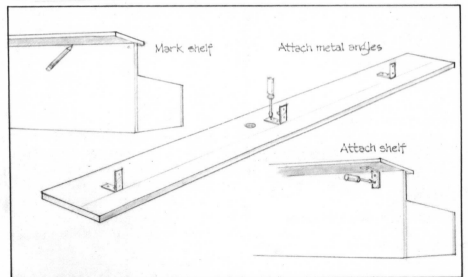

4 Rest the shelf on top of the backsplash so that it extends forward an inch or two. Make sure there's enough room behind the backsplash to turn the faucet nuts with a wrench. Draw a line on the underside of the shelf where it meets the back of the sink. Check to be sure the line is parallel with the edge of the shelf.

Remove the shelf and take the faucet off. Mount the shelf with three 3-inch metal angles as shown. Then remount the faucet.

Hooking up to plumbing: The water supply

The best way to tie into your house water supply and drainage system depends on the kind of plumbing available in your darkroom. Running hoses to an existing washing machine outlet, tub, or sink is quick and simple. Tapping into existing house plumbing and installing new pipes can be done in several different ways, most of which are beyond the scope of this book. A few simple plumbing methods are discussed on the following pages.

If your plumbing needs aren't answered here and you still want to tackle this project yourself, two books that you may find helpful are *The Darkroom Handbook* by Dennis Curtin and Joe De-Maio (for plumbing information that relates specifically to darkrooms), and *Plumbing* from Time-Life Books's Home Repair and Improvement Series (for general plumbing information).

Water supply

The ideal situation for your darkroom is to have hot and cold spigots there already. If you are so lucky, all you have to do is buy two high-pressure washing machine hoses to connect the hot and cold sides of your faucets. (It's a good idea to turn off your water at the wall spigot when you're not using the darkroom because water pressure in the hoses over a long period of time can cause them to split.) You can, instead, make this connection with copper tubing.

The next-best situation is to have hot and cold water supply pipes running through the room or in the wall. You can recognize them because they will be small pipes—1 inch or smaller in diameter—and they usually run par-

allel several inches apart. To be sure you have the right pipes, turn on the faucets they supply and listen to see if there is water running in the pipes.

You can tap into the water supply pipes yourself with *saddle tee assemblies*, shown here. You can then make the connections to the sink faucet with washing machine hoses or copper tubing.

If your darkroom doesn't have water supply lines nearby, you have a big job ahead of you. Call in a plumber to do the work or to consult with you about the best way to do it yourself.

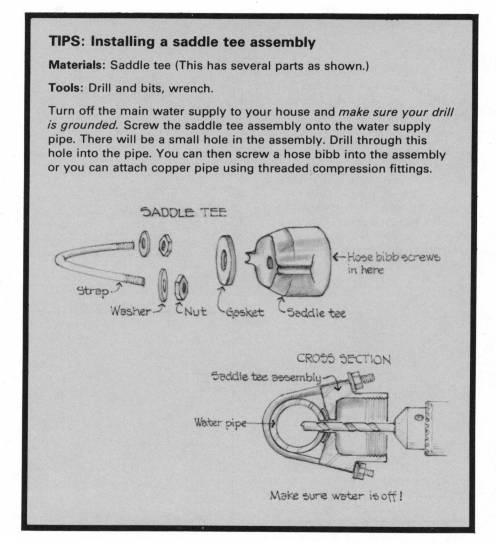

TIPS: Installing a saddle tee assembly

Materials: Saddle tee (This has several parts as shown.)

Tools: Drill and bits, wrench.

Turn off the main water supply to your house and *make sure your drill is grounded*. Screw the saddle tee assembly onto the water supply pipe. There will be a small hole in the assembly. Drill through this hole into the pipe. You can then screw a hose bibb into the assembly or you can attach copper pipe using threaded compression fittings.

SADDLE TEE

Strap

Washer Nut Gasket Saddle tee

←Hose bibb screws in here

CROSS SECTION

Saddle tee assembly

Water pipe

Make sure water is off!

1 HOOK UP YOUR SINK FAUCET

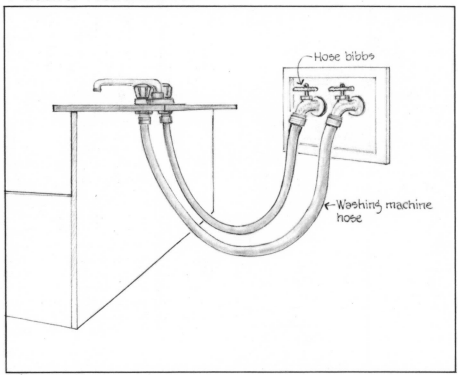

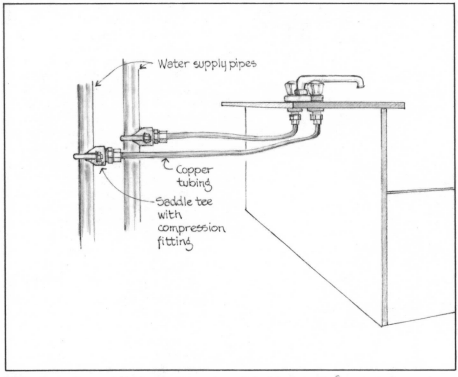

With washing machine hoses
Screw the hoses onto the faucet inlets at one end and hose bibbs at the other end. If you don't already have hose bibbs in your darkroom, have a plumber install them for you or install your own, using a saddle tee assembly (see opposite). You may need an adaptor to attach the hose to the sink faucet.

With pipe Several kinds of pipe can be used between the water supply lines and your sink faucet. **Copper tubing** is flexible (no joints are required to turn corners) and it can be installed with compression fittings (threaded joints that do not require soldering or cementing). You will need ⅜-inch (outside diameter) copper tubing, 2 compression fittings the right size to join ⅜-inch tubing to your saddle tees or hose bibbs, 2 compression fittings the right size to

join ⅜-inch tubing to your faucet inlets, and a wrench. See page 138 for instructions.

Plastic water supply pipe is also easy to work with and it will maintain hot water temperature better than copper over distances of several feet. Only CPVC can be used for hot water supply lines. For instructions, see "Working with pipe," p. 124. *Note:* In some states plastic pipe is illegal.

Hooking up to plumbing: The drain

If your darkroom has an existing tub, sink, or floor drain, or a standpipe drain (a vertical pipe installed for a washing machine), drain your sink into it with a rubber hose attached to the sink drain. This won't work if the existing drain is higher than the bottom of your sink.

If no drain is available, a drain pipe from your sink to the existing drainage system will have to be installed. Even if you choose to do this work yourself, consult a plumber first—drainage systems can be tricky. The following basic information will help you figure out what you need:

Trap Your sink must have a trap (a U-shaped bend in the drain pipe) underneath it. The trap holds water in it as a seal to keep sewer gas from backing up through the drain. If this water seal were siphoned out of the trap by unequal pressure in the drainage system, gases from the sewer could enter your darkroom, making it smelly and unhealthy.

Venting Your drainage system is connected to a vent system that maintains the air pressure in the drain pipes and keeps the water seal in the trap from being siphoned off. Each new fixture must be connected to the vent system by a *vent pipe*. This pipe runs from the drain pipe (at a point near the fixture) to a main vent, which exits through the roof of the house.

Distance from trap to vent The drain pipe from the sink must slope downwards at a rate of ¼ inch per foot. However, the total drop from the trap to the point at which the vent is attached should be no more than one pipe diameter. Otherwise, the vent can't maintain the necessary air pressure on the trap. For 1½-inch pipe (the size specified by most local codes for sink drains), the distance from the trap to the vent should be no more than 3 feet 6 inches.

Buying a trap A trap has three parts: the tail piece, which needs to be the same size (probably 1½ inch) as the tail piece on your sink drain; the J-bend, which is the curved piece; and the trap arm, which runs over to the drain stack. Trap arms come in several lengths—measure the distance from your sink drain to the drain stack and ask the salesperson to help you figure out what length to buy.

Trap assemblies are made of metal or plastic. Buy plastic if it is legal in your state—it withstands chemical corrosion better than metal.

Be sure the trap assembly you buy has threaded joints. *Note*: If you are using plastic, the trap arm may need to be extended with a pipe that is not threaded. In this case, buy an extension pipe a few inches longer than you need. See the instructions to the right for "Working with plastic pipe."

TIPS: Working with plastic pipe

Materials

Pipe For drains, buy ABS (acrylonitrile-butadiene styrene); for water supply pipe, buy CPVC (chlorinated polyvinyl chloride).

Cement Buy the one designated for the kind of pipe you are using.

Measuring and cutting
Measure the length of pipe needed between two fittings. Add the lengths of pipe that will be inside the fittings at both ends. Cut the pipe with a miter box and back saw. (A hack saw will also work.) Scrape off burrs on the cut edges with a pocket knife.

Joining the pipe
Position the fitting on the pipe and mark both pieces as shown so that you will be able to align them the same way. Lightly sand the end of the pipe and the inside of the fitting. Wipe off dust with a clean, dry rag. Do not touch the sanded areas—moisture keeps cement from bonding.

Apply a thin coat of cement on the inside of the fitting and a heavy coat on the end of the pipe. Put the fitting on the pipe, turn it a half turn to spread the cement evenly, and line up the marks. A small bead of cement should squeeze out all the way around. Hold the joint together for at least a minute. Wait several hours to put water in the pipe.

Tools

- Tape measure
- Pencil
- Back saw and miter box
- Clean rag
- Fine sandpaper
- Hog bristle brush (1 inch wide for drain pipe, ½ inch wide for water supply pipe)

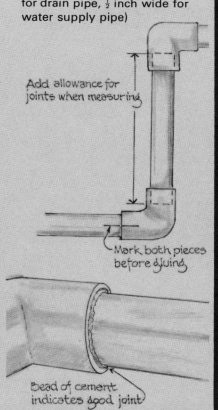

Add allowance for joints when measuring

Mark both pieces before gluing

Bead of cement indicates good joint

2 INSTALL SINK DRAIN

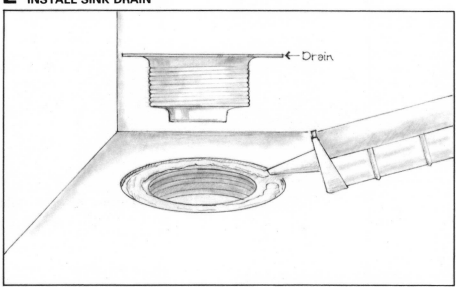

2 Apply a bead of caulk around the drain opening and put the drain in place. Slip the rubber washer on underneath the sink bottom and put on the metal nut that holds it all in place. Some drains come with another metal piece that screws on behind the nut. This is for attaching the trap to your drain.

3 CONNECT TO EXISTING DRAIN

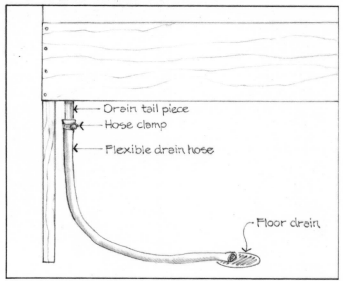

3 (ALTERNATE) INSTALL TRAP ASSEMBLY

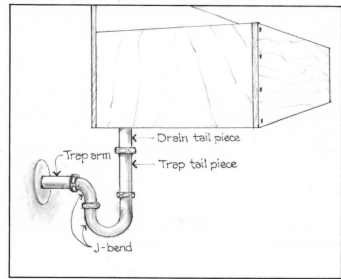

3 To use an existing drain, you will need a 1½-inch (inside diameter) flexible rubber hose (if your plumbing supply store doesn't stock this size, try an auto supply store), a hose clamp, and a flat-head screwdriver. Be sure there is some space between the end of the hose and the water in the existing drain trap. (This will prevent suctioning.)

3 (alternate) Have a plumber adapt the drain stack for the new drain and install the necessary venting. You can also install the trap yourself with a metal or plastic trap assembly (see "Buying a trap" above) and a pipe wrench or large adjustable wrench. Make the connection to the drain stack first (an adaptor may be needed). Then install the trap.

Hooking up to plumbing: The drain

Duckboards

Duckboards, in darkroom talk, are wooden slats for trays to sit on in the sink. They raise the trays an inch or so above the sink bottom so that water can drain beneath them. Duckboards also protect the bottom of your sink from getting nicked or scratched. They should be at least 6 inches shorter than your sink in each direction. We suggest building them in 2-foot sections for greater flexibility.

Below are step-by-step instructions for quickly and easily building duckboards out of 1 × 2 lumber and half-round, plus a couple of suggestions for ready-made alternatives if you don't want to build your own.

Materials and supplies

1 × 2 lumber (one piece, about 6 inches shorter than your sink)

½-inch half-round (two 8-foot lengths for each 2-foot section of duckboard)

Epoxy glue or other waterproof glue

1-inch wire brads

Epoxy paint or polyurethane

Tools

- Tape measure
- Pencil
- Combination square
- Drill and a ½-inch bit
- Saber saw
- Sandpaper
- Paintbrush

Ready-made alternatives

If you don't want to build your own duckboards, a faster alternative is to buy some ready-made item that is waterproof and chemical resistant and adapt it for use in your sink. Here are two ideas:

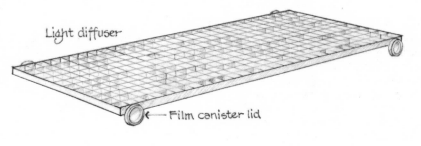

Light diffuser

Film canister lid

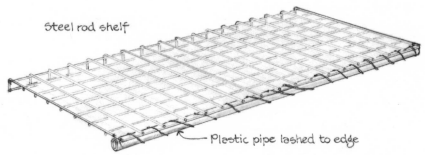

Steel rod shelf

Plastic pipe lashed to edge

Plastic grid light diffusers are available in home supply stores in standard-size panels. Add rubber feet to lift the panel off the bottom of the sink or glue caps from plastic film canisters along the long sides as shown, using a strong epoxy or waterproof crafts glue.

Plastic-coated steel rod shelves for closet storage are widely available in various sizes. To raise the shelf above the sink bottom, buy a length of plastic pipe about ⅜ inch diameter and fasten it under the long edges of the shelf with plastic-coated wire as shown.

1 MEASURE AND DRILL 1 × 2 SIDES

1x2 24" long

1 Draw a line down the center of the 1 × 2 as shown. Starting 1 inch from the end, draw cross-marks 2 inches apart on the center line. On each cross-mark, drill through the 1 × 2 with a ½-inch bit.

2 CUT 1 × 2 AND HALF-ROUND

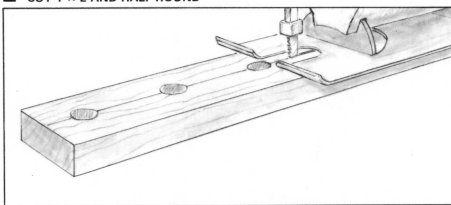

2 Along the center line, cut the 1 × 2 in half as shown. Sand any rough edges. Cut the half-round into 16-inch lengths.

3 GLUE DUCKBOARDS TOGETHER

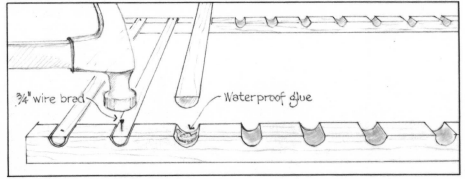

¾" wire brad

Waterproof glue

3 Set the 1 × 2 pieces on edge and glue and nail the half-round in place as shown. Make sure the ends of the half-round are flush with the sides of the boards.

4 WATERPROOF DUCKBOARDS

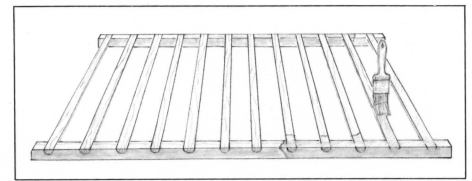

4 Wait 24 hours to allow the glue to cure completely. Then paint the duckboard with epoxy paint (to use the paint most efficiently, paint it when you paint the sink) or coat it with polyurethane. It will need re-painting occasionally.

Variations: Tray storage and other sinks

If you want vertical tray storage under your sink, you can install tracks and removeable panels at one end of the shelf.

Materials

¼-inch plywood or masonite for the top panel and the partitions. Sizes depend on how much storage you want.

Parting stop (⅜ × ¾ inch or ½ × ¾ inch) 8 feet for each partition

Wire brads ⅜-inch brads with ⅜-inch parting stop, and ¾-inch brads with ½-inch parting stop

1¼-inch drywall screws or #8 screws to attach the top panel every 12 to 15 inches

Alkyd paint

Tools

- Tape measure
- Pencil
- Saber saw
- Straightedge
- Hammer
- Screwdriver
- Paintbrush

Cut the strips of parting stop a couple of inches shorter than the width of your shelf and space them as shown measuring 4 inches from the first strip in one pair to the first one in the next pair. Use the thickness of the partitions to determine the narrow spacing. Glue the strips down and nail them in place with wire brads.

For the top of the tray storage, make a corresponding panel of ¼-inch plywood with strips spaced exactly the same. Screw this panel into the bottom edge of the upper rails of your sink base.

Cut the vertical partitions. Paint all parts of the tray storage with the same paint you used on the sink base. Slip the partitions into place.

The bottom shelf and the upper tray support panel can be removed if you ever need to disassemble the base for moving.

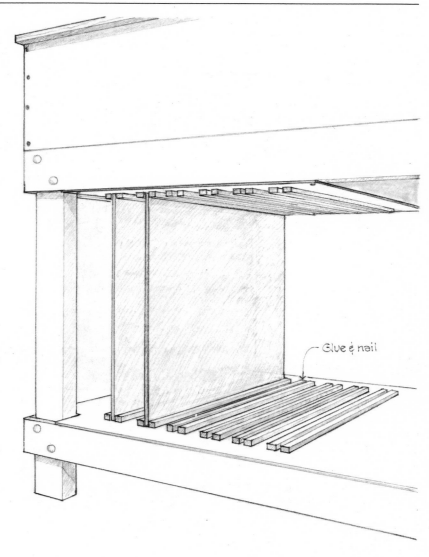

Glue & nail

If you have space in your darkroom, you will probably want a longer sink. Even if you don't need that much space for your trays, the extra space is useful for washing prints and mixing chemicals.

If your darkroom is closet-sized, though, you may want to build a short sink. In this case, you can use a rack to hold your developing trays one above the other. The diagrams on this page show you how to cut the plywood pieces for these sinks. (For pointers on cutting plywood, see pp. 38–39.) To assemble the sink, follow the instructions on pp. 110–115.

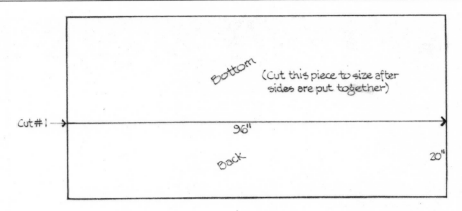

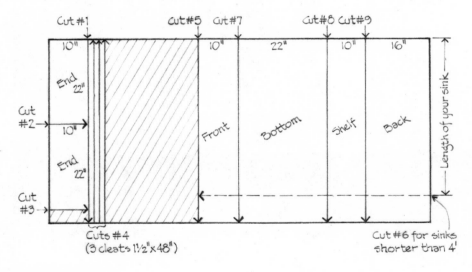

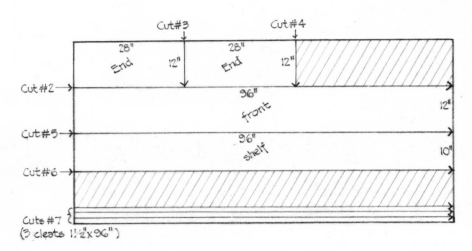

A short sink

With this cutting diagram, you can build a sink 4 feet long, or shorter. Make the cuts in the order we've numbered them, and trim the bottom to fit only *after* you've assembled the sides. Make cut #6 only if your sink is to be less than 4 feet long.

A long sink

For an 8-foot sink, you'll need two pieces of ¾-inch AC exterior plywood. Here's a cutting diagram. Make the cuts in the order we've numbered them to avoid awkward cutting situations. Don't cut the lengths of the bottom until after you've assembled the sides.

A water supply panel

If the only plumbing in your darkroom is a faucet or two, the easiest way to put it together is to mount the faucets on or above your sink and run the water supply lines behind the backsplash as shown in Chapter 9.

But as soon as you add a temperature control unit, you have an entirely new situation: suddenly you need outlets for the temperature-controlled water as well as a faucet for unregulated water, water supply pipes, and a filter. You can build all of this into your darkroom or you can attach all of the plumbing to a plywood water supply panel that sits above your sink. The advantage of the water supply panel is that you can just unscrew the supply hoses and take the panel with you if you ever move to another darkroom.

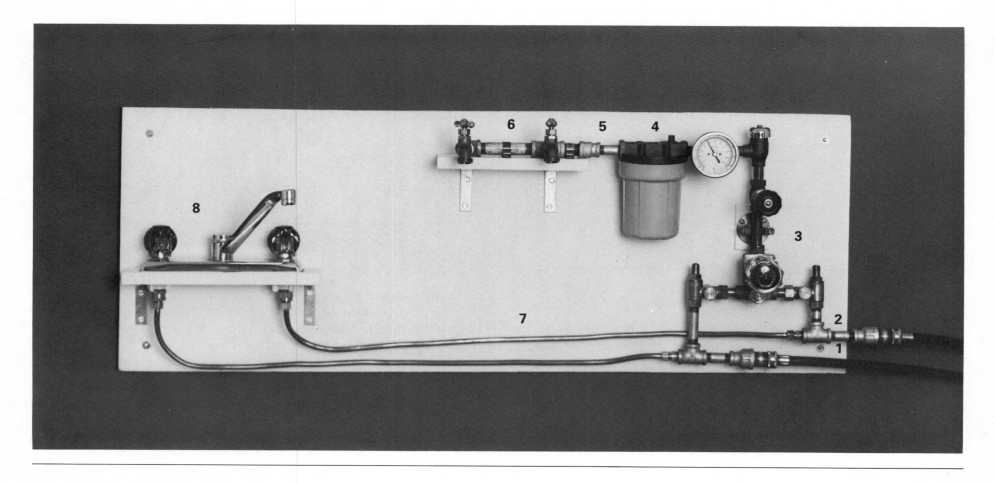

Layout

The water supply panel will supply temperature-controlled water to one end of the sink (the print-washing end) and unregulated water to a faucet near the center of the sink. The panel shown here is 48 inches long, 18 inches high and will work for a sink up to 72 inches long. A longer sink requires a longer piece of plywood and longer copper tubing. All other pieces will be the same.

You can reverse this design and put regulated water at the left end of the board if your print washer is at the left end of your sink.

The components

1 Two washing machine supply hoses carry hot and cold water from your water supply to the water supply panel. Instead of rubber hoses, you can use ⅜-inch (outside diameter) copper tubing and compression fittings. This latter solution is more permanent and less likely to leak.

2 Threaded fittings (of galvanized steel) between the washing machine hoses and the temperature control serve two purposes: they reduce the pipe size from ¾ inch (the size of the washing machine hoses) to ⅜ inch (the size of the temperature control unit inlets). They also divert water to the unregulated faucets.

3 The temperature control unit mixes hot and cold water to the temperature you set and maintains water temperature within a close tolerance. The one on the facing page is the Meynell Photomix Model 157, which is suitable for home use. (Order from Meynell Valves, Inc., 58 State St., Westbury, N.Y. 11590.)

4 The water filter removes sediment and impurities from the water. If your temperature control unit can mix unfiltered water, the filter can be mounted between the control unit and the hose bibbs as shown in the photograph. If instructions with your control unit specify that water must be filtered *before* it enters the unit, you will need to install filters on the hot water and cold water supply lines leading to the control unit.

5 Threaded fittings between the filter and the hose bibbs enlarge the pipe size from ⅜ inch (the size of the filter outlets) to ½ inch (the size of the hose bibbs).

6 Two hose bibbs are outlets for *temperature-regulated water*, which is used for mixing chemicals, washing prints and film, or running a water bath. These outlets are most useful at one end of your sink—the same end as the print washer. Attach rubber hoses to one or both outlets to take the water where you need it.

7 Copper tubing carries unregulated water to the faucet. It is joined to the water supply pipe at one end and to the faucets at the other end by compression fittings.

8 A regular sink faucet is the outlet for *unregulated water*, which is used for cleaning trays and equipment and washing out the sink. It should be near the center of the sink with a hose attachment or sprayer to reach the ends of the sink.

TIPS

Buying a temperature control unit

A temperature control unit is an expensive precision item. Here's what to look for when you buy one:

Size In a home darkroom, you probably use between ½ to 2½ gallons of water per minute. Temperature control units will not work accurately below the stated minimum flow rate, so it's important *not* to get one that is too large. (Larger units are made for industrial use.) If you're uncertain how much water you use, measure it before you order the unit.

Pressure sensitivity The pressure in home water supply pipes fluctuates—especially when other fixtures in the house are in use. Be sure the unit you buy is designed to deal with these pressure fluctuations.

Filters Before you buy a temperature control unit, find out if it requires filtered water. If it does, you will need to buy two water filters—one for the hot water line and one for the cold water line. Some temperature control units have built-in strainers to protect the valve and to allow them to mix unfiltered water. In this case, you need only the one filter shown.

Thermometer The temperature control unit in the photograph has an *in-line thermometer*. This thermometer accounts for about a third of the cost of the unit. To save money, you can buy the control unit without the thermometer and set the temperature by holding a good darkroom thermometer in the water coming out of the faucet.

Use Temperature-regulated water may drop slightly in temperature between the regulating unit and the end of the hose. Check the actual water temperature when setting the unit. Follow all instructions with your temperature control unit. It can easily be damaged. Because washing machine hoses can split or crack, turn off the water supply to the hoses after each printing session.

Buying a water filter

Hot water filters cost quite a bit more than cold water filters. For this project you need to filter *warm* water, so which kind do you buy? As long as the cold water filter can withstand the hottest temperatures that your control unit puts out, you can use it. Many cold water filters can handle temperatures up to 125° F and most photographic temperature control units don't mix water any warmer than 125°. Check the maximum temperature on your control unit before buying the filter.

A water supply panel

Getting ready

All of the fixtures and fittings are mounted on a sturdy piece of plywood. The number of plumbing pieces is kept to a minimum and only screw-on connections are used. *There is no soldering or gluing involved.*

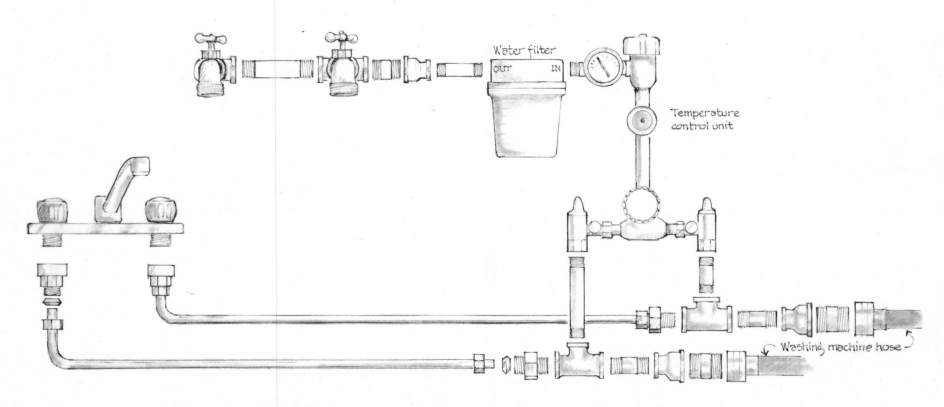

Water filter

OUT IN

Temperature control unit

Washing machine hose

Mounting details not shown here

TIME: 4 to 8 hours
COST: High
DIFFICULTY: Moderate

Tools

- Tape measure
- Pencil
- Straightedge
- Combination square
- Saber saw
- Drill and bits
- Screwdriver
- Hack saw
- Pipe wrenches (Two pipe wrenches, or a pipe wrench and a pair of vise-grip pliers, are the preferred tools. But you can get by with large slip-joint pliers. We did.)

Materials and supplies

$\frac{3}{4}$-inch plywood ($\frac{1}{4}$ sheet)

1 × 4 lumber (A 2-foot length is enough. You may be able to use scraps from another project.)

Epoxy paint or marine enamel the same paint used for sink (Chapter 9)

Temperature control unit (See tips on buying one, p. 131) with mounting bracket and $\frac{3}{4}$-inch screws

Water filter (See tips on buying one, p. 131.)

Sink faucet (Buy a good-quality one. A spray hose attachment is handy for cleaning up.)

Hose bibbs (2) with $\frac{1}{2}$-inch inlet and male threads

Washing machine hoses (2)

$\frac{3}{8}$-**inch (outside diameter) copper tubing** (an 8-foot length)

3-inch metal angles (4) (If the angles don't have screws with them, buy sixteen $\frac{3}{4}$-inch # 8 screws, also.)

$\frac{3}{8}$ × $\frac{3}{8}$-**inch compression fittings** with male threads (2)

Compression fittings (2) the right size to join $\frac{3}{8}$-inch (outside diameter) copper tubing to your faucet inlet.

1-inch metal straps (2)

$\frac{3}{4}$-**inch #8 round-head screws** (4)

1 × 2 lumber One 4-foot length

1 × 4 lumber One 4-foot length

$\frac{1}{4}$-**inch × 2$\frac{1}{2}$-inch carriage bolts** (5)

Pipe joint compound

Fittings All of the following are threaded, galvanized steel plumbing fittings available in plumbing stores and in many home supply stores. See "Kinds of fittings" (right) for a description of each type.

$\frac{3}{4}$ × 1$\frac{1}{2}$-inch nipples (2)
$\frac{3}{8}$ × 1$\frac{1}{2}$-inch nipples (3)
$\frac{3}{8}$ × 3-inch nipple (1)
$\frac{3}{8}$ × 2-inch nipple (1)
$\frac{1}{2}$ × 1$\frac{1}{2}$-inch nipple (1)
$\frac{1}{2}$ × 4-inch nipple (1)
$\frac{3}{4}$ × $\frac{3}{8}$-inch reducing bells (2)
$\frac{1}{2}$ × $\frac{3}{8}$-inch reducing bell (1)
$\frac{3}{8}$-inch tees (2)
$\frac{1}{2}$-inch tees (1)
$\frac{1}{2}$-inch elbow (1)
$\frac{3}{8}$-inch plugs (2)

Kinds of fittings

The following list describes fittings that are used in the water supply panel; *male* fittings have external threads and *female* fittings have internal threads.

Female threads

Male threads

Reducing bell For joining two different sizes of pipe. Has female threads at both ends. ▶

Nipple A short length of pipe with male threads at both ends. ▶

Tee Right-angle junction between three pipes. Has three equal-size female threads. ▶

Elbow Used for turning a corner. Has female threads at both ends. ▶

Plug Used to close off the end of a pipe. Has a male thread. ▶

Compression fitting A brass fitting used to join copper tubing to a threaded fitting. May have male or female threads. ▶

Assembling the water supply panel

The threaded joints described below must be tight to be waterproof, and putting them together takes some muscle. If you're not especially strong, you may want to call a brawny friend to help you with this part of the project.

Joining the threaded fittings

Pipe dope should bead up

The threaded joints will leak a little bit of water unless you waterproof them with *pipe joint compound* (also known as *pipe dope*) when you put them together. This is a messy job, so keep a rag nearby for cleaning off your hands.

1 Squeeze a liberal amount of joint compound onto the threads of both pieces.

2 Spread the compound into the grooves all the way around the pipe.

3 Screw the two pieces together. Tighten the joint with two pipe wrenches (or pliers) as far as it will go. A couple of rows of threads will still show when it is tight. If you have used enough pipe dope, there will be a bead of it around the joint.

Testing the threaded joints

It's easier to fix a leaky joint *before* you assemble the water supply panel than it will be after it is operating.

Test the sections of threaded fittings before hooking them up to the rest of the panel, as shown below.

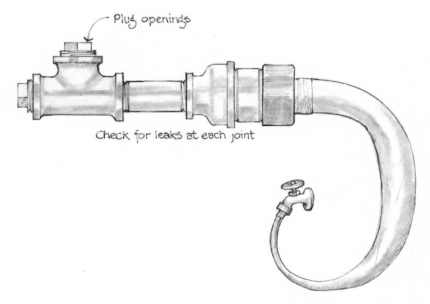

Plug openings

Check for leaks at each joint

Close all but one opening with threaded plug fittings. Then take the assembly outside and attach it to a faucet with one of the washing machine hoses. Turn on the water and check each joint. You can fix a leaky joint by tightening it more or by taking it apart, putting more pipe dope on the threads, and retightening it.

When you're sure that all the joints are watertight, remove one of the plugs and let the water run through the pipes for a couple of minutes. This will flush out any grit or extra pipe dope inside the pipe.

1 CUT AND PAINT WOOD PIECES

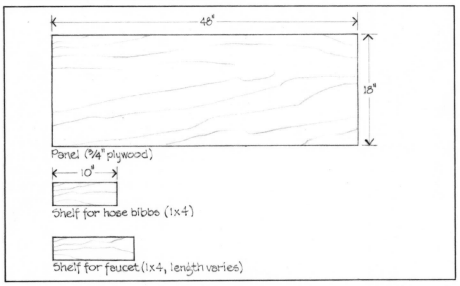

Panel (¾" plywood)

Shelf for hose bibbs (1×4)

Shelf for faucet (1×4, length varies)

1 Cut a piece of ¾-inch plywood 18 inches high and 4 feet long. (Make it longer if your sink is longer than 6 feet.) Cut a 10-inch length of 1 × 4 for mounting the hose bibbs and another length of 1 × 4 at least 2 inches longer than the base of your faucet. If your faucet has a sprayer attachment, allow extra room on this shelf for mounting it. Paint all the wood parts with the same epoxy or marine enamel that you used inside the sink.

2 DO A DRY RUN

2 Lay out *all* the fixtures, pipes, and fittings, following the diagram at the top of p. 132. Screw each joint together (loosely without any pipe joint compound) and take it apart again. This is just a check to be sure you have all the pieces and that they are the right size.

3 ASSEMBLE WATER SUPPLY SECTIONS

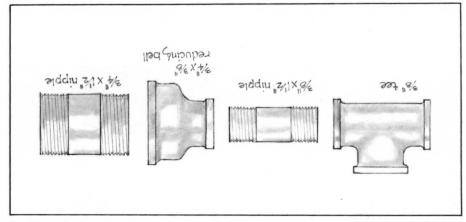

3 Put together the two water supply sections as shown (see "Joining threaded fittings," opposite). Close off the two openings in the tee with plugs and test each section to be sure the joints are watertight (see "Testing threaded joints," opposite).

4 ASSEMBLE HOSE BIBB SECTION

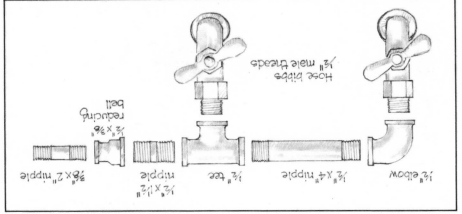

4 Put the hose bibb assembly together as shown. Then screw the ⅜-inch nipple at the end into the tee on one of the water supply assemblies so that you can hook it up to the hose to test it for leaks.

Assembling the water supply panel

Assembling the water supply panel (cont.)

5 ATTACH WATER SUPPLY ASSEMBLIES

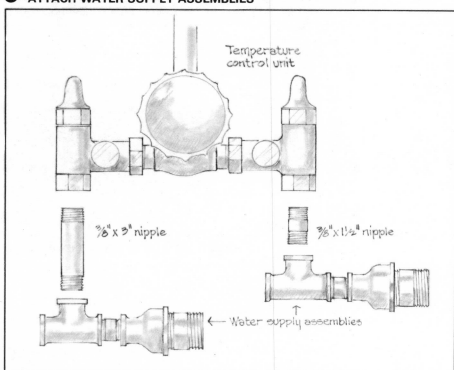

Temperature control unit

⅜" x 3" nipple

⅜" x 1½" nipple

← Water supply assemblies

5 Screw the 1½-inch nipple into the temperature control inlet nearest the edge of the board. Attach the 3-inch nipple to the other inlet. Then attach the two water supply assemblies to the nipples as shown.

6 ATTACH FILTER AND HOSE BIBBS

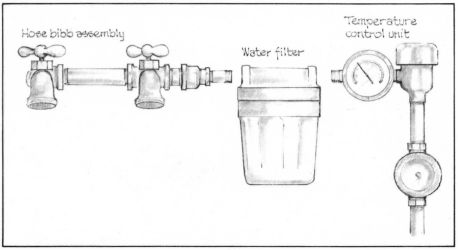

Hose bibb assembly

Water filter

Temperature control unit

6 Attach the water filter to the outlet from the temperature control unit (use joint compound). Be sure that you are attaching the *in* side of the filter, not the *out* side—the two sides often look alike.

Attach the hose bibb assembly to the water filter (use joint compound). Handle this joint *very carefully,* since the weight on both sides could strip the threads on the filter.

7 POSITION UNIT FOR MOUNTING

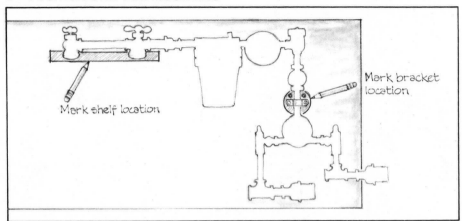

7 Place the temperature-regulated water assembly at the right end of the board. Mark the positions of the mounting bracket for the temperature control unit and of the shelf for the hose bibbs. (If the filter is so large that it causes the temperature control unit to tilt, cut a small piece of $\frac{1}{4}$-inch plywood to put under the bracket as a shim.)

8 MOUNT BRACKET

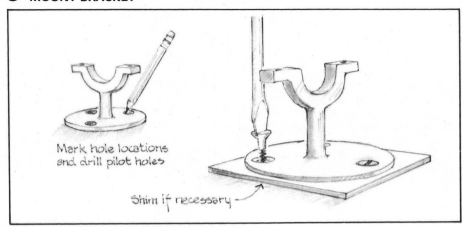

8 Drill pilot holes and screw the mounting bracket to the board with $\frac{3}{4}$-inch #8 flat-head screws (use a shim if necessary).

9 MOUNT SHELF

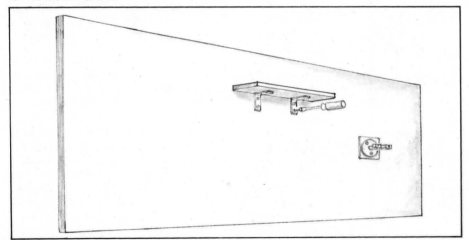

9 Drill pilot holes and screw two metal angles to the bottom of the 1 × 4 shelf. Then screw the shelf to the board in the marked position.

10 MOUNT TEMPERATURE CONTROL ASSEMBLY

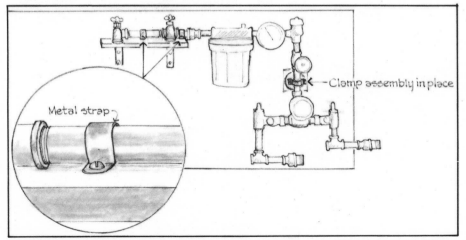

10 Put the temperature control assembly in place again as shown in step 7. Fasten the temperature control unit to the bracket. Fasten the hose bibb assembly to the shelf with 1-inch metal straps, using $\frac{3}{4}$-inch round-head screws.

Assembling the water supply panel (cont.)

Assembling the water supply panel (cont.)

Compression fittings

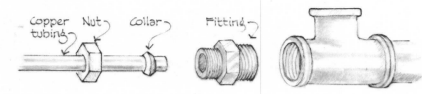

A compression fitting is used to attach copper tubing to a threaded pipe. It has three pieces: the *nut*, the *collar*, and the *fitting*. To put one together:

1 Screw the *fitting* onto the threaded pipe using pipe joint compound.

2 Put the *nut* on the end of the pipe as shown and slide it back out of the way.

3 Put the *collar* on the pipe. Slip it back about ½ inch from the end.

4 Screw the nut onto the fitting. Tighten it with a wrench.

Cutting and bending copper tubing

Cut the tubing with a hack saw. Be sure to cut it straight across, not at an angle. Then file any rough edges.

Copper tubing will bend easily, but it may crimp if you bend it by hand.

The best way to handle it is to bend it around a curved object, such as a coffee can. Bend it only in wide curves.

11 MOUNT FAUCET

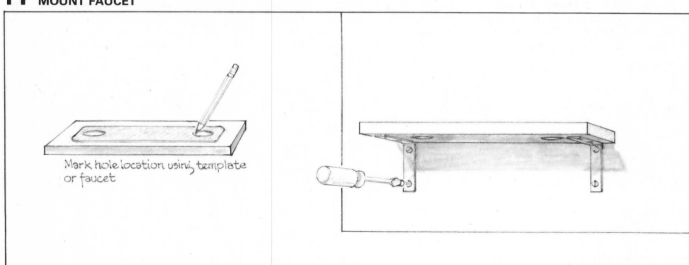

Mark hole location using template or faucet

11 Drill holes in the 1× 4 shelf for the faucet pipes. Many faucets come with a template or washer that shows you exactly where to drill and what size holes are needed.

Drill pilot holes and screw two metal angles to the bottom of the shelf, using ¾-inch #8 flat-head screws. Then screw the shelf to the plywood about 6 inches from the bottom, near the left end. Mount the faucet to the shelf following the instructions that come with the faucet.

12 CUT, BEND, AND ATTACH COPPER TUBING

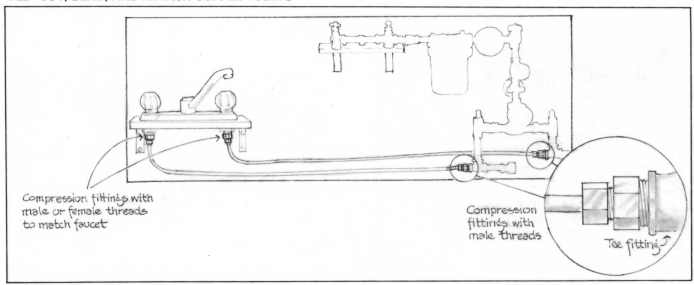

Compression fittings with male or female threads to match faucet

Compression fittings with male threads

Tee fitting

12 Cut two lengths of copper tubing each 6 inches longer than the distance from the water supply pipe to the corresponding faucet inlet (see "Cutting and bending copper tubing," opposite). Bend the tubing as shown to connect the left faucet inlet with the left water supply pipe and the right inlet with the right pipe. Keep the two pipes at least 2 inches apart (to insulate hot from cold). Join the copper tubing to the faucet inlets and to the water supply pipe with compression fittings (see "Compression fittings," opposite).

13 MOUNT WATER SUPPLY PANEL

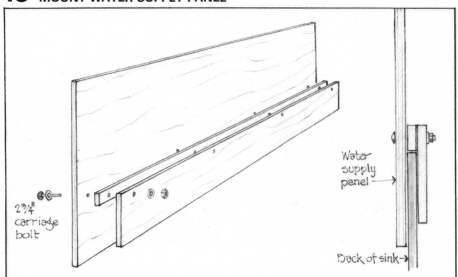

2¾" carriage bolt

Water supply panel

Back of sink →

13 The way you mount your water supply panel will depend on the kind of sink you have. Here are two possibilities:

Mounting to the sink backsplash Make a wood bracket like the one shown to the left. For the bracket, use either two strips of ¾-inch plywood (about 2 inches and 8 inches wide) or a 1 × 2 and a 1 × 8, the same length as your panel.

Hold the water supply panel in place on the sink and draw a line on the back of the panel at the top of the backsplash. This line marks the location of the bottom edge of the thin strip of wood.

Mark and drill ¼-inch holes through the panel and the two pieces every 12 inches. Bolt the bracket to the panel with 2½-inch carriage bolts. Slip the panel over the backsplash. If necessary for stability, bolt the bottom edge of the panel to the backsplash as well.

Mounting to the wall If your sink doesn't have a backsplash, mount the panel to the wall studs with lag bolts. (See p. 33 for information about lag bolts. Locating wall studs is described on p. 71.)

Assembling the water supply panel (cont.)

Print drying rack

Of the many ways to dry prints, *screen drying* (leaving the prints on a fiberglass screen to air dry) is recommended for archival processing because it offers the least likelihood of contamination. Blotters or the cloth belts on heated drum dryers build up concentrations of chemical residues (such as fixer or print flattener) that can then affect subsequent prints. Screen drying works better because the fiberglass screens don't absorb moisture and can be easily washed.

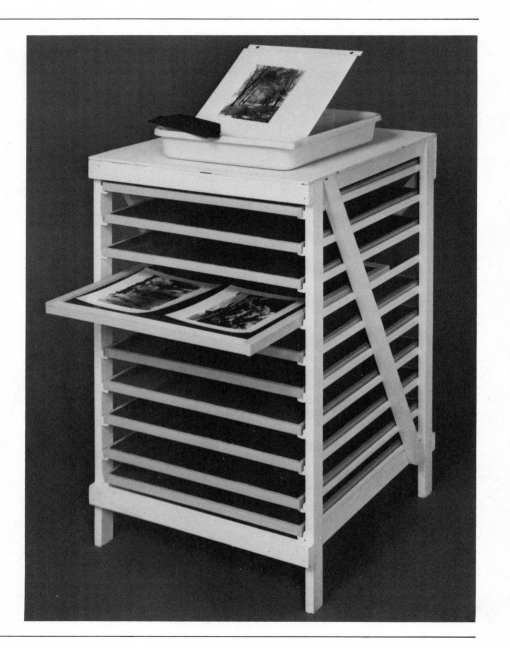

Size

The size of your print drying rack should be determined by space available as well as the size and number of prints you expect to be doing in a single printing session. The rack shown here is 21½ inches wide and 25½ inches deep and has ten screens, each 19½ × 24 inches. Its total capacity is forty 8 × 10 prints or twenty 11 × 14 prints.

If you don't need this much drying space, either build a shorter rack with fewer screens or leave out some of the screens and insert a shelf so you can use the extra space for storage.

For production printing or large prints, you might easily need more space in your drying rack. In that case, build a taller rack with more screens or a wider rack with larger screens. (It's more economical to build a rack with larger screens if you have the space.) Use the same kind of lumber and the same design for a somewhat larger rack. If the rack is *much* larger, build heftier frames for your screens.

Open-air sides

This rack has open sides to increase air flow and reduce drying time. A rack with plywood sides would be a little quicker to build, but we talked with several people whose racks had plywood sides and most of them had drilled lots of holes in the sides to increase air circulation. They felt that open sides would be preferable.

Wheels

Another factor that affects air flow is the location of your drying rack. If it's tucked away in a corner, or in any place where air flow might be blocked, we suggest putting wheels on it. Then, when you finish your printing session, you can pull it out into the center of the darkroom to dry the prints. The wheels are also convenient if you plan to store the rack in a closet or another room and pull it out when you need it. Ask for small furniture casters at your hardware store.

Height

The top of this rack is 35¼ inches from the floor (standard counter height is 36 inches). Adjust the height in your design according to whether you want to use the top as a work surface or store it under an existing counter. Remember that wheels will add a couple of inches to the height.

Finish

Seal the wood with two or more coats of polyurethane varnish, or alkyd paint. It's especially important to waterproof the screen frames because they will be washed occasionally. If you're building your own darkroom sink, use some of the epoxy paint or marine enamel from the sink on the screen frames.

Screens

The screening must be fiberglass—not metal, which will rust. Home-made screen frames may be made of wood or from aluminum screen sections. Cutting, assembling, and painting the wood frames is time-consuming. Metal frames are quicker but they are more expensive and must be mitered. Ready-made aluminum screens, if you can find them with fiberglass screening, may cost a little more than the home-made variety but will save you a lot of time. The drying rack detailed in this chapter holds ten screens.

Using your drying rack

Squeegee the prints on a clean metal or glass surface to get off as much water as possible (thus helping the prints dry flatter as well as reducing the possibility of water spots). Squeegee the back first and then the emulsion side using a plastic squeegee.

Place paper prints face *down* on the screens for drying; place resin-coated prints face *up*. You can also dry RC prints by hanging them from one corner on a clothesline or standing them in a plastic print drying rack (that looks something like a dish rack).

A tip to speed up drying

Screen drying is much slower than heated drying and screen-dried prints will curl. Blowing heated air through your drying rack will make them curl even more. However, if you have a dehumidifier, you can stack the print screens on top of it to speed up drying. With this set-up, you won't need to build the drying rack, just the screens.

Getting ready

Building the drying rack itself is fairly simple and quick, even though there are a lot of pieces. The most time-consuming part of the process is building the screens, which must be done in stages because you have to let the glued corners set up before you paint the screen frames. This project demands no special skills.

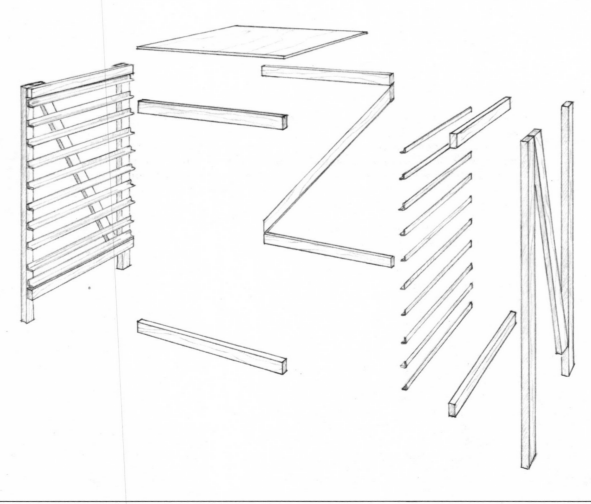

TIME: More than 8 hours
COST: Medium
DIFFICULTY: Easy

Materials and supplies

DRYING RACK

1 × 2 lumber (Five 8-foot lengths)

¾-inch outside corner molding (Five 8-foot lengths. Larger sizes will work if your lumber yard doesn't have ¾ inch.)

¼-inch AC plywood (The piece you will need is 21½ × 25½ inches. Other projects in this book that require ¼-inch plywood are the light box, the lightproof vent, and the sink base. If you are building these, you will find it economical to buy a full sheet.)

¾-inch wire brads

4d finish nails

Glue

SCREENS WITH WOOD FRAMES

Parting stop (⅜ × ¾ inch or ½ × ¾ inch. Fourteen 6-foot lengths.)

Screen bead or half-round (¼ inch or ½ inch. Fourteen 6-foot lengths. This is optional. It's for covering the stapled edge of the screen.)

Fiberglass screening (Two 24 × 84-inch rolls will make twelve screens.)

Alkyd paint or polyurethane

Glue

¾-inch wire brads (You will also need 1-inch wire brads for the corners if you're using ½-inch parting stop.)

SCREENS WITH METAL FRAMES

Materials are listed on p. 151.

READY-MADE ALUMINUM SCREENS

Buy them before you cut the lumber for the drying rack since you may have to alter the measurements of the rack to fit the screens.

Tools

DRYING RACK

- Tape measure
- Pencil
- Combination square
- Saber saw
- Hammer
- Framing square
- Back saw and miter box (optional)
- Screwdriver (Phillips-head)

SCREENS WITH WOOD FRAMES

You will also need:

- Tack hammer
- Corner clamp
- Paintbrush
- Staple gun and staples
- Scissors

SCREENS WITH METAL FRAMES

Tools are listed on p. 151.

Cutting and marking the pieces

The print drying rack has a lot of pieces, many of which will look alike after they're cut. To keep from getting confused, label each piece with the identifying letter given to it in the drawing.

The pieces

From 1 × 2 lumber, you will need:
A Four legs, 35 inches long
B Four side rails, 24 inches long
C Four front and back rails, 21½ inches long
D Three diagonal braces, 37 inches long

From ¾-inch corner molding, you will need:
E Twenty screen tracks, 24 inches long

Cutting instructions for the 1 × 2 lumber and the corner molding are on the next page.

You will also need a *top*, which is cut from ¼-inch plywood. To make sure the top fits well, wait until you have assembled the drying rack; then measure it for the top, which will be approximately 21½ × 25½ inches.

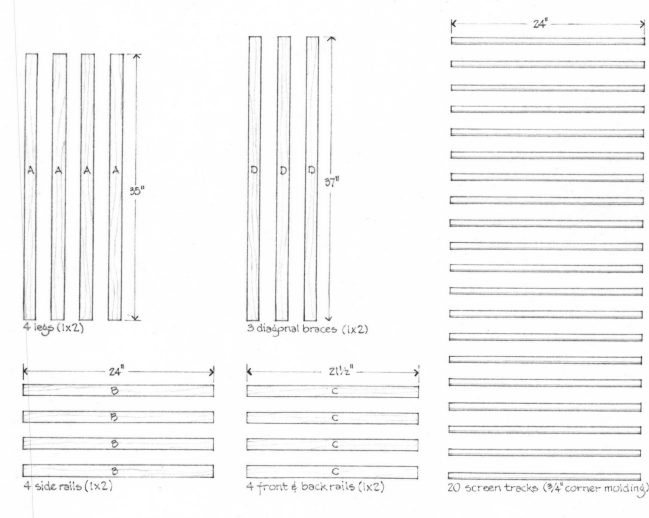

4 legs (1x2)

35"

3 diagonal braces (1x2)

37"

24"

B

B

B

B

4 side rails (1x2)

21½"

C

C

C

C

4 front & back rails (1x2)

24"

20 screen tracks (¾" corner molding)

1 CUT 1 × 2 PIECES

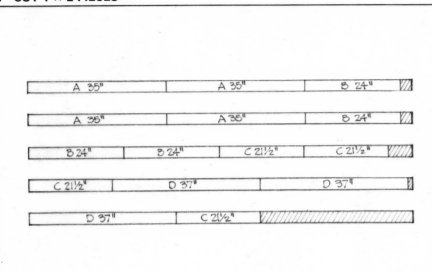

A 35"	A 35"	B 24"	
A 35"	A 35"	B 24"	
B 24"	B 24"	C 21½"	C 21½"
C 21½"	D 37"	D 37"	
D 37"	C 21½"		

2 CUT CORNER MOLDING

3 MEASURE FOR SCREEN TRACKS

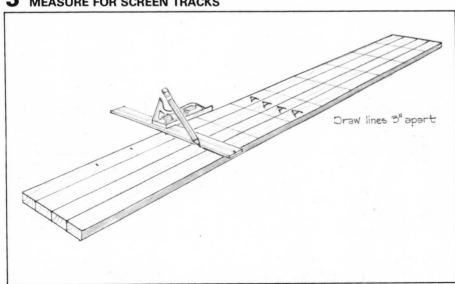

Draw lines 3" apart

1 This diagram shows an efficient way to cut all of your 1 × 2 pieces from five 8-foot lengths. Cut each piece before measuring the next one so that your measurements will be accurate. Use the first piece of each size as a template for measuring others the same length.

2 Cut four 24-inch lengths from each 8-foot piece of corner molding. The measurement for these pieces isn't critical, so it's fine if these pieces are slightly short. For smooth, straight cuts, use a miter box and a back saw.

3 Line up all four legs side by side with the top ends flush. Measuring from the top of one piece, make a mark every 3 inches up to 30 inches. At each mark draw a line all the way across all four pieces.

Cutting and marking the pieces

Assembling the print drying rack

Lightweight materials are used to build a print drying rack that is easy to move and provides as much air circulation as possible. The diagonal bracing makes the rack sturdy.

1 ASSEMBLE SIDE PANELS

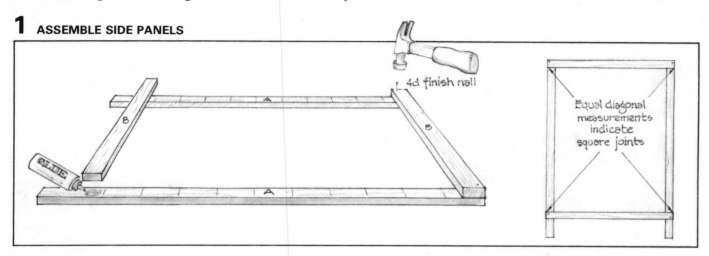

4d finish nail

Equal diagonal measurements indicate square joints

GLUE

1 For each side panel, glue two legs (A) and two side rails (B) together. The top rail should be flush with the top of the legs and the top edge of the lower rail should be on the lowest pencil line. Check the corners for square and put one finish nail in each corner.

Measure the diagonals between opposite corners and adjust the corners until the diagonals are equal. This ensures that the panel is square. Now put a second finish nail in each corner (staggered from the first nail so that it won't split the wood).

2 BRACE SIDE PANELS

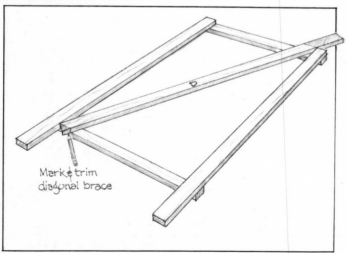

Mark & trim diagonal brace

3 ATTACH SCREEN TRACKS

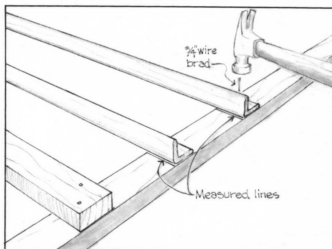

¾" wire brad

Measured lines

2 Turn the side panels over. Put a diagonal brace (D) on each as shown. Trim it even with the top and bottom rails. Then glue and nail it into place with finish nails.

3 Turn the side panels over again so that the inside (the lined surface) is up. Place the bottoms of the screen tracks (E) on the measured lines. Attach the tracks with glue and two ¾-inch wire brads at each joint. This will be easiest with a tack hammer.

4 ATTACH FRONT RAILS

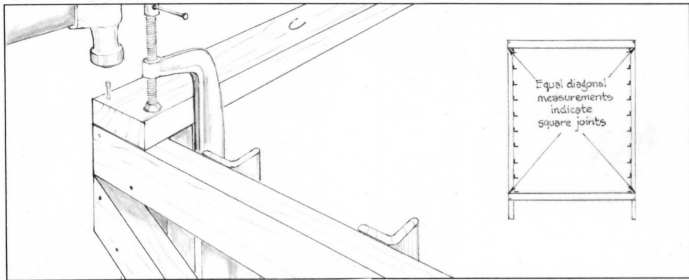

Equal diagonal measurements indicate square joints

4 Put both side panels on edge with the fronts facing up. Glue the top rail (C) in place and clamp it, making sure the top and ends are flush with the side panels. Check the corners for square and put one nail in each corner. Glue and nail the bottom rail in place the same way. Measure the diagonals. When they are equal, put a second nail in each corner.

Note: If you think you will ever need to disassemble the drying rack, use 1⅝-inch drywall screws (instead of nails) and no glue for this step and for the rest of the assembly.

5 ATTACH BACK RAILS AND BRACE

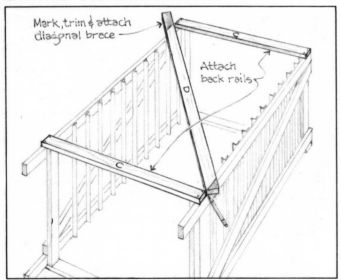

Mark, trim & attach diagonal brace

Attach back rails

6 CUT AND ATTACH TOP

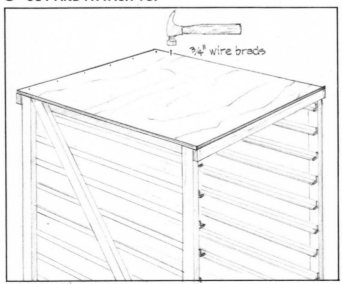

¾" wire brads

5 Turn the structure face *down* and attach the top and bottom rails (C) to the back following the same procedure. Position the diagonal brace (D). Trim it to fit and nail it in place.

6 Stand the rack right side up. Measure it for the top (which will be approximately 21⅜ × 25 inches). Using a saber saw cut the ¼-inch plywood top to size and nail it in place with ¾-inch wire brads.

Building the screens

Since your drying rack screens will be subject to a lot of moisture, use fiberglass—not metal—screening because it is chemical resistant and won't rust. Stretch the screen on wood or aluminum frames.

Wood frames are easy to cut—the corners don't have to be mitered. They take quite a while to assemble and must be varnished or painted to seal the wood against chemicals. A faster but more expensive alternative is to use *aluminum screen* sections. (Turn the page for more information.)

Wood screen frames are put together with glue and wire brads and sealed with alkyd paint or polyurethane. Then the screening is stapled in place. Another coat of varnish or paint over the edges of the screen will keep the staples from rusting.

As a finishing touch, you can tack a strip of *screen bead* or half-round over the edges of the screen. This step isn't essential; it just gives your frames a more finished appearance.

These screens can be hosed off to remove chemical residues, but they should *not* be left soaking in water because the corner joints will loosen. If you're building a larger drying rack than the one detailed here, build sturdy frames for your screens using 1 × 2 lumber or screen molding.

Three ways to build screen frames

The standard frame is made of parting stop and may have screen bead on top to cover the edge of the screen. Instructions follow. A heftier frame for larger screens is built the same way, using 1 × 2 or screen molding. Metal screen frames are also available (see p. 151).

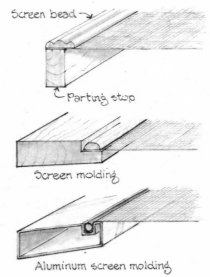

Screen bead

Parting stop

Screen molding

Aluminum screen molding

1 CUT FRAMES

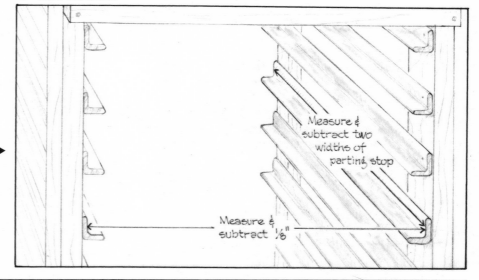

Measure & subtract two widths of parting stop

Measure & subtract ⅛"

1 Cut the front and back pieces ⅛ inch shorter than the inside width of the screen tracks in the drying rack. Cut the side pieces the length of the screen track less two thicknesses of parting stop. (For ⅜-inch parting stop, they will be 23¼ inches long. For ½-inch parting stop, they will be 23 inches long.)

2 JOIN CORNERS

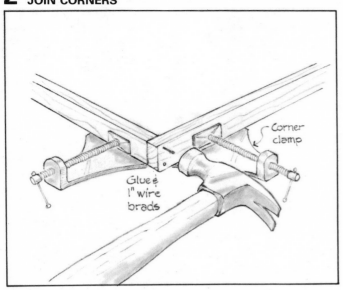

Corner clamp

Glue & 1" wire brads

3 PAINT FRAMES

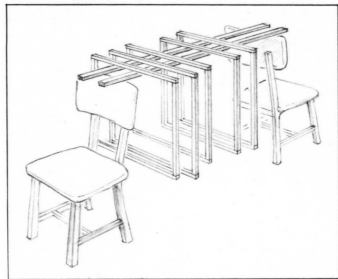

2 Put each corner together with the short piece covering the end of the long piece. Clamp the corner with a corner clamp, glue it, and put in two brads. Let the glue set up for about 5 minutes before removing the corner from the clamp. Repeat for all frames.

3 Make a painting rack by putting two scrap boards across the back of two chairs or sawhorses as shown. Hang the frames on the boards and paint them inside and out. Pay special attention to the corners to be sure they are well covered.

4 ATTACH SCREEN

Staple

Trim

Paint edge

5 ATTACH SCREEN BEAD (optional)

4 Cut a piece of screen about 2 inches larger than the frame. Staple it in place, pulling it tight—but not so tight that it bends the frame. Put the staples about an inch apart and use a tack hammer to set them tight against the screen. Trim the screen just inside the outer edge of the frame. Then paint the top edge of the frame again to keep the staples from rusting.

5 Cut two pieces of screen bead to run the full length of your frame. Cut the other two pieces to fit between the first two. Paint all sides of the screen bead and tack it in place with $\frac{3}{4}$-inch wire brads every 5 or 6 inches.

Building the screens

Alternative print drying designs

In many darkrooms or studios there will be a space that's ideal for print drying. A built-in drying rack is quicker to build than a free-standing one and two ideas for built-in racks are shown here.

On the next page are instructions for building your drying screens with metal frames.

A built-in rack

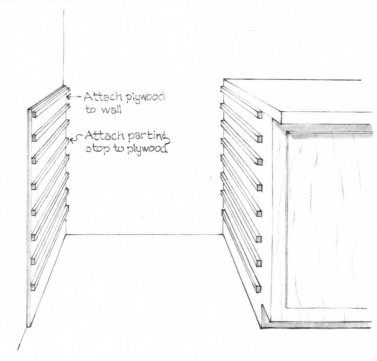

An under-the-sink rack

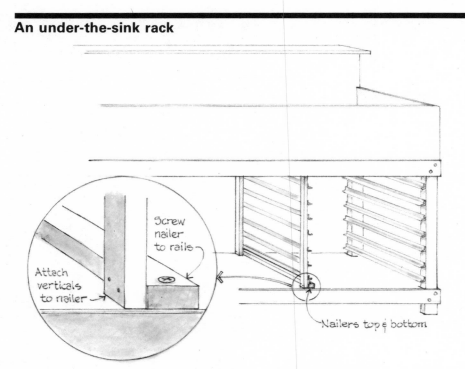

You can build a print drying rack into your sink base instead of building a separate unit. This will save you space and the location is convenient. The design is essentially the same as the free-standing unit: use the legs at one end of your sink base for one side of the rack. Put in a couple of vertical 1 × 2's for the other side (screw them into the top and bottom rails of the sink base). Attach lengths of corner molding to hold the screens. The tracks should be about 3 inches apart.

If you have a space in your darkroom between two built-in cabinets or between a cabinet and a wall, here's how to build in a print drying rack:

1 Check to see what's on either side. You will need solid sides into which you can nail—a built-in cabinet would be fine, for example, but a plaster wall won't hold nails. Use ½-inch plywood wherever you don't already have a suitable side.

2 Use ⅜ × ¾-inch (or ½ × ¾-inch) parting stop for the screen tracks. Glue and nail the pieces onto the sides 3 inches apart.

3 Build screens to fit—⅛ to ¼ inch smaller than the measurement of the opening. Since you are working with existing construction, measurements may vary from one part of the rack to another, so measure it in several places before starting to build the screens.

Aluminum screen frames

You can make the frames for your drying screens out of aluminum sections that are sold in building supply stores for making window screens. They come with instructions·for cutting and assembling at home. They are easy to assemble, very lightweight, and chemical resistant.

Their disadvantages are the materials cost (almost double the cost of the wood screens) and the tendency of the corners to twist so that the screen springs and doesn't lie flat. (We found this to be only a minor problem—a light touch will make them lie flat until the next time you pick them up.) The corner joints for the metal sections must also be mitered.

Tools

- Miter box (A simple wood one is fine.)
- Hack saw
- C-clamp
- Screwdriver or screen installation tool (The screen-installing tool looks like a double-ended pizza cutter. We found that you don't need it for fiberglass screen. A screwdriver will do instead.)

Materials

Aluminum screen section It comes in 6-foot or 8-foot lengths and has a rubber spline for holding the screen in place.

Corner hardware (Four metal corner angles packaged separately from the molding)

Fiberglass screening (Two 24 × 84-inch rolls will make twelve 20 × 24-inch screens)

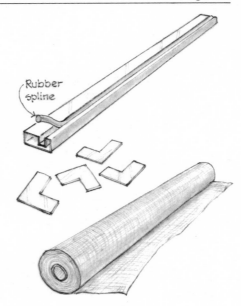

1 CUT SCREEN SECTION

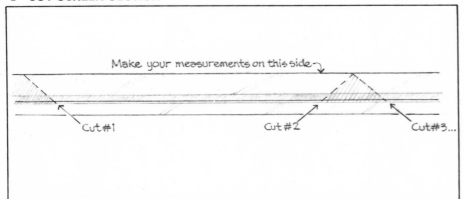

1 Cut four mitered pieces for each screen. The outside dimensions should be $\frac{1}{8}$ inch shorter than the space for the screen inside the drying rack. Remember that you will have to cut *both* ends of each piece for the mitered cuts to be correct. *Remove the rubber spline before cutting.*

2 ASSEMBLE FRAMES

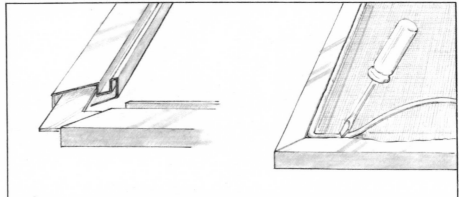

2 The corners fit together with metal angles and the screen is held in place with a rubber spline. Follow the detailed instructions with your screen molding. Stretch the screen taut but not so tight that it twists the frame.

Alternative print drying designs

Index